Making in the Art World

in the
Art World

REVISED SECOND EDITION

Strategies for
Exhibitions and Funding

A POST-PANDEMIC GUIDE FOR ARTISTS

BRAINARD CAREY

ALLWORTH PRESS
NEW YORK

Copyright © 2021 by Brainard Carey

All rights reserved. Copyright under Berne Copyright Convention,
Universal Copyright Convention, and Pan American Copyright
Convention. No part of this book may be reproduced, stored in a
retrieval system, or transmitted in any form, or by any means, electronic,
mechanical, photocopying, recording or otherwise, without the express
written consent of the publisher, except in the case of brief excerpts in
critical reviews or articles. All inquiries should be addressed to Allworth
Press, 307 West 36th Street, 11th Floor, New York, NY 10018.

Allworth Press books may be purchased in bulk at special discounts for
sales promotion, corporate gifts, fund-raising, or educational purposes.
Special editions can also be created to specifications. For details, contact the
Special Sales Department, Allworth Press, 307 West 36th Street, 11th Floor,
New York, NY 10018 or info@skyhorsepublishing.com.

25 24 23 5 4

Published by Allworth Press, an imprint of Skyhorse Publishing, Inc. 307
West 36th Street, 11th Floor, New York, NY 10018. Allworth Press® is a
registered trademark of Skyhorse Publishing, Inc.®, a Delaware corporation.

www.allworth.com

Cover design by Brainard Carey & Mary Belibasakis King

Library of Congress Cataloging-in-Publication Data available on file.

Print ISBN: 978-1-62153-765-6
eBook ISBN: 978-1-62153-766-3

Printed in the United States of America

Contents

This book is dedicated to the memory and work of all artists.

Acknowledgments

This book grew out of Praxis Center for Aesthetics, an online educational platform designed to help artists that I cofounded with my wife, Delia Carey. I personally teach and advise artists on developing a professional career in the arts, and my wife and a team of experts provide support, with the goal of producing an educational resource for artists that continues to change and modify itself to the current art world.

This edition (2021) is wholly revised to reflect current artistic practice and tendencies as shifted by the pandemic, as well as global political movements that have also affected the arts. I am grateful to Tad Crawford for his enthusiasm in bringing this edition out.

The stories in this book about getting into the Whitney Biennial, or proposing a solo show to the Whitney Museum and getting it, are the personal stories of the artistic success that my wife and I have had as a collaborative art team. There are also stories that come from working with many artists as a teacher and seeing what works when trying to develop a career in the arts.

The dominant source of information is surely WYBCX, which is Yale University radio, WYBCX hosts my show, *The Lives of the Artists*, and many of the interviews (now over 1,700 conversations) I do for that show have also made their way into this book in the form of research. In the interviews I conduct for Yale University radio, I ask artists, curators and museum directors what they are working on and how they manage their careers, and it is that information that gives me some insight into how different artists manage and fund their careers all over the world,

especially through difficult times like these, of natural disasters, pandemics, and political upheaval.

In this updated version of this book, I share and analyze that information with you. Thank you Yale University radio, WYBCX.

A bow and a thank-you and an admission of awe for my wife, Delia Carey. She is more than half of everything I am, and without her, I would be a very different person and this book would not exist.

I also want to thank all of the artists who are members of Praxis Center for Aesthetics, the online school I direct, because their ongoing use of the school has enabled it to grow, and the information in this book is also a result of their input and their suggestions for what they need the most and what they struggle with the most.

Introduction

I am writing this book to change the world. The post-pandemic world.

Artists are at the forefront of creative tactics that can alter not only how we perceive our lives, but how we live them. There are new challenges in the post-pandemic era and also new opportunities.

This book is for the artist who wants to either learn to be a professional or use those tactics in their own way, even using strategies to appear "unprofessional" as a way of navigating the world. That last sentence may be confusing, but I believe artists make the rules and define what "professional" means and even how their art is consumed and cared for.

This is also a book written and revised in 2021 and taking into account the current state of global art world affairs, which have undergone radical shifts. The year 2021 started off with a raging pandemic and horrific attacks on the Capitol in Washington, DC, along with a global political lean to the right. It is a time for global change on so many levels, it is an extreme time, and this decade seems like a critical one to address aesthetic issues. Artists have a special role in this challenging decade and beyond.

If you are an artist, you are a leader. You are an alchemist. If you are a leader, you must make a stand and tell everyone who you are and why they should listen to you. In this hypercompetitive world, you must be brave and embrace your art, or your voice will be silenced by those around you who are not afraid to speak up. That is the shape of opportunity, because your voice, your art, must be heard and seen to exist. It's

not about having social- or political-justice content—that is fine too—
but you might also be making total abstractions, which is just as current
and important in these times. Perhaps you are an activist or not, but you
could consider yourself an Alchemist. As an Alchemist, your job is to
transmute, to transform; one example is the dream and practice of turn-
ing lead into gold, literally and metaphorically. To make art. To make
images. In whatever medium you use—you are sharing a message. This
path of inner journey, of secret knowledge, symbols, a visual language
of self-discovery can be explored while leading the way in your field. It
is like turning this basic body you possess into gold, because you make
these displays of beauty from nothing. You are close to a magician in
this way, a maker of something miraculous, your art, your image, your
message.

CHOOSING TO BE AN ARTIST

When I grew up my parents were teachers, and like all the other parents
I knew, they worked a lot and made a modest living. I was told to go to
college, get a degree, and pursue my interests. But since my interests were
art, when I graduated, there were no jobs in the arts except for teaching,
and I didn't want to teach. Also, I wanted more: I wanted to be an artist
and live by my own rules.

THE NEW ECONOMY

In the past century, we have been taught to get a job, go to work, pay the
bills, and everything will be all right. The capitalist system that dominates
the globe needs workers, and schools dutifully turned them out. People
took jobs they didn't like (or resented) and dealt with it until they retired.
For the majority of the working class, their life was devoid of realizable
dreams, of plans, because no one encouraged them, and the means to
achieve those dreams were not obvious. That helps to create anxiety, a
feeling of being lost and unproductive, and even an existential angst about
why we must work so much and enjoy life so little.

THE COMPETITION GAME

It is no wonder we see a rise in antidepressants; life is laid out to be a mediocre exercise in making money, managing stress, and taking care of your family. Now the post–pandemic economy is even more competitive, and when you get out of college, getting a good job is very difficult. The competition is growing all the time. We hear and read about how the rich get richer, and it is an unfair game—insinuating that you probably don't stand a chance.

My advice is don't play that game; don't believe that; it's just what evil corporations want, and it will keep you down and stop you from doing anything creative, like starting a revolution on your canvas or in the streets.

What this new economy needs is innovators. Don't always look for gallery approval, hoping to be taken care of as artists were in the 1980s; those days are long gone. The artists who are really making money are finding ways to bypass the gallery system as well as use it.

Graffiti artists like Banksy are finding ways to bring their work to market without a gallery, without critics, without an intermediary, and without compromising, and you can use their tactics and adapt them to your own needs, even if your work is very different in style, approach, and message.

You can potentially have it all: the independence of an artist like Banksy as well as representation by galleries all over the world.

There are so many ways to live life as an artist that there is no one model you need to fall into, be it academic, hobbyist, or self-taught. Banksy uses one model that he basically invented himself. He is not really a graffiti artist, but someone who has found a way of presenting himself without the typical support (galleries and museums) and created his own mystique, his own story. But many lesser-known artists are doing creative things online and in places you never thought art could be.

CREATIVE IDEAS ARE NEEDED

As an artist, you stand on the edge of a new frontier. The world is waiting for your ideas. Organizations everywhere are looking for creative ideas, and people all over the globe want to be inspired by something new; they want an example that they can follow and do themselves. They want hope! As an artist, it is your job to generate new and creative ideas. Galleries can still be useful, but they are a small part of the game now.

The Worst of Times—and Amazing New Ideas

In the middle of one of the worst economies in decades, a website called Kickstarter was launched in April 2009. The idea was to provide a platform for creative people to show off their ideas and raise money for them. In just a few years, Kickstarter became the largest funding platform for creative projects in the world; millions of dollars go through it every month, right into the hands of artists. Where did all that money come from in that terrible economy and the troubled one we are in now?

It came from people everywhere who want to see creative ideas and projects like making music, inventions, and art be part of this culture, and in 2021 it remains the number one crowdfunding platform with many new competitors in its wake.

The point is that in difficult times, even very difficult times, there is room for new ideas and even new ways to fund artistic practice, such as

Kickstarter. The beautiful thing about Kickstarter is that it is an idea that supports other ideas!

As an artist, you have a big advantage, because you already know how to think creatively, and if you look at the Kickstarter website, you can see that the world values creativity and writing.

Now it is time. Your art, your creative ideas, your willingness to be able to take a risk for what you believe in are all part of the new economy that you must engage unless you want to keep looking for a job that is boring and dull, and will suck the creative life right out of you!

This book will give you tools to pursue your dreams, and the workbook that is included at the end of every chapter is a way for you to make a contract with yourself about realizing those dreams and making a plan for them to happen!

THE ARTIST STEREOTYPE

One of the most crushing ideas or mythologies for artists is that you are more "pure" if you don't promote yourself. We have been raised on these stories, and it has seeped into the minds of many artists and has stopped them from achieving their potential. You know the phrases: "He died penniless, not knowing the value of his work," "She always struggled with money," "He never sold a painting and died alone."

We know the stories of van Gogh and many others who fit those phrases. And we also know how it feels to tell your parents you want to be an artist and the instant financial concern they might have for you, not to mention your friends and other relatives!

Perhaps you know the story of Vivian Maier, a photographer who produced over one hundred thousand photographic images from the 1950s to the 1990s. Her images were found because her storage unit was not paid for and the contents went to auction. When the buyer posted some of Maier's images on the photo-sharing site Flickr, the late photographer became an instant celebrity because the images are beautiful. Then a book and a movie were made about her. Maier had been homeless for a while until two people for whom she had been a nanny when they were children helped her by paying for an apartment and her bills.

It is an incredible story. Also a sad story and a poignant one. When the newspapers caught hold of this story, they ate it up. It fits the age-old myth of the artist. The newspapers commented that she was a pure artist because among other things, she seemed to have no commercial interests at all when making art. The galleries that marketed her work fed the news those lines.

I think the way this is interpreted by many artists is to take it to heart and to think they must not earn money in order to be pure, or a "real artist." (More about Maier in chapter 11.)

Please, if there is one thing you take from reading this book, it should be that those stories are not only outdated and dead, they are counterproductive and can only serve to bring you down emotionally and prevent you from moving forward. Embrace the new economy that is all around us. You are valuable, your work is valuable, and as a contributor to culture, you need to live and thrive off of your work. At the very least, you need the opportunity to thrive off of your work. You can even be critical of capital, of the capitalist system, of money itself—and still have a powerful creative method for funding your art practice.

CULTURE PRODUCER

You are a culture producer, which means that without you, there is no culture, no art, so your role is indeed an "essential worker" and an "essential business" even in pandemic and post-pandemic times. You are needed for culture itself to flourish, because without art, the world cannot reflect and grow the same way on poetic issues of beauty as well as troubling questions about prejudice and justice.

WILL YOU MAKE LOTS OF MONEY AND BE FAMOUS AFTER PUTTING THIS BOOK INTO PRACTICE?

Maybe you will and maybe you will not. But if you follow the book, you will learn how to be a professional artist, and no matter how things turn out, you will know that you tried and conducted yourself professionally and gave yourself a chance. That alone should give you an advantage in the marketplace. As the artist Judith Braun once said to me, "I don't want to look back at my life when I am eighty or ninety and say, 'Oh, I wish I had tried to be an artist.' I want to know that I did my best and have no regrets about it."

There is also a burgeoning DIY movement in the arts now. It is generally meant that now many artists are doing it themselves; that is, they are working outside the gallery system; they are bypassing the traditional intermediary in the equation and working directly with the public. That notion pertains to visual artists, musicians, writers, dancers, and many others in the arts.

NFTs or Non-Fungible Tokens are part of a developing trend started in 2021 that is changing the way money changes hands in the art world as well as how digital art changes hands, and this may eventually be a form that will protect artists from provenance issues, and more. It is also a way to bypass the gallery and auction house and have only the artist and collector involved in a sale.

There are many ideas in this book, but one main concept you can take with you is knowing that you conducted yourself like a professional, giving you the best possible chance at making it in the art world, which

means getting your work into the world as the culture producer that you are.

There are examples of how other artists have done it, and you can follow their examples or make up your own.

You should be reading this book if you want to see more of your art in the world, no matter where you are in your career.

If you have ever said to yourself, "I wish I could just make art, and not have to worry about the rest" then this is a book that can help you. If your dreams are large, like getting into the greatest museum or biennial in the world, or modest, like getting a local café, gallery, or collector to take interest in your work, then you will find some guidance in here to make your travels a bit smoother.

At the end of reading this book, you will have a map in your hand that outlines a strategy that is entirely your own.

If you are an artist and want to let the world know how beautiful your ideas are, then read this book, fill out the workbook, and you will be walking or skipping or running down a new path.

WHY IS THIS BOOK DIFFERENT?

There is a lot of "advice for artists" in book form, on the web, and in blogs and Zoom talks, but most artists want more than a beginning-level business course. In fact, as creative individuals, artists do not generally want a business plan; they just want to keep making art.

But what if you could create a way of working with money that was as creative as making your art?

In this book, I am exploring different ways that artists have used to sell their work and manage their careers, often in very creative ways and on their own terms.

This is a book about the art world and how a portion of it works. This book is meant for the artist as well as the creative person who has yearnings that are not yet defined but tend to the art world. It is also for conceptual artists as well as Sunday painters, because what we are talking about in this book is how to organize and run your life on art.

There are other books on marketing your art and promoting yourself, and this one too will cover that material, but this book will also be a guide you write in, and by the end of the book, you will have a personal plan of actions and ideas to make life in the arts a little easier and hopefully, a little more profitable. In many cases, traditional marketing techniques do not work for the arts, so you will learn about what innovative artists have done that will open a door for you to begin creating your own form of marketing.

HOW TEACHERS AND STUDENTS CAN USE THIS BOOK

You can use this book in several ways. I think the best way is to read it from front to back and fill out all the workbook pages. If you are doing this alone, you can go to the website for more support and can also download the workbook from there if you don't want to write in this book. Here is the link to download the workbook: yourartmentor.com/workbook.pdf.

If you are using this book to teach a class on professional development for artists, or might teach a class in the future on this, there are a few things to consider.

1. Time is always the problem when it comes to creating plans and making them succeed. The teacher, just like the student, often does not have "enough time" to complete the workbook, but the real problem is time management, and that is about changing your behavior.

That means to make this book work for both student and teacher or an independent artist, a time structure must first be adopted that can be achieved. Perhaps thirty minutes, five days a week at first, and soon many things will blossom. That is critical to success on your own terms—"time management" in small letters, as boring as it may seem, will unlock possibilities for you.

Therefore, if the workbook portion is to have its greatest effect, the person must commit to a time frame and schedule so that their efforts (Student and Teacher) will not be in vain.

Some of the greatest obstacles the teacher may find are psychological issues, such as fear, shyness, or a self-destructive attitude. The teacher

should examine themselves as they do the workbook and complete it as well, which will aid in understanding what the students' struggles are. As a teacher, you also have your own struggles, and this book will help you as well with those struggles and make it easier to identify with the students.

The student or artist doing this workbook alone must be brave and must make a commitment to finishing it, using the resources at the beginning to battle hesitation and fear of any kind. In essence, sign the contract with yourself!

Another way to use this book is to form a group. For artists, this is a great form of support. Members of the group read this book and then do the workbook together online using Zoom or a similar platform. You can also host your own seminar on the book using the online presentation tools I mention in chapter 3 so that you can stimulate a group of artists and educators to help themselves understand what it means to create a career strategy in the arts. A group of artists can support one another and become an essential part of your strategy for more visibility and sales.

HOW THE BOOK CAN BE USED IN DIFFERENT COUNTRIES

To be an artist in any city in the world, you need to earn a living in one way or another, and balance that with your art. As rent prices increase and living looks like it will not get any cheaper, we must all find ways to earn money to support our dreams as well as our monthly expenses.

INTERNATIONAL ARTISTS

Almost all of the resources mentioned in this book apply to artists in any country. Because of the online presence of nonprofit organizations, nongovernmental organizations (NGOs), artist-run spaces, Kunsthalles and museums all over the globe, anyone who has access to a computer or phone can use resources that will offer them more exposure and awards.

The "art biennial" is the international form of large-scale exhibition that is designed for artists to participate in from any country in the world.

But more importantly, no matter where you live, there are people around you that can help in some way. In chapter 4, we discuss how to map the entire area where you live and make lists of important places and people for you to contact. This is a universal concept: how to make a friend, and how to allow that relationship to grow personally and professionally. In all walks of life and in any town, the issue of how we befriend people and make good business and social contacts is essential because it also defines who we are and how we present ourselves.

One of the guiding principles that will run through this book is how to be direct and polite in making new relationships. And that idea can be used in any city in the world, or any town, provided there are people there!

HYPE (MOTIVATION) AND ACTION

This is a motivational book, I hope, and that is partially my intent, but the motivational part is also the by-product of techniques that work coupled with my own sense of enthusiasm. In several chapters, I will discuss the role of attitude and creating your own hype, but it all boils down to your intent.

If you are looking for ways to become more energized, more focused, and more productive, if your intent is to create, and if you are creating something wonderful, you will be enthusiastic about it. It is enthusiasm that is being roused by a good motivational text; it is your own sense of power and your ability to change and create.

Whenever you speak enthusiastically about what you are doing or who you are, it is magnetic. People are drawn to others who are excited about something. It can be very serious or even dark or political, but you can still have enthusiasm about it. And since we all want to be happier in some respect or more joyous, then enthusiasm is one of the things we can look forward to. And it is something we can create.

In the chapters and the workbook, we will unlock your own interesting stories and concepts that will generate interest from other people and the press.

THE NEW PARADIGM

The New Paradigm is a call to action for all artists all over the world to change the current system of financial support for the arts and resist the global lean to the political right and do what we can to prevent catastrophic climate change.

Everywhere in the world, we see the seeds of revolution in protests asking for recognition and the right to be heard and fighting against government disinformation. The world came together in its sorrow and in solidarity during the 2020 pandemic and this is a leading force for future generations and the rest of the twenties decade; We are in this together.

As artists, you are free to create new structures, new ideas, and new ways of making a living from your art. Some of that may include selling shares of your work to the highbrow (and high-end) collector (as the late Christo and Jeanne-Claude did), or trading your artwork for services like medical bills and groceries or exhibiting in local libraries and coffee shops. But there are many more ways, some still to be invented by you.

As artists, there is collective power as well as individual power, and if a movement is created that supports artists, like a new educational system with real-world tools for funding your career, wouldn't you join?

This book is the seed of a better world for artists, a new educational system that is co-creative. The new paradigm I am proposing is for artists to continue to seek opportunities outside of the traditional system as well as build their own.

MY STORY—AND HARRY POTTER

There is always the question of nature or nurture; that is, can an artist be self-made, or is she only a product (more or less) of her culture, history, mentors, family, and luck? In Malcolm Gladwell's book *Outliers*, he makes the argument that there is no such thing as a self-made man (or woman) but that everything is a matter of parenting, historic context, hard work, and unique opportunities.

It is my belief that artists can indeed be self-made, so to speak, and that connections can be made across class structures and in spite of economic

difficulties. Hard work is a given, but you don't have to have the greatest parents or be in the right place at the right time to succeed.

My story is one of the first cases that easily illustrates this and, of course, informs much of my thinking for this book. Simply put, I worked at many different jobs such as carpenter, artist's assistant, waiter, and more to pursue being an artist.

After I completed an undergraduate degree at the State University of New York at Purchase, I continued making art, and quickly became frustrated that I could not get a show quickly, so I opened a gallery and started publishing a magazine. I had no background in business. My parents were both teachers, and I went to public school.

I had no idea how to begin a business, so I asked people how I could do it, and it turned out that the nonprofit structure of raising money by asking people for support worked very well for me. That is how I began the gallery and magazine, how I started to understand what being a nonprofit might mean, and how you could raise money to operate it indefinitely.

I left those creative adventures of running a gallery and a magazine after nine years and went to New York City without being represented by a gallery, and I was in the Whitney Museum of America Art's Biennial within two years.

I was still working as a carpenter (handyman) and an artist's assistant when I got to New York City, but I was looking around and asking anyone I could if they could tell me how artists get shows at galleries and museums. I began writing directly to museum directors, curators, and galleries. Since then, I have been a working artist who has gotten sponsorship directly from companies and have also had direct support from collectors and patrons. I believe you can do the same in many parts of the world, regardless of your financial and family background.

HARRY POTTER

I am not trying to say that we don't all have different situations with different degrees of difficulty in getting your art and your dream recognized, and

reaching the right funders, but I am saying it is possible. I am one example, and there are many others. In this book I will give you more detail and insight into the recipe of a self-made artist, but for now, just think of the writer J. K. Rowling. Her story is now well known, but she was quite poor at the time she began writing *Harry Potter* and, with a grant, was able to have the time to finish her book. The material in that book, of course, is compelling and exciting to read, but nevertheless, she is a rags-to-riches story that is worth keeping in mind, and it started with a grant that she applied for.

POSTHUMOUS NOTES

If you are reading this book, you are alive, but one day, you might not be so lucky. After all, history teaches us that many artists become popular only after death, so why not be more prepared than most? When we discuss an artist's career, it would be a failing to ignore the fact that after death, the artist leaves behind a ton of work, usually unorganized. I think it is a kind thing to do for those left behind, as well as a way to preserve your legacy, to organize your archive and think about where it will all go for generations to come. This is not a complex process and involves the details of how to properly label and store your work so that it is preserved and has the appropriate historical documents, so that when a retrospective is mounted of your work, it is easy to gather the necessary materials. This may all seem like a morbid aside, but in fact, it is a very important part of a carefully planned career.

To plan your estate, and to plan what happens to your work after your death, is to take what you are doing very seriously. If you care for your career in this way, you are taking yourself seriously as a professional and others will perceive you that way as well. Having a professional attitude in your studio and your business practice makes all the difference in terms of your own identity and how the world sees you now and forever more.

PREPARING FOR CHANGE

One of the biggest hurdles any artist faces is the willingness to change. You are reading this book because you want more information of some kind to

help you and your art. But more than likely, you will have some resistance to one or more of the suggestions in this book, not because you think it is the wrong advice, but because you don't like the idea of changing the way you are currently working. It is my experience that there is nothing more exciting than change for the better once you prepare yourself for it. That may mean a certain sacrifice in the short term, but in the long term, that means an ability to adapt and learn new strategies that can help you. Think of it as an experiment, we are problem-solving together.

THE CONTRACT WITH YOURSELF
WORKBOOK SECTION 1

After reading the introduction and first chapter, this is the workbook section that should be completed. If it is being taught in a class, this is the homework, the results of which are discussed in class.

If the reader is doing this alone, then please complete each section before moving on so you will have guiding markers for the process of proceeding in the art world.

While success can, of course, not be guaranteed, I can tell you that if you follow the plan I have outlined here for you to fill in, you will be trying and doing all you can to be an artist that is seen and heard in a professional and polite manner. And when you look back on your life at ninety-nine years old, you can say, "I tried everything possible," as opposed to being too afraid or busy to try. At the very least, this workbook completed will give you a map that is an alternative route you can take to pursue a career in the arts.

Do You Want to Be a Professional Artist?

Today in the world of fine art sales at auctions, fairs, and galleries, you only need to be professional and persistent to have a chance to get in the door, especially in our Zoom-dominated environment and online sales platforms for art. In the following workbook pages, you will be taught how to do that with an end in mind, which is the exhibition and increased value of your art.

Written Exercise

Print your name here: _____

As of this moment, I commit to filling out this workbook and giving it a chance, assuming it will help my artistic life flourish financially and artistically and without compromising my aesthetics in any way. I am choosing a different path. I am choosing my own path, and as of this moment, I am making a contract with myself.

☐ Check here if you agree to the above statement.
 Sign your name here as a contract with yourself:

Here is the first written exercise. Think about it and then write very concisely.

If you put practicality aside for just a moment, dream a very large dream of what you would ideally like as an artist, with your career having gone in the direction you like. Imagine it is three or more years from now and everything has happened to you that you desire. What does that mean, exactly? How much are you earning, where are you living, and all the details?

Have fun with this, but take your time.

Don't write anything at this very moment. Pause a bit, reflect, lean back in your chair, and let your mind dream a bit. Again, put practicality aside for the moment and reach for something ideal.

Then fill out the following:

1. I will have reached my goal in _____ years. (Take a guess, be optimistic!)
2. My goal consists of earning _____ per year before taxes.
3. At that time, I will be living in (location) _____
4. Other residences at the time (location) _____
5. Other separate studios (location) _____
6. What I will sell to make the amount of money per year that I just projected _____

(List the number of works and what types and how they will add up to your total income. If you intend not to sell work at all, ever, then say that, too.)

7. My studio practice will consist of the following:
 I will work for _____ hours a day, _____ days a week. I will have _____ museum shows a year.
 I will have _____ gallery exhibits a year.

8. I will be selling work in other ways, including the following (list other ways you might be making sales or commissions, or a second job that you want to have):

In two sentences or less, write what other forms of income might be contributing to your yearly total income.

Different Income Models for Artists

Perhaps you have had the experience of walking into a gallery or museum, and after seeing work on the walls that is clearly bad or at least of poor quality, you say to yourself, "My work is so much better, why are they getting $50,000 for that? And how did they get in a gallery?"

Those are the questions to explore, because the reason they are getting that much money, or at least asking for it, is not necessarily because the work is of high quality. The idea of objective value or objective quality is clearly slippery in the arts. There are no standards or review procedures the way there are for cars, for example. For cars, by reading enough reviews on the web, we can get a sense of a car or almost any product, but art is very different, there are no "quality" reviews that are comparable. Since we know this already, then the question of why some art in galleries is priced so high even though it may not be very good is the right question to ask, as well as why it is there in the first place. One answer is that it clearly has nothing to do with its quality! And since, as an artist, you have a sense of quality, then you know that there is truly something else at work.

The simplest answer is that a big part of what is going on is how the art is talked about, presented, and, more importantly, written about. Similar to the marketing of other products in our lives, art, at most levels, has a story of some kind to help understand it and sell it. Also, it is about being well organized when applying for grants or presenting your work. After I taught this concept in Praxis Center about how mediocre art can get everywhere with the right presentation, one member, an artist, wrote this to me which explains it succinctly;

Good one, Brainard;

Intrigued, and frustrated with this very phenomena, I discreetly asked the director of a major local art center how and why this happens [why sometimes mediocre art is exhibited]. Being fond of me, she took the time to show me. She opened a file drawer, pulled out several examples of applications for grants and residencies, etc, and, one by one, showed what selection committee members look for. In more than one case, she admitted "here's some work everyone loved, but the proposal is so sloppy, inarticulate, and disorganized, while in this case, here, though the proposal is not so interesting, it is succinct, neat, complete, and was received on time, giving us the confidence this applicant can do what they propose, without supervision."

That, she said, was the difference.

Thanks for your service, and keep up the good work!

—Andrew

Exceptions to this are the very lowest ranges of work, such as the paintings for sale in IKEA and Walmart that are mass produced and printed on canvas, or some artwork that sells for under $100 on the streets of cities, in stores, and in galleries. Having said that, the market for the lowest-priced work is huge, and you could make a career out of that as well. There are many factors that increase the value of art, and I will go over a few examples here. The artists I am writing about below represent new as well as traditional forms of entering the marketplace with your art.

SELLING OUT A HIGH-PROFILE GALLERY SHOW

One traditional model is a gallery show that sells out. A friend, Ellen Gallagher, is an example of this tactic. After Gallagher's work was included in the Whitney Museum of American Art's Biennial, the gallerist Mary Boone asked her to have an exhibit. At that exhibit, huge paintings that were often eight by ten feet in size were all sold for about $10,000

each. That began her career and created value. But there were other factors. Ellen Gallagher had a story and a way of describing her work that appealed to art buyers and gallerists. Ellen Gallagher is biracial and has dark skin. Her work looks minimal, and in the beginning, it looked a bit like Agnes Martin's work from a distance, with fine lines often making a delicate grid that looked like lined paper.

How did she talk about her work, and how was it sold? In her work, there is a language of her own that she has embedded into the lines. If you look closely, you see eyes, lips, and other forms that look like doodles, and together, they make up the lines in her work. All those tiny images have meaning that is social and political in content. They are about the history of the African American experience, from minstrels to riffing on the clichés that are often derogatory. Her work has a compelling aesthetic to it because from a distance you see this beautiful canvas of lines, of forms, and up close, you see a personal history about the African American struggle in America. As an artist and a person, Ellen is very easy to talk to and is approachable. She refers to historical examples easily and, as a woman of color, is a representative of the historical achievements that African Americans have made in the United States in the visual arts.

In summary, what gave her work real value was a show with Mary Boone with lower-priced large paintings that sold and, more importantly, she had a way to discuss her work that revealed its inner workings and her thought process. With her work she was able to tell an engaging story that taught all the viewers something about her experience as a biracial woman in America. That was a story that writers could easily write about and that gallerists could use to sell her work. While this is all presentation and communication techniques I am now writing about, it should be mentioned that her work is and was beautiful and delicate and yet had a more intellectually confronting aspect upon closer inspection. To many, this story may seem like winning the lottery, and it is true that luck played a role here, but also her story and images worked very well together, so that the "system of the art world" could easily consume and digest her work in a meaningful way.

DAMIEN HIRST-STYLE MARKETING

Damien Hirst is an example of very high-end marketing, and at the moment, he is still one of Britain's wealthiest artists. He began right out of college to stage shows of his own. Curating warehouse shows in available buildings with his own work, as well as the work of many friends, he began getting collectors to follow and buy his work through sheer persistence and asking people to come to shows by calling and writing and making direct appeals.

His earliest collector was Charles Saatchi, who helped to propel many artists' careers by buying artwork and getting his collection exhibited. Hirst was after the *influencers*, so to speak, so he could become famous.

Hirst is one of the savviest artists in terms of business deals. In September 2008 (in a major recession) he took an unprecedented move for a living artist by selling a complete show, *Beautiful Inside My Head Forever*, at Sotheby's auction house and bypassing his long-standing gallerist. The auction exceeded all predictions, raising almost $200 million, breaking the record for a one-artist auction as well as Hirst's own record with $18 million for *The Golden Calf*, an animal with eighteen-carat gold horns and hooves preserved in formaldehyde. The idea of an artist bypassing his dealer and going straight to auction was unheard of, and totally new. He cut his dealer out of almost $90 million! Not everyone needs or wants to be Damien Hirst, but it is important to understand what he has done. Like other artists I will discuss, he is able to change the rules of the game a little bit, and that is something artists can do no matter where they are in their careers.

FOR THE LOVE OF GOD

Damien Hirst also created a now-famous work of a skull covered with diamonds called *For the Love of God*. He said it would be the most expensive artwork ever sold. He thought it would sell for about $100 million. He received tremendous worldwide press for saying he would try to sell it for that much. It is an age-old marketing technique of announcing you are going to break a record of some kind to generate press attention.

In fact, he never sold the skull for $100 million, but he had a very savvy backup plan. He put together a group of investors, of which he was one investor, and sold the work for $76 million dollars to the group. He is often criticized as a model of excess and market manipulation, and he may deserve that, but he is also offering new ways for living artists to make much more money off their work than anyone previously thought possible. He has ushered in a new era where the marketing of the art is part of the art itself.

When the diamond-encrusted skull was exhibited in London, the setup for viewing it was an artwork in itself. It was exhibited in a small gallery that had several security guards looking very ominous. The room the skull was in was almost completely dark, and there was a long line waiting to get in. Once you were in the gallery, you had a very short time to see the skull because you were moved through rather quickly.

The problem was that your eyes didn't have enough time to adjust to the darkness in the room, so just as you were starting to see the skull on the way out, the angle of the light caused a spectrum of colors to come out of it, and then you were outside. It was an incredible scene. You could barely see it, and once you did, it was all colors and reflection, and you couldn't make out too much. The end result was like a vision or a dream of some kind. The press loved this and so did the people lining the block to see it. If nothing else, Hirst is an example of how far you can go in being creative and caring for every aspect of your work, including his exhibition and how it is seen and perceived and for how much time. He has opened the door for artists to be creative in similar ways. It is notable that his work is fetching such high prices that most museums cannot afford it. This may seem beyond you, but his creative approach can be interpreted and used by any artist.

In 2017, he organized a solo exhibition in Venice titled "Treasures from the Wreck of the Unbelievable," where he made up a whole myth/story to present what looked like ancient treasures from a sunken Greek ship, with pieces that range from Ancient Egyptian-like items to Disney character reproductions, encrusted with faux shells and coral. It consisted of about 190 works, including gold, silver, bronze, and marble

sculptures. He did the show in collaboration with a major collector. It was essentially a giant DIY pop-up show. It was hailed as both genius and the biggest art flop of all time—yet he sold millions of dollars of art from "Treasures from the Wreck of the Unbelievable." The reason it was considered "the biggest flop" was only because the critics almost universally hated it, and so the press called it a failure, yet it remained a financial win for the artist and a show that would be part of his legacy.

The lesson from Hirst is not that you have to be as excessive or as over the top as he is and was, but that you can consider changing the rules of how things are presented, and ultimately, how the art is collected and talked about.

BANKSY

"Banksy" as he is known, is also an artist from England who began as a graffiti artist. Because he decided to remain anonymous, it was a move that got him more and more press because everyone was so curious about his public work. At the beginning, one of his first actions was to bring his own small framed paintings into museums, hang them on the wall with double-stick tape, and leave, without permission, of course. As an artist who wants to exhibit and show the world his work, he found a way. But he kept pushing the boundaries of what he could do and how he could do it. Like graffiti artists before him, he plastered his images all over cities, and all illegally, of course. He went further as he gained notoriety, pulling stunt after stunt—up to his famous self-shredding painting at a public auction that cemented his fame in the upper echelons of the art market.

The content of his work was often political, and that also got people's attention. The press loves good photos, and he gave them plenty of photo opportunities by placing his images everywhere for them to see. He used stencils and spray paint initially so that he could make images quickly and move on.

His great achievement was to protect his anonymity fiercely. In a terrific marketing ploy, he remained anonymous and created a mystique about himself. Everyone saw his images around the city and wondered

who he was. The more people asked, the less they found, and this only added to his notoriety. Banksy had a show in an abandoned warehouse in Los Angeles, California, which he elaborately staged with the help of a curator he hired. He put a real elephant in the room that he hand-painted with nontoxic paint. This was a show that not only brought in a huge amount of people, but also press as well. Celebrities came to the show and bought work, and that was his big start. Not long after, his work was being sold at auction houses. Does this story sound familiar? In the tradition of Damien Hirst and others, he started by creating a show outside of a gallery, in a warehouse, very unconventional. The content was very different though; his work is antiestablishment, antigovernment, and anticapitalist. However, his ability to market himself, ironically, to the capitalist system is very effective and similar to Damien Hirst in many ways.

By painting his artwork all over city walls and streets, he is getting tens of thousands, if not hundreds of thousands, of dollars' worth of advertising—for free! There are lots of books on how to market your work and use social networking platforms, but Banksy is getting tremendous visibility with a very different method. This is not unlike what Keith Haring, another graffiti artist, did in the 1980s, before the Internet boom. He put his work on walls all over the city, gave out buttons and stickers, and relentlessly promoted himself.

Banksy continues to this day with creating groundbreaking ways to get his art into the public without any of the traditional galleries. He goes straight to auction, as mentioned above, and continues to give the commercial art world and wealthy collectors a critique while selling to them at the same time and creating viral videos about his pranks.

THE BANKSY LESSON

The lesson and perhaps inspiration to take from Banksy is that he is playing by his own rules. Like other graffiti artists, he paints on the street, but unlike other artists, he has consciously created his own mystique. By remaining anonymous, he continues to engage the public in a guessing game. Also, his content often touches on issues of social and

political injustice, and this is something that many people can respond to—especially as the world continues to be in turmoil with riots and protests. Rather than have images that are decorative, his work is engaging the viewer and asking them to use their minds and agree with him or not. That is a provocative idea that brings the viewer into his fold, his world.

In a Banksy filmmaking effort, *Exit Through the Gift Shop*, which I strongly recommend seeing, he cleverly uses another filmmaker's footage of him and other street artists to document the whole genre of street-art painting. But he also skewers the art world by presenting an artist who had never had a show before, who calls himself Mr. Brainwash, and is a total unknown. Like Banksy and Hirst, Mr. Brainwash had a warehouse-type opening that was a success. He is profiled later in this chapter.

The method of Banksy and other artists who mount their own shows in abandoned warehouses is becoming more popular, and it is one of the new methods that you should consider. You can remake the idea in any way you wish, but in this economy, there are more empty spaces (retail storefronts and wholesale warehouses) than ever, and it is worth considering, since post-pandemic consumers are now used to buying everything online. You don't have to mount a giant solo show; a group show in an empty commercial space can work even better because all the artists will have their own mailing list, and it can generate even more traffic that way.

TINO SEHGAL

Tino Sehgal is a high-profile artist who has had a solo show at the Guggenheim Museum. I want to talk about him because he has approached the sale of works in a way that in itself is still quite new to the art world and is, I believe, one of the reasons for his success. It is also something you can adopt or use to stoke your own creative approach no matter what level you are currently at in your career.

Tino Sehgal creates what he calls "constructed situations" in which one or more people are performing instructions created by the artist. That means, much like a theatre director, he tells a group of people that he hires to have conversations based on a theme of some kind. In the show at the Guggenheim,

you never see the artist, there is no art on the walls, and when you walk in, a small child of about ten years old asks you what you think the word "progress" means. You begin to have a conversation with that person and then you are led to another person who continues the conversation until you reach the end of the ramp at the museum. What the artist has done is train all the actors, so to speak, to ask certain questions of the audience members.

The reason I am using this artist as an example of a new method for selling your work is this: on the sale of his work, he stipulates that there is no written set of instructions, no written receipt, no catalog, and no pictures. That's right, he sells his work (which is a set of instructions really) so that you could, in fact, buy one of these pieces, but there is nothing physical to own, not even a receipt. During the show, there was another piece of his, which was a performance of a couple kissing endlessly on the floor of the museum. The two people kissing would do so for two hours at a time, and then the actors were changed. The remarkable thing to me is that "The Kiss" piece was owned by MoMA and lent to the Guggenheim for this show! So what I want to examine here is how he sold the work and why it is significant and also important to your process.

SELLING WHAT YOU CAN'T DOCUMENT

His work could be called performance art. It looks and feels like performance art when you see it, and it certainly isn't a painting or sculpture. It is necessary to have live performers whenever his work is shown. He is the first artist in the performance art world to make significant sums of money from his work. There were many other quite famous performance artists who were jealous of his success and frustrated by it, because they never found a way to market their own work.

What Tino Sehgal did was to address the issue of collecting his art directly, because your art cannot be in the marketplace if it is not collected. Let's take this situation apart for a moment, because as poetic as some of Sehgal's work is, how the art world consumes it is very important.

The people who buy art for personal collections and for investment are not only wealthy but also speak the language of business all the time. Since

they probably accumulated their wealth through hedge funds, private banking, stocks, etc., they are very familiar with the language of money, and in fact, it is their passion. So when a dealer and an artist explain to a potential wealthy collector that upon buying the work, there is no written set of instructions, no written receipt, no catalog, and no pictures, it raises the very interesting question of "Then how do I buy it and show it in my home?" At that point, they are already engaged. They have never heard of a sale like this before, and they want to know more. What they end up finding out is that the artist tells them verbally what to do, and they have to stage the performance themselves with actors in their home. Because this is such an unusual way to buy work, it generates interest in people who collect and are fascinated by the language of money themselves. Museums can buy and loan the work; it can also be resold, and that is what makes it part of the market. It is also what makes it unlike anything a collector has heard about before.

Sol LeWitt also had a process similar to this. He would sell instructions to make a drawing or mural on a wall. The collector bought the instructions and could have Sol LeWitt's team of painters execute the drawing on the wall of their choice. The artwork could also be moved by erasing or destroying the wall mural and making it again in another place. Furthermore, LeWitt's work could be loaned to museums in the same manner. Tino Sehgal is taking

a page from LeWitt's book here by making a sale in a manner that is itself not only creative but very savvy, because the collector is engaged largely in a conversation about how the work itself is purchased, and that is an interesting conversation for collectors. Also, the public and the art world became amazed that he rose so quickly to such heights but also that he was selling his work, which to most people seemed like performance art, and previously no one had sold work in that genre for so much or in such a fashion.

MAURITZIO CATTELAN

The well-known Spanish artist Mauritzio Cattelan continues to make headlines with provocative works in different mediums that also challenge the idea of what can be bought, such as his *Comedian* (banana ducttaped to wall)—remember that? And a functioning solid 18k gold toilet.

MR. BRAINWASH, BORN THIERRY GUETTA IN FRANCE

This is the story of an artist who has done something extraordinary in just four years. He began making art as a total unknown, and was not represented by a gallery. Two years later, his work had already been sold at auction for over $100,000. The art world loves to hate him, and he gets tossed aside by bloggers and the press on a regular basis. He began his career as a filmmaker, but that is a stretch because he was using a video camera and never actually made a finished film. However, he was making a documentary movie on artists who work in the streets, using stencils, spray paint, and sometimes sculptural elements to place their art illegally all over buildings and street signs, sidewalks and more in multiple cities. They were all graffiti artists in essence, but he ended up profiling some very important figures in that scene, such as Shepard Fairey and Banksy in his unfinished film.

HOW IT WAS DONE, DIY STYLE

His story begins with him putting up posters of his artwork, in a graffiti style, all over Los Angeles. That was the beginning of his marketing, you

could say, for his exhibit. Then he rented an abandoned building, the former CBS Studios in Los Angeles, California, and decided to stage his own show there. He worked tirelessly to fill the space, hiring other artists to do much of the work for him. Like Andy Warhol, he made prints as well as paintings and created portraits of numerous famous pop figures. He also created sculptures and installations. He hired other artists to make most of it for him.

He oversaw the entire process, but to make enough work to fill the gigantic building he was in, he needed people to manufacture and create new designs for paintings. He did this entire production by himself; that is, he had no gallery dealer or representative, just employees. It was, as the press called it, a DIY show, a do-it-yourself exhibit. He must have spent a great sum making all this happen, and has said that he asked people to purchase works in advance to finance much of it. He did hire a curator to help him, the same one that produced a Banksy show a few years earlier.

As a promotion, he said he was going to give away two hundred prints to the first two hundred people that came to the opening. That night, an estimated seven thousand people came to his opening. He sold almost a million dollars' worth of art! And in one bold stroke, the art world knew his name. To this day, some parts of the art world continue to look down on him or dislike him because he did not travel through the usual channels of the art world. He did it in his own way, on his own terms. And in my view, that is just fine because he is prospering off his work, doing what he wants, and like Damien Hirst, he is challenging the so-called rules of the art world.

Since that show, he opened a similar one in New York in an abandoned warehouse. In New York, the show was also mobbed, and he gave away hundreds of posters and sold work as well. As of 2021, he continues to paint, and has one million followers on Instagram.

It is a way of looking at the world that could give you freedom to do what you wish on your own terms. And that is the idea of this book, to allow you to grow in whatever direction you wish, to interpret the advice in the rest of this book through your own lens so it becomes your unique path that only you can build and walk on.

This is a wonderful example of how an artist can not only work outside of the gallery system, but can create their own mystique, marketing, and sales on their own. Is his art good, and is he talented? In this case, as with the others, that is not the question for me to decide. Because, talented or not, he is making it in the art world and I am interested in exactly how and why. Selling work at major auctions is the ultimate goal of being recognized in the art market. When we examine an artist like this, for the purposes of this book, we are not determining if this is good or bad art; we are looking at his techniques for earning a living and becoming well-known in the world of art.

Part of his initial success was due to his having mounted a show that was so large (over 125,000 square feet) and also to his status as an unknown artist. When you do something on a scale that is record-breaking, the press pays attention. It is a technique used by many promoters (to claim, true or not, that this is the biggest, the largest, the longest, etc. in a press release) and was one of the elements brought into play for this show. He also asked for the help of other people who had organized events in the past. Besides being a driven, obsessive artist, he was also getting all the help he needed. The movie that I previously mentioned, *Exit Through the Gift Shop*, is a must-see for readers of this book. You will see more details of his story and will probably find it quite inspiring. As with Banksy and Damien Hirst, Mr. Brainwash took the idea of an independent warehouse show to a new level. He was bold and brave enough to believe in what he was doing, and took it one step further than most by making it on a scale that most never imagine doing.

There are many lessons to take from this artist, but I think the most important one is that this is a way of working, a way of making it, that is new to the art world. It is rare to see an unknown artist rise this high and this fast, especially in this manner, separated from the art institutions that are normally the stepping-stones to success.

THE OUTSIDER, OR THE SELF-TAUGHT, FOLK ARTIST

The outsider artist has many definitions, but for the purpose of this chapter, I will consider an outsider someone who may or may not have gone

to art school but, in general, an artist who feels they are not "inside" the system as in a traditional gallery. But I will also use it to define any artist who feels "out of the loop" or somehow apart from what they believe most other artists are connected to. The artist I just wrote about, Mr. Brainwash, would be an outsider in these terms.

Outsider artists are usually considered to be folk artists, that is, artists with little information about the history of art and their place in it. So please understand that while there is overlap in these categories, I am referring to artists who feel like they are "outside" the system of the art market and exhibitions, and want a way in.

Most likely you fit into this category; I know I always have. I did go to art school, but from the start, I wanted to work outside the art world system, partially because I had no idea of how to get on the inside of the art world. When I would ask people how to become part of the club of artists working professionally, I got some odd answers. One of the most interesting was from a friend who said, "Brainard, in order to be on the inside, you have to be on the inside." At first that was annoying to hear, but after a while, something sunk in. I saw myself as always outside of something, and in order to think the opposite, I would have to feel like I was already there, already on the inside. Ironically, one way to do that is to simply recognize that as an outsider artist or one who feels like it, you are exactly the kind of artist that people on the inside of the art world are looking for, something new, something fresh.

But let's look more at this label with a specific definition, like selling work on the streets. To begin with, it means that you have fewer rules to think about. As an outsider or someone who just feels that way, you can say to yourself that you are creating work independent of any trends, and because of that, you are not compared to others unless you choose to be. Yet there is even something more freeing about this idea, because as an outsider, you can also create any strategy you like, and since you have no set of rules, it is a wide-open arena.

SELLING WORK ON THE STREETS

Selling art on the streets of a city may not be for you, but consider it for a moment. In New York City and many other cities and towns, artists set up small tables on the street and sell their work. The more savvy artists that have been there for a while are selling matted photographs or prints of some kind in the range of $15 or two for $25. Sounds too cheap, right? These are prints and profit is made in multiple sales.

The artists who are selling on the street are able to get a license to do so fairly easily because they are selling their own art, which is allowed in Manhattan and many other major cities. Of course, many artists set up with no license at all. It is a legal process to navigate but once you have a spot on the street and ideally a license to sell, you are ready to go, with very little overhead.

This is a valid system of making a real business outside the traditional art market. The artists that are doing very well on the street are selling inexpensive matted prints, but also they are usually hiring others to do it for them, thus increasing how much they earn. It is a fairly simple business plan. If matted prints of your work (which means common color copies or something as inexpensive) cost you about $4 each to make, then you could give someone $2 for every print they sell. So if they are making $4 for selling two prints at $25, you are making $17 on each sale without being there. Not too bad, is it? You could also sell matted prints to boutiques or small stores at wholesale for $8 each. You make $4 with every sale. I am outlining this simple business model because to most readers, this may seem like the least attractive way to sell art, but it is also an easy way to see how sales and profits are made. I have seen artists create street sales on many levels, and it is helpful to discuss because it is such an independent venture and the model can be adjusted in all types of ways.

SELLING ART ONLINE

Selling online is now a powerful and also the dominant way that art is discovered and bought. There are many ways of doing this and I will outline a few of them. Especially in the post-pandemic market, sites like Artsy are

flourishing like never before, as are artists selling on their own websites. Post-pandemic buying is safer and easier online and that will not stop anytime in the near future because it is also very convenient. The pandemic created numerous new systems that will continue to be used in the future because of their conveniences and their ability to aid or replace older systems.

Education is one of those systems, because while we will still go to classrooms, we will have an online component of all levels of education that will likely continue and be part of all class curriculum. The same is the case for visiting your doctor—"telehealth" is now a permanent part of how we interact with doctors.

EXAMPLE OF SELLING ART ONLINE

One example is Abbey Ryan, an artist who sells a painting a day on eBay and earns almost $100,000 a year from it. She has a blog, a website, and has created a way to remain in the studio all day and make a living at it. She was written about in business blogger Seth Godin's book *Linchpin* as an example of a businesswoman cutting out the intermediary and bringing her work straight to market. Abbey Ryan does not need to leave her studio to make these sales happen.

Another example is Ashley Longshore, who sells her work through Instagram and her paintings regularly sell for $20,000 and more. However, people do not click a "buy" button for that amount, they do it over the phone and she invoices them. Her Instagram is what builds the buzz, and she also spends lots of time sending out press releases and looking for a way to get more attention. In 2019, she had a show in a clothing store, but not just any clothing store; it was the Diane Von Furstenburg store in Chelsea, in Manhattan. After mounting a show in her store, the owner not only appeared on a video of hers, but so did the model Iman, who was gushing about her work. That of course drove more sales, and you can see all of this yourself on Instagram or by doing a search. You can also see on her website how she makes it easy to purchase work through a typical check-out cart system that is simple. That is the kind of out-of-the-box attention Ashley secures and it has taken her very far.

The Online "Funnel" for Sales

Selling art online can also be a very calculated and specific process if you use advertising online to build a list of collectors, and then allow those collectors to purchase work from you by making it available to purchase. This is at once one of the more straightforward methods and also a complex process. I wrote a small book recently titled *Sell Online Like a Creative Genius*, and in that book I outline the process by which artists as well as businesspeople sell things online. As an artist you are using the same tools and techniques that any advertiser online uses to find your niche audience and begin communicating with that audience.

Here are two types of "funnels" to generate sales online:

Funnel #1: The essence of the book I wrote about selling online is that there is something called a "funnel" which is the name of the process by which you acquire a collector and then sell work to them.

It works like this:

1. You run an ad on Facebook or Instagram or both. →
2. The ad collects emails of interested collectors without selling them anything. →
3. Then you send automated emails (that you write beforehand) to those collectors so they can buy a work of yours or contact you about the art.

That is the method that all advertisers online use, and most likely, you have already bought something that way. You perhaps just clicked on an item (which shows interest) and then you kept getting ads or emails about that product. In that process, something specific and complex happened.

What specifically happened was that you showed interest—maybe you looked at an item on eBay or Amazon or another site, and then you see more ads for that same thing wherever you go online. The same thing can happen with your art. The complex aspect of that process is called "retargeting" which means that as soon as you show interest, ads are then sent to you specifically to engage with. You can either do all of this yourself,

or hire someone to help you, or you can take a course, or you can let another platform partly do it for you. For example, if you have a painting for sale on eBay or Etsy, and someone looks at it, they will begin to see ads for your painting wherever they go online. eBay and Etsy are partly doing a funnel for you—they are doing the "retargeting" part. However, you are not getting the emails of those interested, so after eBay or Etsy stops retargeting, which is just for a few days, that interested person is gone.

If you want to make a funnel, you can learn how, but it takes time and dedication to looking at analytical data. Either buy a book, or take a course, or hire someone, because there is so much involved in it I spent a whole book on it, and you have to be able to embrace the learning curve of online advertising.

There is another method that is even easier than the one I just mentioned that I didn't discuss in my book, Sell Online like a Creative Genius, and the following is that other funnel.

Funnel #2: The "Giveaway" model. This method is a classic marketing approach that many online businesses use to sell what they have and it can work particularly well for artists selling art. This is how it works.

Your goal is to convert as many followers as you have on Facebook, Twitter and Instagram into email address contacts. Then you can sell your work to those contacts after creating a desire in them to own your art.

It begins by creating a Giveaway, which in the case of visual artists means creating an inexpensive print of your art that you announce is being given away.

You can decide what kind of print you are making. You have many possibilities, like creating a print on aluminum or paper or canvas from any image that you have made.

First you make a post on Facebook saying something like "Today I launch my new website, and I am going to give away a print of my art to celebrate! Just sign up if you want a chance to have a print of mine for free (including shipping)."

Then you provide a link to a page where visitors can fill in their name and email to be entered in a contest where one person wins a free print. All of the names that are filled in for the contest get added to your email

provider (like MailerLite) to be used at a later date. This grows your email list and generates interest in your art. All of those that signed up for a free print now want your art —they hope they will win it.

Then after seven or ten days or however long the giveaway is, you announce the winner (on Facebook, Instagram, and Twitter) with a photo and even a video if you can of the winner showing it off.

Now you have many new emails on your list of people who wanted to own that print for free but did not get it. You have created a desire for your work in all of those people that are now on your mailing list, even if it was just a dozen people at first.

The next step is to email all of those people and tell them they can buy the print or other work of yours and you are offering them a 10-percent-off coupon for the next week (or the next three days). Then these people who wanted a print but didn't get one, now have the chance to buy one from you, or an original artwork at a discount.

Here is the summary of Funnel #2:

1. You launch a Giveaway for a print. →
2. To enter, individuals must enter their email address on a page with a sign up form. You are building a list of people interested in your art by collecting their email. →
3. Then you announce the giveaway winner. →
4. Finally, you email all the other people on your list with a discount code to buy something else from you.

That funnel set up a whole marketing process for you that will help you sell original art as well as prints. You will have a mailing list that will grow because on holidays you will announce a new giveaway, and new customers will come on board and new sales will be made as you follow up with these emails. You could do a giveaway four times a year or more.

I have given classes on just this model alone because there are many steps and plenty of ways to get creative with this process, but the outline above should get you moving in the right direction and making sales.

For a website to manage sales that has e-commerce capabilities, I would strongly recommend squarespace.com for its elegance of design, its user ease, and its price. You can also use WordPress with a variety of plug-ins, but that tends to get complicated unless you are great with WordPress, so I would stick to a website that has simple templates, a blog page, and e-commerce that works well, which means they have a checkout cart that is easy to use.

Alternatively, you could use something like Etsy, which will do retargeting for free for you as part of their listing price.

CONFIDENCE AND WHY IT MATTERS

The role of confidence in your art-making is one of the cornerstones of being a professional. If you can't find a way to become confident about what you do, it will translate that way to the buying public.

To take control of your self-confidence and sense of worth as an artist, the following are a few steps to take.

The first step to take, or acknowledge, is that you have something to say, a desire to share your work with the world.

After asking yourself this question, "Do I have something worth sharing?" think carefully about your answer. Perhaps you are not sure, or maybe you do think you might have something worth sharing. Take your time with this question, because if you look over all the reasons you have to be an artist, one of them is surely that you have something to offer the world that is yours alone and worth sharing.

Step two is to get shows, even online ones. Often when I am working with artists directly, this is the biggest issue. Confidence is often something that is built up slowly and deliberately. One woman I worked with didn't show her work in almost ten years, and she was in her sixties, trying to sell work again. To build her confidence, she began applying to juried shows that you will see on lists like artdeadlines.com. They are not too difficult to get into and often cost a little money to enter, and may not be the best shows, but for some artists, they build confidence because you will be accepted into many of them.

Then she went to the local council on the arts and found out about other shows in her area that were juried and began applying to all of them. Soon she got into a local show, not at a commercial gallery, but a nonprofit center for the arts and a library. It may not seem like a big show, but it built her confidence, and she was able to move on.

Step three is to present yourself through FaceTime or Zoom or in person and display the confidence you have. One of the most important issues is how you communicate what it is you do and what kind of work you do. Can you answer that question quickly? It is this that builds confidence, if you can answer that question quickly and with a sense of enthusiasm. It doesn't take much practice to get started.

FAKING IT

Each action you take to get your work out there is another step to build your sense of worth about who you are and what you have to offer.

Another way to look at the issue of confidence is to begin by faking it. We have all been to interviews or situations where we were being evaluated, and rather than have the true sense of self necessary to master the situation, we can get through it by acting as though we are calm and collected, even when we aren't. When you are asked in a job interview if you can handle the job and if you have doubts about your abilities, what are you going to say? It can be the same with your artwork, only the situation is a bit more tricky because you made the work yourself and have a very personal relationship to it. Therefore your approach has to be careful and planned. Say what you want your art to be, even if it is not there yet, you can talk about what your art is reaching for, what it means to you and what its message is.

THE INSIDE SCOOP ON SELLING ART

Sometimes it is nice to see what it feels like on the other side for just a moment, so here is one exercise I like to do. Wherever you are, assuming there is not another pandemic lockdown when you read this, try this outdoor exchange in person to learn about behavior—dress conservatively

and go to a gallery that is the largest you know of and can easily get to and preferably the most intimidating (Many galleries thrived post-pandemic due to online sales of their art).

Once you are at the gallery, look around at the artwork there and ask to speak to someone about it. Either a gallery employee or the owner will come out. They have no idea how much money you have, so with an air of confidence, ask the person approaching you to tell you more about the piece of art you are looking at. What you will hear and see is the selling of an artwork. And since you are perceived as a possible collector, since you are telling them nothing about yourself other than your question about the art, they will do their best to sell you the work. The advantage to this is twofold. On one hand, you get to be the person in power, the collector, and on the other, you can watch as the gallery owner tries to sell you art work.

The insight that you can gain here from listening is in how they describe the art and what they convey to you as they try and sell the work. Pay careful attention to their words because this is how the gallery owner likes to talk about work. Then you will learn how to describe and talk about art in terms of its value to this particular gallery. Be sure to ask questions, such as, "Has the artist sold many of the works in this show?" or, "Why is the work valued at that price?" This can be fun and very educational. It could even start a new career for you as an art buyer for collectors!

However, for the purpose of this chapter, it is about building confidence and getting out into the world of galleries without having to feel as though you are ready for it. You are never obligated to buy something after a conversation, so be brave and try this. I think you will find yourself smiling afterward.

Again, this is just an exercise, to walk into a gallery as a buyer and ask questions to see how an artwork is sold and talked about. You don't even have to give the your name, just say "I prefer not to" if you want to leave your name and details out of the conversation—that will intrigue them more, too.

You will find some people likeable right away and others less so, but it all has to do with how they talk about art. So try to imagine if this is a person you would want to work with by the way they are talking to you.

You can always follow up later, there is no need or pressure to introduce yourself as an artist—you are just researching.

EGO AND GENEROSITY

The artist's ego has a history. In movies and books, we often see the cliché of the artist as self-involved, egotistical, and blind to others' needs. In some forms, this can be charming, but it can also be offensive and self-destructive. Since we have already talked about building confidence and self-worth a bit, it is time to examine where you will go with it, and when to use checks and balances.

When I first owned a gallery, I was visiting an artist's studio which was a total mess of paint cans all over the floor and piles of work on paper. I wasn't sure where to look or what to say about the artist's work. Then she brought me over to a pile of drawings, many of which had newspaper pages sandwiched between them. She began looking through them and then stopped without showing me the drawing and stepped back. The

artist said to me, "Oh, this is a wonderful painting, [and in hushed tones] yes, this is really a great piece." Then she carefully pulled out the drawing on paper with great reverence and turned it over as she herself seemed to be taken back at its beauty. The drawing, which I now own, was a large splotch of brown. It looked like brown paint was poured on the paper and ran off in small rivulets randomly, leaving a large brown spot and small drips running off the edge. I had no idea what to say when I saw the drawing. I didn't think it was extraordinary at all and might have passed it by if I were looking at several works together.

But the way the artist treated this work and the pride she had in showing it to me made me reconsider. After all, if she thinks it is so amazing, I wondered, what is it that she does see in it? I was drawn in and looking for an answer, which I didn't find right away. Her ego and sense of self were charming in this scenario.

EXTERNAL JUDGMENTS

Often, artists want to hear from someone else that they are talented or that their art is of value. This is almost like asking someone, "Am I attractive?" It is awkward and very subjective. If we take the example of wanting to know if you are an attractive person or not, it will help to understand this difficult question. What makes a person attractive? Besides the cultural implications of where you live and what the standards for beauty are in your community, there are several issues that make you pretty, handsome, or attractive. First, there is how you physically look and dress. That is what people first see, and it makes an impression. If you use an online dating service, you can usually see a picture of the person that tells a bit about who they are. However, the description of who they are and what they like is essential, so if we like the image slightly, we read the description of the person we are considering dating. On a dating app like Tinder, we make those decisions rapid-fire in a just a few seconds. The Tinder description is akin to an artist's statement or the artist's story, only much shorter, but we will get to that in a minute.

After looking at a person's picture, we read about their interests, and either we want to know more or we do not. That means how people describe themselves plays an important role in what we think of them. In fact, in the example of online dating, it makes all the difference.

With art, it is not so different. You want to know if your art is good or not, and perhaps beyond that, you wonder if your art has a place in the historical timeline of art. That is, is it great?

To begin with, how you present yourself and your art will make all the difference. If you perceive yourself as a professional and your art as potentially unworthy, and act that way, you will be treated accordingly. Unfortunately, it is not solely based on your art, because everyone needs to know more, just like dating, but the art is what people react to first. This is where an artist's statement comes in, or some kind of text that helps people to understand your work. That means being able to not just describe what it is you are doing, but also to make your text engaging and interesting, maybe even humorous. Again, the dating analogy holds, because you do not want to write a boring description of who you are; you want to say something that will pique the reader's interest right away, literally in the first few seconds.

Consider for the moment the statement of the well-known painter Marlene Dumas, who uses the line "I paint because I am a dirty woman." That is simple yet provocative. If she wrote her statement like many people, it would sound like this excerpt on her from Wikipedia:

> Stressing both the physical reality of the human body and its psychological value, Dumas tends to paint her subjects at the extreme fringes of life's cycle, from birth to death, with a continual emphasis on classical modes of representation in Western art, such as the nude or the funerary portrait. By working within and also transgressing these traditional historical antecedents, Dumas uses the human figure as a means to critique contemporary ideas of racial, sexual, and social identity.

That also sounds interesting, but her shorter version is less stuffy and makes you smile. We will be talking more about putting together your artist's statement in chapter 5, but for now, it is enough to understand that there is no standard for beauty in art. There are many things that affect this situation, including how the work is described and presented.

LEAVING THE QUESTION ASIDE

For the time being, I suggest you leave the question aside as to whether your art is worthy or good or exceptional or if you are talented. There are numerous historical examples of artists whose work was not recognized in their time, and after death, it found its way into museums. Van Gogh is certainly one example, but there are many others, and what about the artists whose work didn't survive after the artist died? Could there have been extraordinary artists that we have never heard of whose works have perished? Absolutely. It is tragic, but it is also all too common. So rather than think about whether or not your work is good enough for a museum, concentrate on how you are presenting your work. The more time you spend in the studio making art, the more time you spend looking at your work, writing about it, and showing it to others, the more you will feel that you are getting better all the time and that your work as well as yourself are valuable and of quality.

ESTABLISHING VALUE
WORKBOOK SECTION 2

In this section, please fill out all the questions, and use extra paper if you need it.

In this first question, write down why you think your work is valuable; that is, what are you offering people, what do you have to say, what do you hope the viewer will receive from your work? In the second question, try to explain why you think it hasn't happened yet.

1. The reason my work has value is because . . .

2. The reason my work is not in more galleries or being sold in other ways is because . . .

3. Now that I understand why my work is valuable, I will pursue selling it. ☐ Yes or ☐ No

4. After reading about how other artists have sold their work, my favorite way was (circle one):

A. I prefer the traditional gallery method, supplemented by a side job.
B. I will use the marketing of my art as part of the art itself (like Damien Hirst).
C. My work is noncommercial like Banksy, and I will utilize a system like his.
D. Like Mr. Brainwash, I will start a factory and employ people.

E. I will sell art on the street and hire vendors to do it for me.

F. I will do something else, which is:

Getting into the Whitney Biennial

When my wife and I got into the Whitney Biennial, it was a turning point in my career. The Whitney Biennial is a show of mythic proportions. Besides the Venice Biennial, it is one of the most coveted shows for artists for several reasons. Besides its fame and notoriety and the overwhelming amount of press it usually gets, the Whitney Biennial is a show that attempts to bring together the best or most interesting works by American artists (and often international as well) that are living today.

This means that if you are a young artist in the Biennial, you will see your work hung next to others who are already major figures in the art world. Also, there is always an element of surprise about who gets in, and it is almost always controversial, which is always a big help when it comes to press! The curator that invited me and my wife to be in the Biennial once said, "This is the story every artist wants to hear." She was talking about the story of how I got invited to that show. So I am telling you this story because it tells the tale of how a relatively unknown artist who had no gallery representation or major shows got into the Whitney Biennial by asking.

MY STORY

On a cold January 1st, my son was born in a birthing center on Fourteenth Street in New York City. I was very happy about this, but also my perspective on the future changed instantly. Now instead of just paying the bills and wanting to get by, I had to think about the future, a savings account,

my son's education, and more. I had one great fear at the time. I was afraid that I was going to have to get a regular job, like teaching full-time, or carpentry, and that I would never make art again. The idea of spending most of my life doing something I hated was an awful thought. And for me, what added to this looming dark future was that I would be a model of compromise for my child. I would be showing him that you have to do something you do not like in order to pay the bills, and more directly, to pay for him! The thought of communicating that to a child, the idea that his parents are compromised because of him, was dreadful. What would that teach him in the end? Certainly not to follow his desires, but to pay his bills by taking a job that he does not like because his real passion is not financially feasible.

Within that first month of his birth, I made no art, which only increased my anxiety. I knew I had to do something, and what I wanted was to be in the Whitney Biennial. But before I explain what I did, let me explain briefly what I did to arrive in this position.

THE BACKGROUND

I attended undergraduate school at SUNY–Purchase in New York, and I used to spend summers on Block Island, working in restaurants. After I graduated, I went to Block Island for the summer and decided to stay for the winter and open a gallery the next summer. My girlfriend and I did it together. The first step I took was to find a retail space and determine the costs of running a gallery. I didn't have the money, so I went to the bank for a loan. Then I sent out a letter to a mailing list I got from the local newspaper. In the letter, I told everyone what I wanted to do: open a gallery and show contemporary art in the summer and have openings every two weeks. I asked for donations in different categories from $10 to $100. I spent almost ten years running that gallery and also started a small magazine that was funded by local ads, which I secured myself.

Neither of those businesses made a lot of money, but it was enough to survive on and travel a bit, and I learned a lot about what it looks like from the gallery end. I saw many artists submitting their work along with

their art statement. What I found was that I tended to only show people I knew and rarely anything from images I was receiving from artists. It was not that I didn't want to show the work of artists I didn't know, but it was easier to work with people I knew. That taught me a lot.

The images I was getting from artists looked very good at times, but usually the artist's statement that came with it was awful. I would look at work I liked and when I read the artist statement, often felt the opposite. The artist statement had a way of undermining some of the best work I saw. However, with friends and people that came by, it became personal right away. They would tell me about who they were and showed me their work, and if I liked them and their work, I would give them a show! What that experience taught me was that it is all very personal. As people, we respond to others who make us feel comfortable or happy or angry and uncomfortable. If I want to work with someone, it is not only because I think their work is good, it is because I like the person and feel that I can trust them and work with them easily. That was the part I didn't under-stand initially. It wasn't about the art entirely, it was about a good working relationship.

Eventually, I left Block Island and closed the businesses, not because I didn't enjoy it there, but because I wanted to go to New York and pursue the art world. You see, on a small island or probably any small community, there is a wonderful feeling that you know everyone in the town. However, I found that it was creatively constricting and claustrophobic as well. I was making art all the time and having a show a year in my own gallery once a year, and I felt I wanted much more.

NEW YORK CITY

When I arrived in New York City, it was the opposite feeling. Since I didn't know anyone there and the city was so vast, I felt as though I could do anything. The sense of no one knowing who I was, or even caring to some degree, gave me a sense of creative freedom. So I pursued the dream I always had for the city, which was to open my own storefront in the East Village and make my art there. Surprisingly, storefronts were cheaper

than apartments in the right neighborhood (and still are in many areas of the city.) It was a commercial storefront of about 250 square feet on East Tenth Street. It was not built for living, but I made a loft bed and lived there anyway, and kept a clean clear space in the front to work. I began working on books and other work on paper. I had very little money, so I got a job as an assistant to an artist, and that kept the bills paid. Then I met the love of my life, and we began spending all our time together. In that state of abandonment that love often brings, new ideas came to mind of what she and I could do together out of our storefront. The idea we had was to wash people's feet, give out hugs, and apply Band-Aids with a kiss on the bandage the way a mother would do.

I wrote up a small press release about what we were doing and said the store was opened on certain days. Then I printed out this piece of paper and actually walked around to all the newspapers and hand-delivered it to the writer I was after. I will never forget the feeling of walking into a news office and asking to be directed to the arts writer. I was pointed in a direction, and all of a sudden, I was at his cubicle, interrupting his writing to say I am an artist and I have a press release for him. Though he was shocked, he was also very kind and thanked me for coming by.

I did get some press and a small show in a nonprofit gallery in Brooklyn, and then within a year, my son was born!

MY SON IS BORN

Now we move forward to January, and I am frantic and stressed out about how I am going to make a living with my art. So I made a video about giving out foot washings and hugs and decided I would send out a physical package to people and ask for donations to support this. A DVD is really inexpensive to make, so the package was cheap to mail. I sent it to well-known artists at first. The first letter went to the artist Jenny Holzer. Now remember, I have had no major shows, and I am an unknown artist in New York. In the letter, I told Ms. Holzer that my wife and I were artists and this is what we have been doing. I asked her if she would consider donating a small amount to help us. She sent a check for $200!

Then I began to search for other artists that I liked, like the late Christo and Jeanne-Claude. I wrote them a letter, and they sent me $400!

The letters were not only inspiring to me, but they showed me that I could be a fundraiser for my own cause! That was a big thrill and I have raised money this way ever since.

I was getting the *New York Times* delivered daily, and I would always read the section on the arts. And it was in February, a month after my son was born, that I noticed a news item that said the Whitney Biennial curators had been chosen. That was one of the things I was after! I put together a packet right away and sent it to the museum. I put the curator's name on the envelope. I also made an unusual decision. I decided not to put in a résumé, and I said that the work was a collaboration between two people. The reason I did not want to put in a résumé or biography was because I didn't feel like I had a very glorious past. What would I say, "I lived on a small island for almost ten years and had a show every year in my own gallery"? I felt that my past was also irrelevant to understanding my present work collaborating with my wife.

This again brings up the example of dating techniques. When you want someone's attention and you want them to like you, it is usually

best not to tell them everything about your past, right? The reason for that is obvious, I think. Too much information! In this instance, it worked for me. I sent in a package with a short letter describing the work I was doing, and I signed it, "With love, Delia and Brainard." It was an unorthodox package, that is for sure, but it was also a complete one. The museum had my name, number, and email address (I had no website), and a short letter and video describing the work. I waited and waited. Nothing came.

THE WHITNEY MUSEUM CALLS

In April I noticed another news item that said people can send in their art to a particular person at the Biennial, the "biennial coordinator." I sent in a copy of the first package and also sent another package to two other curators at the Biennial. So that was a total of four identical packages with a letter and DVD to the Whitney Museum! I could have just emailed repeatedly, but I assumed that a physical object had less chance of getting lost.

I waited and heard nothing, and it was the summer. I knew the names of the artists who got into the Biennial would be made public in November, so I was getting antsy. My wife suggested that we use meditation or "mind control" to help us. That meant that we picked a quiet time each day (when the baby was sleeping) and did a specific meditation together. It was a version of the old Silva Mind Control method. Here is how it worked. We would use a visualization of getting into an elevator and going down many floors. With each floor, we became more and more relaxed, and finally when the elevator reached the bottom floor, we got out in a deeply relaxed state and began visualizing what we wanted to happen. I pictured myself in an office at the Whitney Biennial being greeted by the curator. I imagined that my wife and I were talking to her, and very enthusiastically she said, "I would love you to be in the Biennial!" We did that every day. If nothing else, it made us relaxed and focused on what we wanted. Then in August, we got a call from the museum saying that they wanted to interview us.

Of course we were thrilled. We set a date to come in, and I began asking everyone what I should say at the interview. I got all kinds of advice from "Say something that sounds very important and interesting" to "Just be yourself, don't talk about philosophy or history, just relax."

Many artists assured me that it was routine, and I probably wouldn't get in anyway! That was my first taste of professional jealousy, and it made me feel awkward to think that some of my friends thought the interview was inconsequential and didn't mean much. In fact, I learned that the interview meant a lot. It meant you were being considered, and now they want to put a face on it, to see what you are like, to make the final decision.

THE INTERVIEW AT THE WHITNEY MUSEUM

My wife and I went to the museum for our interview and made a decision not to bring anything with us, like a résumé, which they asked us to bring. In the office, we were asked many questions, none of which were difficult to answer. At the end of the interview, with slight frustration, she asked if we could send her something about our past. We explained that we did not believe in the past! And with exasperation, she said, "Well, I don't know if you went to art school, or any school at all, can you send me something?" Of course we said yes, we would. Then she handed us her card and said, "Please keep in touch about new projects you are doing." We were thrilled but had no idea what had happened. At home, we decided that instead of sending a résumé, we would send her detailed biographies of both of us. That meant a long prose piece about where we were born and lots of excessive detail about our childhood, including things we made up. It was our answer to writing about the past. We wrote so much, which was probably useless to them, but they had also most likely made a decision by then.

The curators never came to our studio or asked to come. However, late in the month of August, we received a call from the curator at the Whitney Museum saying we were invited to be in the Biennial! She also said that we could not tell anyone, even our parents, because they didn't want the press to know before it was officially released.

THE STORY EVERY ARTIST WANTS TO HEAR

Why is this "the story every artist wants to hear," as the curator said to us? Because we were not chosen or sought after. We were not "solicited" by the museum. We had no gallery representation. We simply sent them our materials and a letter and got into the show. It is like winning the lottery, and as the saying goes, you have to play to win. We played, we wrote, we reached out, and of course you could, too. Let's analyze the approach for a minute so it can be adapted to you and your medium. To begin with, it is important to keep up on who the latest curators are for the Whitney Museum or any other museum or gallery.

I read the *New York Times* for some of that news and also the *Art Newspaper*, which you can get online. That is essential to read and keep up on what is happening in the art world. Then once you have decided you know who you want to reach with your work, usually a curator, send them a letter. The letter is the tricky part. What will you say, and will you include a statement and a biography? Of course it is up to you; sometimes a résumé is asked for or required, other times not. But remember you are writing a letter to a person, and that person has to read something that they think is interesting. Remember the dating analogy? You must decide what to say in the letter that will generate enough interest to have them look at your work. You can be as creative as you want. Send a poem, send a diatribe, a manifesto, a joke, or a very straight letter, it is up to you; just remember the goal—to get the reader's attention and to have them open your images and look at them and think you are an interesting person.

THE WAY TO WRITE A LETTER THAT GETS A RESPONSE

The format I use now, whenever writing a letter to a curator or someone that I want something from, is this;

1. The beginning of the letter should be a compliment (such as why a specific show they curated was truly good—be sincere and thoughtful here in at least two or three sentences).

2. The second part of the letter should say why your work has a connection to the shows they are mounting.
3. The third part of the letter should ask for what you want, like a virtual studio visit, or ask if you can send them your website.

My meditations on seeing it all happen at the Whitney Museum may or may not have had some effect. I feel that when you are focused on something, it brings in other elements that can help. So perhaps the meditation didn't make it happen, but it did prepare me for the meeting. I saw myself relaxed as well as enthused in the office of the curator. I had no special philosophy or statement behind the work. I was able to be myself, more or less. If you are a painter, sculptor, video artist, or conceptual artist, you have as good a chance as anyone, but you must present yourself in a way that makes sense and is attractive. The moral of this story is, "If you do not ask, you will probably not be invited."

In chapter 8, I describe the details of getting a solo show at the Whitney Museum and how, even though I proposed it, the museum's promotional materials called it "a commission."

WRITE A SAMPLE LETTER NOW
WORKBOOK SECTION 3

Now you know how I got into the Whitney Biennial, which is the way you could get into almost any museum in the world. Of course, your work has to be interesting, and a little luck helps, but if you don't do something to share your work, you will never have a chance.

1. Write a letter to a museum. This is an exercise, so you can't blow it. But take your time and put together a package that you think will interest a museum. Try to do something different. Don't simply send images, résumé, and a statement; send a letter that is polite and nice but that also reflects who you are and start off with a specific compliment. It is OK to be quirky and funny, or whoever it is you are.

2. When you write the letter and assemble the package, imagine you are the curator getting this package. Would it make you smile or frown? You can be as wacky or as straightforward as you want, but it must communicate clearly and efficiently. Don't be afraid to make a mistake, just do it!

3. Research some curators in your area (do this no matter where you live or how old you are).

4. In your letter, write directly to the curator and tell them you would like to have a Zoom meeting with them for ten minutes to talk about an idea that you have. Propose a time. This is a draft letter, so it doesn't have to be perfect. However, you must ask for a meeting so that you have a question which requires a definite yes or no answer.

5. Put the package all together and then put it aside; we will refer back to it soon. Take your time, this is important, but we are not mailing it yet, and it can be easily changed.

Presentation Tools and Techniques for Artists

As phone apps and the latest social network formats are changing the way we share images all the time, the way in which you present yourself and your artwork continues to change as well. To begin with, I will caution against a common practice of artists that usually gets them nothing but frustration, which is to send out a lot of cold letters (email or regular mail). If you want to present yourself to a gallery, do not buy a list of gallery addresses and send them all a generic package with a website link, images, and a résumé. It is remotely possible you could get a reaction from this, but the best tactic is to be targeted in your approach.

First, choose the nonprofit centers within your reach and choose the galleries that you like. Not the galleries that you think would be appropriate for your work, but the ones you admire for good shows.

To do this is fairly simple. First, look at a map or just write down the name of your city. You are about to make a list and a plan. If you wrote down the name of your city, begin searching on Google for the words "art gallery" and your city. Look for your state council on the arts and write down their number as well. I think it usually pays to take a trip to your local council on the arts.

EUROPE AND THE GLOBAL ART COMMUNITY

If you are living in another country, in Europe or somewhere else, there is usually something like an "office of contemporary arts," which is funded by your ministry of culture or similar. Wherever you are, you

are putting together a list of everything in your area that is art-related, meaning galleries, museums, and nonprofit centers. The nonprofit centers are places of education, usually. That means they are supported by your government because their goal is not for profit; it is to help artists in some way. Nonprofits, or in Europe, NGOs, are everything from community centers to granting agencies to foundations that have been set up to give money to artists, and also museums and universities could be part of it.

After you have made the list of art-related institutions and galleries within your area, begin to sort them by which ones are closest. So pick all the places that are near to you and refine your list. Separate the types of organizations you are listing in different categories, such as galleries, universities, museums, nonprofits, art-related NGOs, and foundations for grants. Now you have a list of places and people to meet.

Take it one step at a time and begin by deciding how many you are going to call and visit in a week. I would pick a low number, like two or three in a week to start. Pick a time of day that you can spend thirty minutes on this task.

The next step is to look at your three contacts for the week and do a little research on each on the web so you can understand more about what they can do for you. Ideally, you have done enough research on each that you know who the staff is at the places you are calling. Then give them a call or write them a letter. You are not sending them links or images of your work; you are writing them a letter to ask about their services. If they provide grants, you want to be on their mailing list and know when the next application is due. If you are writing to a university gallery, you want to know who curates their gallery and who you can send a proposal to for having a show there. If you are writing to an organization that supports the arts in some way, like an arts council or NGO, then you want to be on their mailing list, and you want to know if there are any opportunities you should be aware of, like competitions or grants or juried shows. If you are writing to a museum, then you want to be on their mailing list as well, and you want to know if they look at the work of new artists. Let's look at each case and exactly how to proceed.

PRESENTING TO MUSEUMS

For museums, which are usually not for profit, what you are looking for is two things. One, you want to know who the curators are there. You want to know their names and what they have done in the past. It should be easy enough to find their names by looking at the museum's website. If that is difficult, call the museum and ask who the curators are for contemporary work. The other thing you would like to know from a museum is if they have a policy for looking at the work of new artists. You can write them a letter and simply ask that. Now let's go to the next step of this situation. You have a list of the museum's curators, and you have a sense of the shows they have, and perhaps they do look at the work of new artists. If they have a policy of looking at work, simply follow their rules. Usually they ask for a letter, images, and a biography of yourself. Keep in mind that most museums that have policies of looking at artists' work are usually not exhibiting those artists right away, then plan one to three years in advance.

What museum curators often do is look at your work so that they can understand more about what is going on in contemporary art. Also, even if they like your work very much, they will want to see more before committing themselves, in most instances. Normally you will get a letter back from the museum curator stating something like, "Thank you, please send us an update in six months." The reason they are saying that is so they can see how your work evolves, and also to see if you are professional enough to keep sending them work on a regular basis. The next step with museums, which you can do at any time in your career, is to target a specific curator. In my experience, it is easiest and best not to target the top curator.

Look for a new curator at a museum, someone who is probably young and handles something that might not even apply to you, like booking performances or music. Write to that curator directly and ask him or her if you could meet with them to talk about a project that you would like their feedback on. I always ask if I can meet the curator for a ten-minute Zoom meeting. Usually that is hard to say no to. It is also helpful if you Google the curator and find out something about their past so you can make a reference to it in a letter, showing that you know who they are! The letter might look something like this:

Dear [Curator's name here],
(Begin with a compliment.) I just read your text on the paintings of [artist's name here; find this by researching on the web], and I thought you did a great job at articulating the importance and subtlety of her work. (Say why in the next sentence and make this section at least two paragraphs long.)

(This is the ask section.) I am writing to you because I would like to have a brief meeting with you (ten minutes) by Zoom (or FaceTime) to tell you about a project I am involved with that has similar tendencies to the work you just wrote about. It would take ten minutes or less and will be easy. I value your words and the way you approach your writing and hope you can have this brief meeting with me to hear about an idea concerning my art that I would like to share with you.

Is it possible to meet on [date] at [time] by Zoom or FaceTime for 10 minutes?

Sincerely,
[YOU!]

PREPARING FOR A MEETING WITH A CURATOR

The idea is to get a meeting with a curator, any curator at the museum, and this is what you will do once you get the meeting.

You will prepare yourself for the virtual or in-person meeting in the following ways:

1. If in person, bring printed images, not a laptop with pictures on it, but printed images, preferably fewer than ten, on eight-by-ten sheets of glossy paper (or a similar size). They can be printouts from your computer, but keep everything very neat and organized. Do not bring original work or anything that is awkward. The idea of this meeting isn't to evaluate you or your art, but to make a proposal.

If you are doing it through Zoom or FaceTime, make a PowerPoint presentation of your art that is no more than 5 minutes long (so you can discuss it) or you could use your phone to show them your actual studio.

2. Decide what you are going to ask the curator. Yes, you are going to ask them a question, because if you don't ask them something, you will have a pleasant meeting that will end with the curator saying, "Thank you and let's keep in touch," and you do not want that! You want something more valuable from the curator, which is a reference. But what will you ask? What will you propose?

3. This is the fun and creative part. It depends on your medium, of course, but think about how you would like a show of your work to look. How many pieces would you put in that show? Will the show have a message? Is that message political, personal, spiritual, or something else? When talking to a curator, it is easiest to discuss ideas, because quite honestly, talking about art is difficult. It is usually

difficult for the artist as well as for the person viewing the art, so talk about ideas, or things you are interested in, from books to movies or philosophy.

IT'S ABOUT IDEAS

Make your idea succinct and understandable. Perhaps you are telling them you want to have a show of paintings or sculpture or something else. Say exactly how the show would be put together and why it will be exciting. Tell them why you think the show is important. You should be able to say all that in less than one minute. Then wait for the curator to respond with something like, "Oh, that is interesting." Then tell them that you want to present this show, do they know of any venues that might be appropriate for it?

Wait for an answer; do not jump in with nervous talking. This method gets the curator off the hook from having to talk about their museum, and most likely there is little they can do for you there. However, they know other people that may be able to help you, and they might say something like, "Oh, you should talk to X, that gallery might like it, and also Y, because that is a space that encourages dialogue," or they might even say, "So-and-so at this museum might be interested." Whatever their answer is, explore it a little, ask more questions if you don't understand something they say, and take notes with a pencil and paper! Then thank them and leave.

When you get home, or end the virtual call, write them a brief thank-you note. That is the way I got a solo show at the Whitney Museum, which I will go into detail on in chapter 8. I made an appointment with a curator I did not know. I described three ideas to the curator, and she told me two places for the first two, and for the third, she suggested another curator at the museum! It is really that simple if you just make the meeting and think of something to say. We are all interested in ideas, and especially when the person talking about the idea is enthusiastic and positive. When I talk about ideas to a curator, I am very excited about it, like I was as a child when I expressed my enthusiasm easier. People are very attracted to

others who are sincerely excited and happy about a creative project; it is the life force we all desire and live for.

We have covered how to present your work to a museum, either for review (if they have a policy for that), or by talking to a curator about your ideas. Presenting your work in these cases is fairly straightforward, with the exception of talking to a curator, which is more creative and personal. Your ideas for the work you have could be a small show of four paintings, or videos, or photos, then a larger show of perhaps two mediums (paintings and video or music and drawings, etc.), and then the third option, a large solo show of something more comprehensive that has a particular message.

GALLERY PRESENTATIONS

Galleries are very different from museums in two ways.

One, their motive is profit. If they don't sell, they are out of business. Also, like museums, they are surviving in post-pandemic culture by giving virtual tours to collectors.

Two, they are privately owned, so there are no strict rules or standards at all. You are approaching a business owner who has certain goals. One may be to show great art, but the most important thing to them is making money.

For a short time, I helped a friend who was a musician get booked at clubs in New York city. This is what I learned; if you have a band and want to be booked at a club or bar or venue of some kind, you have to convince the owners of the venue that you can bring in a crowd; that is all, and you are booked. Sounds simple, doesn't it? It is all about the money. When people come to see bands, they drink at the bar, and that is how money is made there. So if I can just guarantee one hundred people will come, I can have almost any night at any club. Amazing, isn't it? It is all about the money and not necessarily the music at all! If you have a band, the key is obviously how to bring a crowd in. That comes from great self-promotion with stickers, Facebook, YouTube, giving away and selling CDs or merch on the street and online, free downloads and more. I know one band that

packed the house by telling every one of their friends they would supply free beer to everyone after the show!

I mention this because it is not dissimilar in the gallery world. You have gallery owners who want to turn a profit and are not afraid to talk about money. You may wonder, "Is the quality of your work important to them?" Yes and no. Like the story I told about booking bands, if they feel you can bring in a buying crowd, they are interested. A friend of mine, who is a private banker and works with some of the wealthiest individuals in the world, told me, "You have to think, 'what does the person want' that you are trying to reach." So in the case of a gallery owner, what they want is to make a profit and bring in more collectors. They have a list of the collectors who have bought from them in the past, and they are always trying to increase that list. If they do not increase that list, they are asking the same people over and over again to buy art, and that is a limited situation financially.

So in your approach, which I will outline here, it is much more than just sending or showing them images; you can do this even if they are a largely private gallery that sells work remotely. You can certainly send in images, but you must understand how the mind and the eyes of the gallery director work. He or she is not only trying to decide if they like your work, but more important to them, they are deciding if they can easily sell this work and bring in more collectors. Of course, if you are well known and trying to switch galleries, they are interested because you have made money for gallerists in the past. If you are not well known, then you are like hundreds of others who write to them, and if you try to look at it from their perspective, why should they show your work?

AN OFFER THEY CAN'T REFUSE

This leads us to the current trend in artist-driven marketing, which is making the dealer an offer they cannot refuse. That means making a proposal to a dealer that makes financial and aesthetic sense. This approach was created as much by the rising costs of running a gallery as the competition among artists to get into a gallery. This means that the traditional

approach of sending them your images online is not the best way to make a deal with a gallerist. To begin with, go back to your list of galleries in your area, research them online, and visit them in person when possible. Try to attend at least one opening, go to the all the Zoom tours they have from each of the galleries you wrote down. Take a look around at the opening or Zoom tour; do you like what you see? Ask questions about the work at the opening or in the Zoom tour, and someone from the gallery will tell you more about it. Do you like the way they talk about art and sell it? If so, this is a reason to want to work with this gallery. If not, then move on or try another opening there to give the gallery another chance.

In the smallest galleries, your approach could be simple. Walk into the gallery and ask the person behind the desk if they look at the work of new artists. They will give you their answer, which, if yes, usually means either sending them images by email or a studio visit from the gallerist. If the gallery is more established, then the example of making a deal they can't refuse will have a chance of working. But how do you make such a deal? In this area, you can be as creative as you like, but it is a business proposal. Some form of "I have a great opportunity for you that could be a win-win situation for both of us," and then of course explain your idea, which involves sales, the press, and new collectors.

Here is an unusual example that worked well. An artist named Andrea Fraser does what she calls "institutional critique," which means that much of her artwork, which is sculpture, prints, and performances, are critiquing the institutions of the art world, such as galleries and museums. Her proposal to a major gallery went something like this: She proposed a show in the summer (typically a downtime for galleries) for a month. The show was simple to put up; it was just a monitor in one corner, playing a video over and over. The video was of the artist having sex with a collector. It was shot from a security-type camera attached to the ceiling of a hotel bedroom. It took place in real time without any close-ups. The video will be in an edition of ten. However, the first collector who bought the video also acts in it. Thus, she is having sex with a collector. So for the show to work, one video has to be sold at $10,000 before the show opens. For the gallery, they have already broken even before the show opens! From the

artist's point of view, she is creating a situation that, to her, exposes elements of the art world, that is, artist as prostitute, gallerist as pimp, and collector as john. But for the rest of the world, the public gallery audience, and the press, it had a different effect. They were shocked, aghast, and fascinated. That is one model of making the dealer an offer he can't refuse. That particular show did very well and got her tons of local, national, and international press.

Now you might be thinking you do not want to do that! However, your approach can be more subtle. Imagine telling a dealer you will have a show of your paintings, and there will be a band there, a comedian, and a magician. The performances will be on one night, and there will be different parties on other nights for select groups of people from museums, such as the young collectors' club or other associations that are interested in the arts. That is just a sketch of an idea, but you get the basic concept. Come up with a deal that is exciting and impossible to refuse and generates a new audience. Even if your idea doesn't work the first time, you will get a gallery owner's attention with this kind of approach and they may negotiate and brainstorm with you.

Many more approaches for a virtual opening on Zoom, for example, could be having a panel of speakers that collectors want to hear from, like art historians or other collectors. Now museums in post-pandemic culture are saying they have a greater attendance to their public lectures then before the pandemic because it is so much easier to go to an artist talk or a panel discussion. So consider putting something like that together, a Zoom talk or panel discussion or studio tour.

SOCIAL NETWORKING

A website is not the only way to show your work online, of course; we have Facebook, Instagram, Twitter, and other sites, which are free and make it easy to put up images. And with Facebook, Instagram, and Twitter, you can put up images as they are made and get comments right away. I think that a website, a fairly simple one, is necessary, but social networking will help drive traffic to your website. There is much more to Facebook in that

you can actually meet people who can help you and who are real! The same goes with Instagram, the dominant platform now for artists. For example, most of the people I "friend" on Facebook are involved in the arts. I look at other pages, in particular art critics' Facebook pages, and comb through people who are interested in the arts: collectors, museum directors, artists, and more.

It is amazing how you can connect directly with people. If you search on Facebook for "art collectors," you will see amazing resources for meeting collectors. There are groups of collectors and all kinds of pages for them. This is a valuable resource. I have written directly to collectors introducing myself and asking them to lunch or a Zoom meeting. I have met with museum directors this way as well, and I think it is one of the best networking tools for artists out there. Instagram and Facebook are great ways to not just exchange messages and become friends, but to actually meet people in the real world at an exhibition or your studio or even in a Zoom meeting, which is more personal than just writing.

MAKING FRIENDS ON FACEBOOK

There are many ways to promote and share your work on Facebook, but I will go over a few basic steps.

1. Begin adding about five to ten friends a day at the most (or Facebook will stop you). Make these friends art-related, such as collectors, curators, gallery, and museum staff. When you add someone as a friend, send a personal note, even if it is the same one to everyone. Something simple like, "I would like to be your friend because I like the work you are doing with [the name of a museum or something related to them], and I would like to keep in touch. Sincerely, [you]."

2. As you build up friends, start commenting on their posts as much as possible (a few times a week would work). Spend part of each day, maybe thirty minutes or so, sending notes

or making comments on other people's postings. Write thoughtful comments on images that people who you want to be friends with are posting. If you have a Facebook page already, you know the value of this. If someone comments on a photo or comment of yours, you take an interest and often write back. The more sincere and interesting the comment is, the more response you will get.

3. In your status updates, post images of new work you are doing. Try to avoid talking about your pets, children, domestic minutiae, and other nonessentials. You want this to be productive time, so use it that way.

4. Warning! Do not use the same password on your Facebook account as other accounts, like Gmail, because that makes you an easy target for hacking. That means someone breaks into your Facebook account and sends commercial messages to all your friends. Beware. I know that is basic, but a hacked site can ruin your day!

5. The last Facebook tip that I would suggest is to limit your time on it, for while it may be a helpful tool, in excess, it is a major time waster. As of this writing, in 2021, Facebook is the biggest platform with Instagram, but there are many, many others, some of which are yet to emerge. I personally try to keep it to a minimum, so I don't spend too much time in front of the computer, but keep your eye out for new forms of social networking that are sure to arise!

PRESENTATION AND LECTURE TOOLS (NOT POWERPOINT!)

When you begin to present yourself and your work for different audiences, you need a basic plan to begin with. Traditionally, PowerPoint has been the digital tool of choice for presentations.

But first let's talk about the audience. Are you presenting your work for a grant or fellowship? Or presenting your work for a university audience?

You might want to present your work and yourself to a potential funder. All of the above require a similar approach with slight differences in tone or delivery, but how do you create a basic presentation? At this point in time, I would suggest Prezi, which is a very sophisticated update of PowerPoint presentation.

You can still deliver a certain amount of information in a narrative order if you like, but there is something more interesting and dynamic about Prezi. To begin with, you first assemble in a folder on your computer some things related to your presentation. Then, instead of the typical slide show of PowerPoint, you are using a nonlinear approach. Prezi has a way of letting you put all your information down on a desktop, your pictures and blocks of text, and then you simply draw lines between them in the order you want it to be presented. It is very visual and easy to use, so I suggest going to their website to see it for yourself. The advantage to this is that you can present it directly from your computer, or it can remain on the Prezi website so you can present with any computer that is online. If you feel uncomfortable with it, PowerPoint is the next best option, but I strongly urge you to explore Prezi, as it is much more exciting to look at.

THIS IS YOU, ON ART
WORKBOOK SECTION 4

This is the part where you get to present yourself.

Look at workbook section 2 for your preferred method. Did you pick A, B, C, D, E, or F?

Write down which one you picked, and put the letter or words here:

Spell out the choice, for example, "My work is noncommercial like Banksy's, and I will utilize a system like his."

Write your choice here:

Take your time with this exercise, but complete it.

On a separate sheet of paper, do one of the following:

If your choice was A, get *Art in America*'s annual guide to museums and galleries (or an online guide that is similar). It comes out in August, and you can order it as a back issue. Also, make a list of galleries near you. Once you have done that, you will have all the sources for income in your hands.

If your choice was B, reread the section on Damien Hirst and write down what you will do next. A DIY show? Or perhaps something in the street or something totally new? Be creative here. This is the DIY movement; you can create a show anywhere and make it interesting.

If your choice was C, then think about how you will show your work and describe yourself. Will you create a new identity for yourself? Will you put art in public places without permission? Stage a warehouse show? Sell on eBay? Make a plan, invent yourself, use a pseudonym if you like.

If your choice was D, put your business cap on and decide how you are going to stage an extravaganza of a first show. How will you raise the funds to do this? Who will you hire to help you run the show? How much money do you imagine making? Also watch the movie *Exit Through the Gift Shop* by Banksy; it's on Netflix.

If your choice was E, then call your local town hall or government office and ask what the rules are for selling your own art on the street. Write down that information, and if you need a license, get it. Write down when you plan to sell on the street and how often. If you are traveling, call ahead and ask about street vendor licenses for that town.

If your choice was F (something of your own creation) that is new or a mash-up of the above, write down the next steps to move toward that goal.

Relationships in the Art World and How to Maintain Them

As we leave the realm of formal education at the level of high school or any level of college, the choices the world presents in terms of living are quite stark. Money is king. That is it, really. It does not mean that you cannot chase your dream and have it, but you have to find a way to fund it. You must build the friendships that it takes to get there in a sincere way as well.

WEALTHY FRIENDS

Once I was in a local restaurant with my wife talking to a young, charismatic waiter who had just gained admission to an elite high school that he described as looking like Hogwarts of Harry Potter. We asked him what he wanted to do, and he said, "I want to be a governor of the state or something like that, in politics."

As he told us more, he also described his main hurdle. All his new friends at this school, he said, come from extremely rich families, and he lives with his single mother, who doesn't have much money. The key, he said, is to figure out how to get all that money to run for office. He hoped his friends would help him, but he made clear that without a lot of money, he could not even come close to his ideas. It was exciting to hear his enthusiasm and see his bright teenage eyes. It seemed like he was making a bold move that had a good chance of working. When we came back to the restaurant a year later, we asked him how school was going. With a smile, he said he had changed his plans. He told us that the students he was working with were all very rich, and they had their own set of rules for

how life works out. He said he found that their outlook was mean-spirited and he wasn't interested. He dropped out. Now he wants to make videos or open a coffee shop, but is not sure, and for the time being, he continues to work in the restaurant.

SMALL DONATIONS ADD UP

Winning friends is certainly a social grace, but for the moment, consider the historic 2008 presidential election. Obama began running for the Democratic nomination for president against Hillary Clinton, who already had all the big Democratic donors in her pocket. Like the waiter in the previous example, he needed to raise a lot of money, ideally even more than Hillary Clinton! We know now that he did just that, and it was largely because he used the Internet extremely well as a networking tool. He went beyond traditional friends and supporters to generate new revenue and used all the social platforms to make bridges. Instead of getting the large donors, Obama raised enough money to outspend Hillary Clinton by seeking the small donors. And, as we now know, he was successful. Everyone wants a friend that will give them a break, but it isn't always about an introduction or who you know; in fact, it is as simple or as complex as making a friend. How does one go about making friends? Well, in the online community, there is a strategy that, again, is very similar to dating. In the business world, when you want to get someone's attention, you think to yourself, "What do they want?" So if you are in the business of selling golf balls and want to reach the organizer of the U.S. Open, you have to figure out what they want. Perhaps in this case, the organizer of the U.S. Open would like more sponsors, or maybe you have researched this person well and notice on their Facebook page or in the news that they have an interest in watching birds or some other hobby. One of the ways to get to this person is to ask him or her a question about birding or tell them a bird story. Does that sound strange? It is human nature; we are interested in our own ideas, hobbies, and dreams, and if someone else asks us about them or helps us, we become very interested in that person.

MAKING REAL FRIENDS

The steps to begin building relationships are not that hard to follow, but first you have to decide what kind of friends you really want. If you are trying to build your career, to become a professional artist by doing your best to exhibit and earn a living from your work, then you need people who will support that effort. You want to meet collectors, gallery owners, curators, directors of nonprofits, and many more. In the workbook for this section, we will write down some names and groups to contact. The next step is to get out of the studio and do what is perhaps the most difficult part: begin talking! To begin with, as I have said, you should start by finding out what museums and galleries are in your area and the dates of openings of art or even poetry readings or other events at the museum that are virtual (Zoom) or not.

Zoom and FaceTime are now replacements for in-person meetings. You can do it all, or most of it, from the comfort of your home or studio.

This is the way you will meet interesting people and have friends who can help you. The reason you are going to the museum events, virtual or not, besides it being fun, is that there are often collectors and the supporters of the museum at the openings. There are others who are simply interested in art. It will pay to do a little research before you go to the museum. It will help if you go to the museum's website and find the list of museum supporters and board members. If they have pictures, look at them and read the little bios about each one. Consider printing out the pages of brief descriptions of some of the people you may meet at the museum opening or even virtual Zoom event. Have fun with this; it's like being a detective. Yes, it is calculated, and so will be the expressions of your desires if you take things step by step in this fashion.

OPENINGS AND PARTIES (VIRTUAL AND IN PERSON)

There are now virtual openings and parties as well as physical ones.

So the next step is, of course, to actually go to the openings or events one or two nights a week and do very little at first, just look around. (Or drop into Zoom virtual events and listen and watch.) Enjoy the art, the

atmosphere, have a few nibbles, but not any wine, yet. (If you are doing it virtually, it's the same, refrain from drinking as it often inhibits bravery.) And if you have been researching some of the people from the museum, see if you spot anyone in the crowd or in the Zoom talk. If you are there for the first time, don't push yourself, just watch. See how people are talking to each other, watch hand gestures, and listen in on the topics of conversation. It will give you a feel of what people are talking about and how they present themselves. Take a look at what everyone is wearing. Can you tell anything about the people you are looking at? Try to figure out who looks like they work at the museum.

There are ways to do this virtually through Zoom by sending private messages to attendees and starting a conversation by message.

TALKING IN PERSON VS. POST-EVENT EMAILS

These are some of the games I play when I am in a new environment where there is the possibility of meeting interesting people. After watching an opening like this for a while, you can skip talking to anyone and go home the first time, or even the second time if you are feeling uncomfortable. But at some point, after going to an opening, find someone there to talk to. If you see someone in particular like a curator or museum director you recognize, you can introduce yourself in this way: Walk over to the person you would like to talk to and, while looking in their eyes, say, "Hi, I would like to introduce myself, I am X, and I am really enjoying this show." That or something similar is all you have to say. For many people, this is very difficult at first, of course, but you have nothing to lose, so try it! You will find after doing this a few times, it is really quite easy. After you introduce yourself and say that you like the show, you can either be silent and wait for them to respond or simply say thank you to them if you know they work with the museum. Most likely the person will say thank you, and you can leave it at that or tell the person why you liked a particular work of art there and ask them what they think. To direct the conversation to something in the room is a good technique, because then you are not focusing on either yourself or the person you are meeting, but a topic of mutual interest.

This is the way to get everywhere, because as you practice, you will find that you get better at talking, better at introducing yourself. I know this may all sound very basic on some level, but it comes down to that. When you go to parties, you probably have the tendency to meet other artists and stick with them. So to meet other people there, it must be a conscious act that you do, knowing your goal is to meet new people who could help you.

One artist told me that the way she addresses this difficult action—to start a conversation with a complete stranger—was to think of herself as a "stage mom" to herself. In other words, she said it is like a child actor that wants the roles on stage or in television but does not want to do the audition. She imagines herself as the stage mom to that actor saying, "It's OK, you can go on stage, I'm right here, you can do it, this is how you get the chance to get the role you want." You could use her method and be the stage mom to yourself when you have to do uncomfortable things like make new friends in public that are rich.

You can also do all of this virtually by following up with people at Zoom or other virtual events by email and commenting on their social media posts and reference the opening or Zoom talk you went to where you saw them.

THE RIGHT QUESTIONS TO ASK

The question to determine when meeting people is how can they help you? How do you know if you are in front of someone who could really do something for you? The more questions you ask them, the better position you will be in. Sometimes I ask the fairly dry question, "What brought you here?" And try to find out more about what interests them in the arts. Because I am always endlessly surprised when I ask people what it is they do; people tell the most amazing stories. And often the connection we have is much more than what I might have presumed. The idea is to just talk, ask questions, explore, and you will meet very engaging people who will inspire you. Ask what their favorite piece is in the show, or why they like or dislike something. It's OK to fail at this a few times, with the

conversation ending awkwardly—just keep trying, and you will soon be talking to someone interesting.

The next step is to keep in touch with them by getting their email address, ideally, and mailing address. One way to get their address is to say, "I would like to keep in touch." It is easy to get almost anyone's email address, and you can always look it up afterward (just remember their full name). Virtually, through Zoom it is easier to ask for contact info and you can see their name as the user in chat forums.

Now that you have one or more email addresses of people you have met who seem like they could buy your art or fund a project, you need to write a letter.

Your letter should be polite, brief, and end on a positive note. Be friendly and ask the person you just met for a date to have tea. That's right, the next step is to take the conversation away from the party and away from the museum or institution and into a café where you can ask them to be involved in a project or ask for advice on fundraising, or for a studio visit. Now, let's take those one at a time. There are certainly many more things you can ask for and base a meeting on, but for now, let's go over these examples: a project, a studio visit, and fundraising advice.

The format of the letter should always be roughly like this:

Dear (name),
The first paragraph gives them a compliment of some kind that is sincere . . . "when I met you the other day at X museum I was fascinated by your interest in animal behavior." (Or whatever they were interested in.)

The second paragraph should explain why you relate to that issue (say animal behavior) and why that also relates to your art.

The third paragraph asks for something: a Zoom meeting, a call, a request of some kind.

The last line says you will follow up in week.

Sincerely,
You

The formality there works for everyone, internationally. It shows respect, and that is always appreciated, as opposed to "Hi—we met at the museum . . ."

MEETING TO TALK ABOUT A PROJECT

If you are meeting with someone to talk about a project of yours, by virtual software or in person, then say in your letter to them that you would like to ask their advice about your project in the third paragraph. The idea of a "project," so to speak, is really very new in the art world.

What is a "project" in terms of art and the art world? Though the definition will change with time, I am sure, at the moment, a *project* is a fairly vague term that describes an idea an artist has, which either incorporates the artist's art into an event of her making, or is an idea that is purely creative and has very few, if any, boundaries. It could be a film, a musical, a painting exhibit. An example of a visual project: "My project is to exhibit my paintings in a room meant for relaxation and meditation." An example of no boundaries: "My project is to make wishes and draw them for one hour a day, in silence, for a year, trying to get the moon to change its axis."

Those two examples are very different. The first we can understand very easily. If you are having a show of your paintings and you want to incorporate dancers, music, entertainers, or anything else into it, you are creating a project. It is simple really, just a statement explaining your artistic intentions in an exhibit that is beyond the artwork itself. An idea, in essence, that is about how your work is presented to the public with an awareness that the idea itself can be part of the art.

In the second, rather odd example, about wishing for an hour a day, for a year, to change the moon's axis, there is more flexibility because anything is possible. It is, of course, also very abstract and conceptual (idea-based). But a project in this realm means it could be entirely a thought about something.

Because of the times we are living in, art has come to the point where collectors and the rest of the art world are open to hearing something new. They are open to hearing any idea from any artist because anyone can

have a new idea or project or way of seeing the world that is of interest to someone else.

And that is what we are talking about here. We are discussing what you will say to the person you have met at the museum or museum Zoom talk. What is it that you will talk about over tea with them in a café? Or while using FaceTime in the comfort of your home?

WHAT TO DISCUSS

Will you discuss your project? Now that we have some sense of what a project is, you can decide if you are the kind of artist that wants to talk about that. If you do, then of course decide first what your project is. Let's say it is the project where you want to exhibit your paintings and also have some type of entertainment with the opening or even part of the exhibit. The entertainment—jugglers, for example—help reflect what is happening in the artwork as well, or have some connection to it. It could also be people meditating in the room or a film or lecture or reading. If this is the project, then the reason you would like to meet Ms. X or Mr. X from the museum party is to discuss a project, an event that you could use advice on. One of the key words there is "advice." Keep in mind when you are sending emails and asking people for a meeting, what you want is their advice. Be clear about this in your email to them asking for a meeting in a café or their office. If you have to elaborate with them on the phone, just say it is an art event that you are planning and looking at different options to produce it, and you would like to share the idea with them and ask their advice. Then you actually have your meeting, and you discuss your project.

To present your project at a meeting, do the following: Bring a sheet of paper that has the project described on it in brief terms. The kind of text you might see on the wall of a museum, explaining what you are about to see, written for the general public. With that sheet of paper, bring no more than six printed images that represent your project. I strongly suggest you bring even less, like three images, and your page of text, in total. What you will do is talk and show only a little bit. That is why it is very important not to show images on a computer unless really necessary. This meeting is

about building a relationship, not a lecture on your work. So bring some-thing to the table in a manila envelope with your sheets of paper. Bring an extra copy of the text. After sitting down, first talk a bit about what the project is. You are a painter (or filmmaker or other type of artist) and you want to have an event and bring in different elements to build excitement and to have a memorable time. When you are ready, you can show your friend a few of the eight-by-ten images you have printed out. Do not give them the text yet, just talk about the show and how you see the whole project coming together. After answering any questions, it is time for you to ask a question.

In this instance, your question might be, "Do you know of any venues where I might create this event?" Then wait for an answer. This is the kind of question that can get you a lot of help because the person you are talking to can evade his or her direct help by offering you names or resources to go to. You could also ask, "Do you know who might be interested in getting involved with a project like this?" Again, the idea here is to get pointed in different directions, to other people or institutions. Because after you are done with this meeting, you will ideally have a few references and leads in your hand to make other relationships. And now it is getting personal, because so-and-so just referred you to someone and you can use their name. That is one example of how to present a project to a new acquain-tance that might be able to help you either through their primary network or business or by referring you to a friend or resource. This tactic will work for curators as well as collectors or those just interested in the arts. Let's move on to other things you might ask them.

A STUDIO VISIT/ZOOM STUDIO VISITS

You may also be making the meeting with one or several of the people you have met at openings, so you can bring them to your studio to look at your work and possibly buy it. You can also make a presentation on PowerPoint or Prezi and share your computer screen during a Zoom meeting. That works especially well for anyone showing videos or digital art.

We are talking here about building relationships in the art world. And if step 1 is to go out and talk to people a bit, then step 2 is to make a meeting with them, and step 3 is asking them something in that meeting, and for this example, what you are asking for is a studio visit.

You can do this virtually now with great ease, but we will cover it both ways.

A studio visit is special because it is so intimate and the viewer is investing a lot of time in coming to your studio and looking around. Also, for people who are not artists themselves, going to an artist's studio is a very unusual and even exotic adventure. The key to getting a studio visit is to make the person you are asking feel comfortable with you. If you are just getting to know someone, asking them to come to your home or studio may seem a bit forward, even awkward. The easiest way to get around this is to have a very small party.

Invite six or seven people over, depending on the size of your studio. These people should all be persons who have an interest in your art and are not fellow artists or family. If you have a small gathering like this, you can ask the person you are meeting if they could come to a small party at your studio. If you ask them this directly, they will answer directly and perhaps ask you which day. Be ready to have a day in mind, then get people there! The way to have a party like this is to invite the right crowd, which again is a just six people or so. People who are either fans of yours already or new people that are learning about you are the ones to invite. You do not want this to turn into a party where people are drinking and talking or dancing. You should have wine and cheese there, but it is a very sober event where you are there to talk about your work. That is a very important consideration when deciding how you will have a party or give a tour of your studio. The setting has to be very focused on your work. Remember your goals when you are showing someone your work. You want to sell them one of your pieces, you want them to take an interest in you and the way you work, and you want them to come back again. You are a professional, and they see that by the way you act.

Keep the event to a two-hour window, like three to five o'clock or in the early evening. Keep in mind that you want them to buy something, but in

the first visit, just make them comfortable. If you have any press clippings or reviews of some kind or a book, have them all in a little pile that is within reach somewhere in the studio.

THE STUDIO TOUR

Take your visitor around assuming that they are feeling a bit shy and are not sure what to say. In most cases, this is the fact; how would you feel in a new studio where you do not know anyone and were being shown art? The way to break the ice easily is to tell a story about one of the pieces. This can be wide open, but it is an important talking point when someone visits the studio; telling a story can relax both you and the visitor. They are in a foreign place, so take them by the hand (not literally, but figuratively) and bring them to your work, or get them something to eat and then bring them over to a work and tell them a story. It could be anything, but something authentic, something you can easily remember. You could talk about how you built the painting, your technique and what was in your mind. Or you could talk about what was happening to you the day you started the artwork or the time in your life it was and the transition you were going through, or the narrative of the work itself, its message, so to speak.

If there are things in your image that you can decode or explain for the viewer, they are more drawn in. Give them tools to feel comfortable by describing what you like about the painting, what works, what doesn't work, even. You are educating the viewer on the process of looking at art. Everyone loves this no matter how sophisticated or amateur a viewer they are because they are learning, and that is a reward in itself. If you practice this with different people, you will get better. You will get better at telling a story and then involving the viewer in your story. That is the next-to-the-last step in this process, and we are far into it now. You have met, written to, and finally gotten a studio visit from a curator or helpful person and they are in your studio.

The final step is telling them a story and becoming better at involving them in the story. For some this comes naturally, but for most it does not.

After you pick a story of some kind and feel comfortable telling it, then ask your viewer questions that can bring them in. No one wants to hear a lecture on your art, they want to relate to it, they want to feel that they have a personal connection to it. The only way they will get a personal connection is for you to help them make it. If at some point you are telling a story and it involves an encounter, you can ask, "Has that ever happened to you?" or something similar and get them to start talking about their experiences. Then at some point, bring it back to your work. Then do it again; ask them more questions so they would begin telling the story of the painting with you. Now you have a fan and an admirer.

CLOSING A DEAL

The last step is to get the check or cash in your hand. This is the part where you must be brave. Even gallery owners have difficulty closing a sale, but it is not that difficult. Making the person comfortable is the first step, and after talking to them and involving them in the work, you can say something like, "Would you like to have this?" It is simple and bold, but they have to respond while you are smiling, waiting for an answer. They will probably say something like, "Yes, but . . . " And then if you want to be smooth but effective, interrupt with, "For only $100, you could have it—today." They are still comfortable; you have gotten to the point quickly. If they want to purchase something from you, you have made it easy, and if not, they can get out quickly now. They will either say, "No thank you," and you can leave it there and go on with the story, or they will say, "$100?"

And then you say, "I will negotiate, but for a $100 deposit, it's yours, and then we can work out a payment arrangement for the rest."

If they still seem at all interested, you can go on to say, "The total cost is $5,000, but yes, for a small deposit and whatever arrangement we make, it's yours. I could have it delivered next week."

All the terms are negotiable, you can get a down payment and also say delivery could be as soon as next week (because delivery happens when it is paid in full).

That may have seemed aggressive to you, but it is a polite, brief way to get the visitor to agree to your terms and get it out of the way. Otherwise, it is also a way to end the conversation about it if they are not interested, which is also good to know!

Attitude makes a big difference

VIRTUAL STUDIO TOURS

The same process is even easier to do with Zoom and FaceTime. I talk to curators throughout the world and all of them are doing studio visits virtually to supplement the physical visit or instead of that visit. Collectors are doing the same thing. It makes it easier for everyone and is now the default process just to make it more possible.

And with Zoom studio tours, it is less awkward for the curator and artist since they are not in your private studio space.

Fundraising Advice

This is the last reason I am going over out of the three reasons to ask someone for a meeting. We talked about meeting to discuss a project and also talked about an invitation to a studio visit. The last one is to have a meeting about fundraising. That is, how to raise money for yourself, your art. That money could be for a trip you want to take, for tuition to college, for a new body of work you want to make, really anything that sounds interesting (just not living expenses, because that is less exciting to talk about). So think about what you might want to raise money for; you probably already know.

The next step for you in the scenario is to meet the person for a conversation at a museum café, their office or by Zoom. Your goal is to talk with them about supporting something, to help raise money for something of yours. You do not have to bring anything with you in the first meeting. In fact, I wouldn't. If you really think this person might be able to help financially or have friends that could, it is easiest to just talk without documents.

Meetings can also of course take place by FaceTime or whatever you are comfortable with. The way to conduct yourself at a meeting is the same in person or via a platform like Zoom and Facetime.

THE FIRST MEETING

You are building trust in the first meeting. You are establishing a level of comfort between you both, so illustrations and documents aren't needed

unless you feel strongly about it for some reason. In this meeting, you are telling the person about what you are doing and why you are raising money. Your dream realized, in essence. But first, to make it easy, you can start by asking them questions. How are they, how is work, or what do they do exactly, or some question like that. That is a technique I often use, to ask someone several questions before I begin to talk about myself. Also, the more you learn about the person you are meeting before you ask them about fundraising, the better. Imagine if they host an annual fundraiser for mental health that is hugely successful and you didn't know about it. That is why it is very important to always research the person you are meeting as much as possible so you don't make an error like that. Also, when you have researched the person well, you will know what contacts they have access to and what kind of activities they are involved in. Don't hesitate to ask them about things you know they are doing. It is a great way to show that you know who they are. That will flatter them, and as they say, you will get everywhere that way.

TAKE NOTES WITH A PAD AND PEN

The reason you are holding the meeting is to get to know them, feel comfortable, and tell them what you are doing and how they might be able to help. There are many ways to solicit funds from people, but I like to use the approach of asking them indirectly, at this stage, if they know where or whom you could ask for support. Again, this tactic prevents you backing them into a corner. It gives them an easy way to get out because they can mention other people or resources. What you will probably hear from them are other places you can go to ask for funding or even individuals. Then you have a reference, and that is important. When they tell you about such and such an organization, ask them if they have a contact person there; try to be as specific as possible. Take notes on a small pad. I think that is the least offensive, the small pad and pen. You can tap notes into a phone, but it is awkward, because it looks like you're texting, and a laptop is too big. I like small leather-bound pads that look nice and are convenient. Just use a pen and a small pad to take notes about who they are

mentioning, get names of individuals, and take note of any relationship or institution that is being mentioned.

After the first meeting, it is required that you send a thank-you for meeting them and always act as polite as possible. In an email thanking them again, make a summary of what happened and tell them what actions you are taking and that you will report back to them on what happened.

THANK-YOU NOTES

Those simple actions, such as sending polite thank-you notes after meeting someone and following up, are professional practices that will always benefit you. Being polite goes a very long way and is hard to forget. The next step is to build your relationship with this person on a deeper level is by attending events that they are involved with, even offering them help or a donation of your art. Board members of museums and others on that level are often looking for help in different ways. They often have a foundation of their own that they are raising money for, and if not, they are usually helping other organizations, and if you take an interest in those organizations, you will be even more in the favor of the collector/patron you are talking to.

HAVE A PARTY AND MAKE A MIRACLE HAPPEN

It was the first miracle that Jesus got tons of attention for; don't you think it will work for you? In fact, the example of turning water into wine is a great one. All politics and religion aside, it is a fantastic story, making it one of the most memorable parties in history; don't you think we can learn something from that?

Let's take it apart for a minute. The story is roughly that there is a wedding. At the wedding, everyone is drinking and having a good time. After a full day of nonstop partying, the wine is finished and the guests are disappointed and also drunk! Luckily, there is a magician there who does an amazing performance. He turns the water that is there into wine. The only witnesses to this event were drunk from a full day of drinking

wine. The perfect story. Whatever happened from then on is history. The story of that miracle maker continues to attract press, admiration, and controversy: all the things you could use for your art practice. Parties can be events where something truly spectacular happens. You may not be able to turn water into wine, but perhaps you have another trick up your sleeve? I am talking here about a party not where everyone gets drunk, but where something very memorable and interesting happens, and perhaps it is all virtual as well?

THE PARTY

To have a party, you don't really need me to give you instructions. However, to do a professional job, where the goal of the party is not to get a date or show off your new place, but to meet collectors and raise money, you need to be more calculated and thoughtful. Of course you can take this idea in any direction, from a very low-key intimate party with three guests to a gala event like Jesus apparently attended with performers wowing the crowd at a place you have rented or borrowed. Let's begin by talking about a smaller event, with three to six people as guests.

For a party this size, you prepare in much the same way as for a large party in terms of the sophistication of your design. The guests that you are going to invite are people you have met once or twice for coffee or at an opening and you have exchanged several emails with. They are collectors, curators, or perhaps friends of the family who have an interest in art.

I know this party is a reach for you. It is not about a cozy scene you can settle into; it is a party where the guests learn about you and your studio. The guests talk to each other a lot, but you are the master of ceremonies. You determine when it starts, stops, and what happens in between. It is important to have something to eat. You can go with the traditional wine and cheese, but if you pay more attention to the food, you will present a more attractive setting. I recently went to an opening in a gallery in the Lower East Side of Manhattan. The gallery could not have been more than three hundred square feet: it was tiny! If twenty people had been in there, you wouldn't have been able to move. There was a group show of drawings,

and instead of wine, there was a small table with eggnog and homemade Swiss cookies. The eggnog came with a dash of whisky in it, and the cookies were delicious! It may seem like a trifle, a detail that doesn't really matter, but I think it does. I am not advocating alcohol in any way, but it can be one of many elements. That was a good opening in terms of the art, but the hosts were even more memorable. They were two people who seemed to put some care into what they served their guests, and that is the most memorable thing at a party!

In the case of the gallery I just mentioned, that I went to for the first time, I felt compelled to write them a thank-you note for the opening. The note was in my interest, of course, but it was also just being polite and knowing that everyone likes it when someone notices what they have done. This is what I wrote to the gallery, by email, which is one way to begin a relationship:

> Dear Eva and Hp,
> I very much enjoyed your opening last night and had to write you to tell you why. First, you have selected a wonderful and fresh group of artists, but also because you were such good hosts.
> The delicious eggnog was a very elegant touch as was the warmth of the homemade cookies you served.
> I simply want to say thank you for making such an aesthetically pleasing space, you are adding much to this world!
>
> Best wishes, Brainard

And this was the reply of the gallery director:

> Thank you so much Brainard, this means a lot! Hope to see you at our next opening!
>
> All best, Eva

And that is all, but it is good because it is the beginning of a professional relationship. At the next opening, I will introduce myself to the director, and they will be happy to see me and will wonder what I do. At that point, when they ask me what I do, I can decide what I want to tell them. In my case, I can say, "Oh, I am writing a book about the art world," or I could say, "I am an artist." Before I get to that point, I will make a decision with myself about what I want to talk with the director about. But now I have a personal connection, and this is a way to meet more people and invite them to the party we are planning here!

A SMALL PARTY

Invite three to seven people who are similar in relation to the gallery owner I just wrote to, someone very new. Clean up your apartment, studio, or house. If it is your studio, don't overclean it; it should still look like a studio, just make it easy to walk around so people can see everything clearly, and so they can navigate the space easily. You could invite each person personally in a letter saying something like this:

> Dear [guest's name here],
> I am having a small gathering of six friends at my studio, and I would like to invite you to be a guest there as well. It will be from six to seven on Monday evening, and there will be cheer as well as art and a brief studio tour. Can I count on you being there?
>
> Kind regards, [You]

Now you can write something that is more flowery or less formal than I did, but it should contain that basic information. You can add to that by explaining exactly why you are inviting them to meet other people there of interest or elaborate on a new body of work. Once you have your group and you have prepared your place and bought the food, there is one other element you can use to make it special. You can have a performer there.

You could have a well-known local poet or writer read their work to a small crowd. That not only takes you out of the hot seat, but it is an additional draw that will add to the appeal and comfort level of your invitation.

Just like the first miracle that we were talking about, a performer doing something memorable that is just for pure fun and entertainment is always a good draw. And it can also be very low-key, as I said, like a poet reading or a brief talk by someone on something of interest. Be creative here. Remember you are orchestrating an event, and everything is in your control, so enjoy the process of putting it together and making it memorable. The one mistake you should not make is to invite your friends. This is not about hanging out with your friends; it is a professional atmosphere where you are cultivating relationships.

This kind of party can also work virtually on Zoom to have a poet and a musician take turns between presentations.

GETTING A CELEBRITY HOST FOR A BIGGER PARTY

Once you have pulled off a small party of an hour or two in your studio or home, you can move on to a larger affair. The same rules apply: Bring in almost all new people and make it a very polished and polite affair. That doesn't mean it all has to be so special; it just means that you consider everything. That you consider the food, the drink, the conversation, the entertainment, the music, etc. Just as in professional fundraising and museum level parties, as your own parties increase in size, you can move to a different level of showmanship, or miracles. One step up is to have a party at your house or someone else's house and have it hosted or cohosted by someone who is a celebrity of some kind, or a local personality. That may seem like a stretch, but often it is not as far as you think. Do you know anyone that is a celebrity or do you have a friend of a friend that is? If so, you can ask the person to cohost a party if they like you and your work, and that doesn't mean they will be there; it just means their name is on the invitation. Now it is easier to get people to show up on a Zoom party.

I had a friend who got Leonardo DiCaprio to say yes through his agent that his name could be used as a host for his fundraising party. It is not an

uncommon practice. The tricky thing is to make their agents trust you, especially if they don't know you. That is why it is better to have a friend, but if you don't, you must earn some trust. It is OK to start at this cold; most people do. Even seasoned fundraisers and directors of development can't hook a celebrity with ease or without being intimidated! It is a considered and planned request. It is one aspect that may or may not work, but if you don't try at all, there is no possibility, so you might as well.

CALLING YOUR HERO ON THE PHONE

There are countless stories of well-written letters to celebrities that get a response. Instead of telling you about artists that I work with and teach to reach the contacts they are after, I will tell you a casual story that happened among friends.

In one story, I was at a friend's studio, just looking at his work. We were both fathers of infants and had met in the park pushing strollers. As he was talking to me about his photographs, which were altered in different ways, he kept saying he wants to show them to more people. I asked him who he wanted to show it to. He said people that he respects, other artists that are well known. I asked which ones, and he said someone like Andres Serrano would be amazing. Andres Serrano was one of the top art photographers in New York at that time. My suggestion was simple: "Why don't you call him and invite him over?"

He balked at the suggestion and said he didn't have his number, anyway. I said that I thought his number was probably easy to find in public records online, since he wasn't a celebrity. I encouraged a bit more, but to cut to the chase, he called up Andres Serrano and asked if he would come to his studio, and he did just that, the next day! I will tell you what Andres said when he came to his studio in a minute, but first, what did my friend say to him on the phone? It was human, simple, and quite direct. He called up someone he didn't know, had to ask for them because someone else picked up the phone, and then awkwardly introduced himself and invited the listener to come by for a studio visit. It is that simple, and that crazy, and sometimes awkward, but that is all that is expected. It is not easy for

anyone to just reach out and ask, but it is a very human gesture, and when it is sincere, we all respond to it, if we can.

THE HERO ARRIVES

This story continues with the actual studio visit. When Andres Serrano came to his studio and looked around, he said, "These are some of the best works I have seen in a while," or something very similar to that! He also gave the artist the name of a dealer (Stefan Stux) and said, "You should go see him and tell him that I love your work and recommended he see it!" That is a pretty good recommendation, isn't it? Now you might think there are extenuating circumstances here. After all, the artist lived in NYC, and so did the person he invited, and also, the timing was right. You might think this wouldn't work for you. However, this is not the only way to reach people and ask for something, to ask for help or advice. You can write to people as well with regular mail or email. The visit can be by Zoom or in person.

MY FIRST MENTOR

The reason I gave that advice to a friend was because of an experience I had in my first year of undergraduate art school. I had met a friend there named Mark. He was an art student, and I hadn't chosen my major yet. He told me that he liked my drawings and that I should try to get a show in New York, and I should show the work to other well-known artists. At the time, I was not only very young, but I also didn't even have much work. I continued to listen to my new friend and watched the way he worked. After college, he was already working with some of the most popular painters of the time, like Ross Bleckner and others. I asked him how he met all these artists who were famous, and he told me they are all in public phone databases! He simply began calling them all up and asking them a question. The question he would ask depended on his situation. One question was if they would consider selling him a small drawing or something that he could pay for in installments, since he was a student.

Think about that for a minute. A well-known artist gets a call from a very young artist, asking if he can buy something on a payment plan because he doesn't have much money. That is an unusual call that is quite flattering to the artist. Because even if that artist does not really need the sale, he or she also realizes that the person wanting to buy their art is more sincere than the average collector who is making an investment. Do you see the attraction? Even though the caller, my friend Mark, does not know the famous artist, the artist is impressed that someone without much money wants to buy his or her work. What would typically happen next is that he would get invited to the artist's studio. That was nearly enough reward for him, because while he was there, Mark could talk to the artist, see the studio, and maybe even ask for a job. Did you need studio assistants? Can I buy that drawing scrap on the floor?

The result of his efforts was to get a job as a studio assistant in New York City and an incredible collection of art by major artists! That's right, Mark built an amazing collection this way. He bought all these works paying as little $25 a month to these major artists.

BUILDING A COLLECTION OF YOUR OWN

Mark told me he would go to artists' studios, famous ones, and look for a very small drawing, even something on a scrap of paper or something that looked odd for some reason, and he would ask about buying it. The artist would either give him a payment plan, or in most situations, they actually gave him the work for free! They gave him the work because it seemed small, and they liked that Mark was so enthusiastic about it. In Mark's apartment, he framed all the works beautifully, and it was one of the most interesting collections of art that I have ever seen. Each piece was fascinating because at first it looked nothing like what you would expect from the well-known artist who made it. Upon closer inspection of the work, you might see traces of the style of the artist, but it had many surprises in it. Mark was the person who made me realize that the world of art might work very differently than I previously thought. Just as I casually advised a friend to call an artist he wanted a studio visit from, this is the person

who shifted my perspective from not knowing to seeing a way into a world that I knew very little about and had no connections in. He taught me the importance of artists starting their own collections of other artists' work and building valuable relationships in the process.

GETTING A DREAM JOB

There was another time I had a friend who was looking for a job. She went to undergraduate school for industrial design. She wanted to design her own products but also to work for someone she admired. I asked her who her hero was, and she said the name of a woman I had never heard of, but was a major designer now in her early seventies. In short, I encouraged her to write a letter to the designer, telling her why she liked her so much. My friend wrote a letter and sent it off to the designer (via regular mail), and when the designer read it, she called her up and asked her to come down. When my friend arrived at her studio, she told me the designer announced, "Here is the angel that wrote to me, everyone, come meet

her!" And though my friend was a bit embarrassed by this introduction, she was offered a job right away and kept working for her, quite happily, for several years.

A MAJOR CELEBRITY CONNECTION

That was all a digression to illustrate how getting someone well-known to host your party may not be as hard as it sounds, or for that matter, to meet someone well-connected or famous.

Here is another example I saw when I was a teenager. My mother worked for a thrift store that existed to fund a local youth program. It was a small used clothing store no one knew anything about except neighbors. The woman who was running the store wrote a handwritten letter to Yoko Ono one day, saying that she was a big fan of John Lennon and that she was sorry he was gone and a little about her thrift shop and the organization it supports. More than anything, the letter was an honest and heartfelt statement. It was not formal in any way and did not even directly ask for money, but it was effective. She got a call from Yoko Ono's office saying they were sending a check for $2,000. The woman who wrote the letter didn't even believe the call was real at first. She thought it was a friend joking with her. In fact, Yoko Ono did send a check for $2,000 to her and asked specifically that it not be announced in the press. Amazing, isn't it?

ASK DIRECTLY

In chapter 2, when I talked about sending out letters to fund my own art, this was one of the stories I was thinking of. I had written to Christo and Jeanne-Claude, Jenny Holzer, and other well-known artists asking for a direct donation. In those cases, they gave it to me in amounts between $200 and $500.

The point I am continually trying to reinforce here is that you can directly ask people for what you want, and the higher you aim, the easier it is to hit your target because there is less competition there. Most artists are applying for all the traditional grants and services that are out there. I am

not saying that you shouldn't apply for them too, but when you think out-
side of the traditional box and write to people directly, the odds of success
increase dramatically because there is no one you are competing against!
So keep this in mind as you plan your studio party (virtual or not). From
your guest list to inviting a famous host for your party, there are ways to
make it a very special event that will attract the people you want!

MAKING FRIENDS
WORKBOOK SECTION 5

No matter which career path you chose in workbook section 4, now it is time to meet people and make connections, which is the heart of this process. Begin by starting with where you live now. Find out what museums, galleries, or art institutions of any kind are near you. Near means within easy traveling distance. It shouldn't be more than thirty to forty-five minutes away by car or whatever transportation you use.

Write down a list of those places here:

Now call or Google each place and find out who the curators are there, then write down their names here:

The Artist's Statement and the Critic

What I will tell you about an artist's statement will be different from what you will read in other books on the topic. New York art critic Jerry Saltz has a Facebook page, and one day he told all the artists that he would edit their statements on Facebook or give commentary. He got tons of replies and, for the most part, was very critical and even began cursing at artists and calling them mediocre! As a critic, he can often be mean and hurt people, but at the same time, the ones who are not getting hurt find that attractive. I mention this because I think it sheds some light on critics and how they will view your artist's statement and respond to it.

When I was in the Whitney Biennial exhibition, I was thrilled to find that Arthur Danto wrote about my work in *The Nation* and, in general, said wonderful things about the show. Danto was one of the most powerful art critics in the world. He has written many books on art, theory, and art history and is a profound thinker that many in the art world reference. I asked the curator at the Whitney why there were so many terribly angry reviews of the show in general, but Danto loved it. She said that Arthur Danto was very powerful and could write what he liked because he has nothing to prove. Isn't that an interesting thought? Perhaps the reason that some critics as well as artists can be so negative and even downright mean is to boost their own status because, in general, that impresses people. Kind of like the bully in the schoolyard—that is, if he isn't beating you up, you are lucky to consider him a possible friend. That is also an abusive relationship, so I am suggesting caution when dealing with critics and taking their advice. The reason to talk about that before I discuss how to

make a good artist's statement is that you should be interested in what others say about their work, be curious, be open, be aware that all the artists that have ever written statements are writing something very personal, and it should be handled gently, as this is all personal indeed.

Critics like Jerry Saltz are after power and will demean others to get it, while the best writers who have that power already can be more sensitive and generous in their approach.

OWNING A GALLERY

I owned a gallery for nine years, and in that time, I received hundreds of artist's statements. What I noticed were two things. Sometimes, many times in fact, if I liked the artist's work and then read the statement, I often changed my mind and didn't like what the artist was saying and, in turn, didn't like the work even though I had liked it initially. That is how powerful a good or bad artist's statement can be. Think again about the dating comparison. Let's say someone is interested in you and wants to date you, and he sends his picture. At first you think he is handsome and has a kind face. He describes himself as playful and intelligent, so you decide to write back. Then he sends you another letter with his personal statement or a little more about himself. Now he tells you more about how wonderful he is and all the sports he is involved in, how many awards he has won, where he has lived, why his marriage didn't work out, and his two kids, etc. Perhaps you will change your mind now, thinking this guy seems full of himself, and what do you care what awards he has won or about his ex-wife and his kids? Or perhaps you will feel differently, but the point is that when we present ourselves or our artwork, what we say about it carries incredible importance, because no matter what people think initially, they will reevaluate what they feel after you have explained or talked about your intentions.

THE TITLE OF AN ARTWORK

Words are amazing and powerful, and they can change the meaning of what we are seeing. Consider the now-infamous photograph by Andres

Serrano titled *Piss Christ*, in which a crucifix is floating in the artist's urine. When you look at the image itself, it is beautiful, a rosy color pervades, and we see a crucifix slightly out of focus looking romantic and, quite honestly, like a very Christian picture, a believer's picture. In fact, Andres Serrano is a Christian and a believer. It could hang on an altar and would seem appropriate. The only thing that made it controversial was what the artist said about it in the title. The artist stated in the title card on the wall that the image was taken of the crucifix in a jar of the artist's urine. Can you imagine looking at the image and thinking or feeling that it is beautiful and then hearing that it is actually in urine? The artist's statement has not only changed the way you see the picture, it also caused a huge controversy that made him world famous! What I find even more amusing is that we do not actually know if it was in fact in urine. It doesn't look like urine, and there is no proof that it is urine; it is simply what the artist said in his statement. That statement changed the entire meaning of the work.

A ONE-LINE STATEMENT

As I mentioned earlier, Marlene Dumas said, "I paint because I am a dirty woman."

As the artist's statement of an extremely well-known painter, hers is one you should pay attention to. It is brief, perhaps too brief, but it is also extremely successful because probably after reading this once, you will remember it and maybe even tell someone else. She is a painter who could have easily talked about how she uses the figure as a means to critique contemporary ideas of racial, sexual, and social identity, but she doesn't, and it is to her credit. What she has written is engaging, humorous, and sexy. We smile or laugh when we hear this, and it feels bold and aggressive as well. Of course she could write more about her work, but for the purposes of most artists' statements in applications, websites, and even exhibits, this works. Of course if she wants to explain more, or if she has a catalog coming out, more could be written about her work from different perspectives, like a historical, political, or philosophical context, but that is not necessary, initially.

Most artists struggle so much with their statement, and here is a way to be brief, not prosaic and dense, but simple, accessible, and engaging. The most important thing as with any text is to be engaging. When you begin an article in the newspaper, the first line has to grab you and make you want to read the rest. The same rules follow with an artist's statement. Some people advise that you hire a professional writer, but I think it isn't necessary in most cases. Just write. Write something that someone without an art background might understand.

ARTIST'S STATEMENTS FOR GRANTS AND AWARDS

Here is another way of approaching the statement. These two artists won a New York Foundation of the Arts grant, and I have never forgotten their statement. I came upon this when I was reading about the grant recipients, and they used the artist's statement to say a bit about what they had done. But first, let me explain how a jury for a grant usually works. As they look through hundreds, perhaps more, of applications, this is how it is presented. Usually in a fairly dark room, or from a computer screen, just before they see your images, they read your statement. So that means your statement should stand on its own, so that after it is read, the jury is thinking, "I can't wait to see this!" That is the feeling you want to create, not confusion or anything that lacks clarity.

Let's look at the statement by Suzzy and Maggie Roche, two singers who were trying to get a grant for a sound-experiment project.

Our new compositions were inspired by two tape recorded conversations. We studied the rhythms and tones of the two women and translated their vocal patterns and personal expression into a musical piece. We abandoned any preconceived notion of structure in order to follow the natural curve of their stories. After twenty years of writing songs, we have become increasingly interested in the way people speak, and intrigued by the idea that human voices are always singing.

Isn't that beautiful? If I were in the jury, I would be excited to hear what they were doing, and I would want to give them a grant if it were even slightly interesting; do you know why? Because even though I have no idea what their work sounds like, their approach is very poetic, and the last line is particularly beautiful. Their idea that human voices are always singing is absolutely beautiful. I want to believe that very much. It is affirming of life and art, and no matter what they do, I would want them to be able to continue their experiments. Wouldn't you? Also, note the length of their statement; it is quite short and to the point. This type of artist's statement is less a summing-up of all their art and more specific to one project, articulating their approach. This is a method to keep in mind because instead of writing something long and partially biographical, it gets right to the heart of the matter without overexplaining things or becoming dull.

THE TRAUMATIC STORY AS ARTIST'S STATEMENT

Another type of artist's statement is the biographical one that often includes a traumatic experience in the artist's life. The reasons this one can be very effective are several. Unlike Marlene Dumas's and the Roach sisters', this one tells the story of a very personal and traumatic experience that helps the audience to understand the artist's work.

If you are not familiar with the work of Joseph Beuys, he was a German sculptor who was born in 1921 and died in 1986. Some of his more well-known works consisted of a chair with animal fat on it as well as felt. He used felt in many forms—as a suit, and piled up in layers—and for most, it was very abstract and not easy to understand.

The story he wrote is another type of artist's statement, which I have reproduced below. It is about a traumatic event in his life during World War II.

Had it not been for the Tartars I would not be alive today. They were the nomads of the Crimea, in what was then no man's land between the Russian and German fronts, and favored neither side. I had already struck up a good relationship with them, and

often wandered off to sit with them. "*Du nix njemcky,*" they would say, "*du Tartar,*" and try to persuade me to join their clan. Their nomadic ways attracted me of course, although by that time their movements had been restricted. Yet it was they who discovered me in the snow after the crash, when the German search parties had given up. I was still unconscious then and only came round completely after twelve days or so, and by then I was back in a German field hospital. So the memories I have of that time are images that penetrated my consciousness. The last thing I remember was that it was too late to jump, too late for the parachutes to open. That must have been a couple of seconds before hitting the ground. Luckily I was not strapped in—I always preferred free movement to safety belts. . . . My friend was strapped in and he was atomized on impact—there was almost nothing to be found of him afterwards. But I must have shot through the windscreen as it flew back at the same speed as the plane hit the ground and that saved me, though I had bad skull and jaw injuries. Then the tail flipped over and I was completely buried in the snow. That's how the Tartars found me days later. I remember voices saying "*Voda*" (Water), then the felt of their tents, and the dense pungent smell of cheese, fat, and milk. They covered my body in fat to help it regenerate warmth, and wrapped it in felt as an insulator to keep warmth in.

—Joseph Beuys

THE STORY: WHERE FACT MIXES WITH FICTION

That is a gripping story from the first sentence; it draws you in and hints at the life-and-death situation we are about to read, to the dramatic ending with a last line that speaks to his materials. However, after reading this story, you can then look at his work, his use of felt as well as animal fat, and it takes on a new meaning. In fact, it tells a story; it is not abstract, but rather illustrative of why he uses those materials! Now the abstract work seems filled with life and death and the struggle to survive. You have

a clear insight into his work, and looking at it reminds you of his story. He also wrote a résumé that was highly unusual. Instead of listing exhibitions, he started with his birth, calling it "Kleve exhibition of a wound drawn together with an adhesive bandage." He went on to create a résumé that was in itself a work of art, or at least a work of nonfiction artfully done! Let's go back to his statement and look more closely at what he has done here. At the very least, he has told a compelling story. When I lecture and talk about his statement, I often read this story aloud to the audience, and I almost always get audible gasps when I read the part about his plane crashing and the copilot dying on impact. Again, like a good novel, this text brings in the reader and leaves them affected by the words in a powerful way.

FACT-FINDING

However, parts of this story were probably made up. Apparently, research shows there were no Tartars in that area at that time. And furthermore, eyewitnesses say the pilot died shortly afterward, and Beuys was conscious

and was taken to a hospital to recover for three weeks. Beuys was making his own myth about himself, and you can just as easily adopt this strategy even if you do not want to be a major figure in the art world as he was. Does that mean that you should make up a story about yourself? Possibly, but embellishment isn't out of the question, and this is straightforward myth-making and self-aggrandizement at that.

The point I am making with this example is that your statement can also begin to create a myth about yourself—that is, a fictional story that is mixed with the truth. If this appeals to you, then use it and experiment, and if it doesn't, use one of the other methods. The point of an artist's statement is simply to get the attention of the person you are showing work to or the institution that you are applying to for a grant, or for your average juried show. No matter which it is, it is important to make yourself stand out and look different from others who are competing with you in 250 words or less.

MORE ON THE CRITIC

As I said earlier, the New York art critic Jerry Saltz has a Facebook page, and at one point, he offered to edit people's writing if they posted their artist's statements. On his page, he said an artist's statement should be . . .

> [written] in plain language. Keep it short, simple, to the point. Use your own syntax; write the way you speak. No platitudes! With giant abstractions ("nature," "beauty," "ambiguity") say what you're doing with these big things. Or AVOID . . . them. Don't be afraid to be funny/weird, your stupid self! A glimpse of real self is powerful.

He is affirming much of what we are saying here, that you need to be straightforward to a large extent, and that you need to be clear. But what he is not saying is that you can also break the rules, as Beuys did, and make a story up that is compelling, edgy, and effective.

EDITORIAL HELP

I am not saying you should not seek the help of an editor. An editor can be very helpful indeed! All writers use editors, and even a friend who is a good writer can be of assistance.

After you finish your statement, show it to someone who will give you their honest opinion. Show it to someone who knows nothing about the arts and show it to a child and examine the responses you get. The statement should be understood easily by almost everyone. If it is difficult to understand, then something is wrong and should be adjusted. Ideally, it should also be very exciting or engaging so that it is memorable and makes one want to see the work.

WRITING YOUR STATEMENT
WORKBOOK SECTION 6

This is the fun part. Write your artist's statement!

Have fun with this and remember it could be short like Marlene Dumas's "I paint because I am a dirty woman," or mix fact with fiction like Joseph Beuys did.

You can also write something sincere and real. But do not write something boring and all about the history of art or why you make art. If you can't think of anything interesting and engaging, write an incredible-sounding story that is at least fun to read!

The longest it should be is 250 words, and ideally, make it much shorter—like the length of a tweet.

It is OK to be quirky, strange, or neurotic here. The main idea is to write something interesting that people will not forget and that gives insight into who you are and what message you are conveying with your work.

Write it down here or use a separate page.

Optional: read it to a friend or post it on Facebook and ask people what they think.

A general rule of thumb is to keep it at 250 words or less, though these samples often break that rule; the shorter it is, the more likely it will be read at all.

Here are a few samples to get you going:

This one is by the artist Monika Bravo.

> Lured from early age by philosophical questions, my work is influenced by Jungian psychology, Zen and Daoist practices. I offer a large body of work that ranges from moving images, photo objects to video interactive installations. Along with industrial materials, sound and technology I create objects/environments that allude to recognizable landscapes thus examining the notion of space/time. The viewer is induced to connect by exploring, interacting and at times by focusing on an object-place-scene for a duration of time in a manner that is both meditative and

investigative. These environments are short of a scripted storyline; in contrast I am interested in providing the viewer with the necessary elements and conditions for the production of a personal and intimate narrative. It is an art of seduction, illusion, and introspection, where subject and representation exchange and engage in conditions that can allow the mind to convey from one reality to the next without the limit of boundaries.

Something very different by Laura Owens. This statement is from a major New York gallery in a press release, but it breaks form for a press release. Notice how informal it is, but somehow interesting because it is so personal and sincere. I think this is too long for almost any purpose, but nevertheless it pulls you in, it tells you something.

To whom it may concern,

For this new body of work, I decided to move back to Ohio. I recently renovated my parents' garage and have been working in this new and also very old context. I grew up here and hadn't been back for any length of time since I was a teenager. It's been interesting. Election season, and Ohio suddenly feels like the center of the world. . . . I thought I had escaped, not so!

I was really disappointed to find out the Cleveland Art Museum would not be open until next year! They have traveling blockbuster shows in one part of the museum; but it is really nothing compared to the quantity and quality of their permanent collection. I made a concerted effort to try to find the location of the grocery store owned by my great grandparents, who were Bohemian and lived in Newburgh Heights, or Little Bohemia. I haven't found it (yet); but I did find the Bohemian National Hall and Cultural Museum.

As far as the work goes, in some ways it's all over the place. In other ways, it's getting more unified. . . . For instance, recently I have been paying a particular amount of attention to the edges of the canvas. Trying to get it to recede just a touch within the canvas through the way it

is primed and also delineating other rectangular shapes within the canvas to make additional edges. So it gives me more chances to cross the edges because in some cases there are two or three manufactured edges as well as the actual edge. I think this allows for more ways to talk about the space in the painting and three-dimensional space or actual space. Just saw a picture of Lichtenstein's Perfect/Imperfect paintings and this really resonated with me, his use of edges, although his seem more intentionally humorous.

In general I think the way I am working in many of the paintings comes out of a long term relationship I have in looking at Matisse . . . and more recently, the Matisses I saw at the Barnes collection a number of years ago— their surfaces, the drawing and the space, the triptych and the way the canvases relate . . . etc. In many ways I have been consciously trying to do this since around 2003; but I think it's only now I am really "getting it" in any real way.

I also had been a real nut for Marie Laurencin when I was in college. I just bought a catalog of hers. In many ways her paintings always fuzz out around the edges or create a lot of inner edges that are fuzzy and shifting. Sort of the opposite of Matisse in terms of structure, but similar in some ways to what I am thinking about.

So anyway with the idea of edges . . .

I also wanted to play around with the edges of the gallery. Where the work is in the gallery, thinking about the different spaces. Waking up some spaces, putting other spaces to sleep. This will be determined by the installation, and so it's sort of a whole lot of b.s. to tell you how it's working in a press release . . .

Also with the edges of the show . . . hoping to leave up some of Jenny's work . . . bring in some of Rob's . . . sort of to soften the edges of the show (in terms of time) . . . To not erase and break completely, but to get more close to what I see as reality . . . not cut nice and clean, but quite messy and gray.

So in this way I continue on with some sort of oblique collaborations. Edgar Bryan was asked to make the ad . . . recalling his years as an Air Force graphic designer. Also, I will be continuing the Faith/Failure continuum. A piece originated by Mungo Thomson, then remade by Florian Maier-Aichen, and then by Karl Haendel . . . I hope to take the piece out of the world of black and white . . . into the world of color, out of the world of paper, into the world of linen; and for the first time the piece will be made by a woman. Other collaborations will be included, some more obvious and some less obvious . . . but this is just to point out that the edges of my authorship are messy.

Go Bucks!

Laura Owens

This is from Amy Yao, and is more enigmatic, but that too is engaging, almost poetic:

What does it mean? Color use in the man-made environment, workplace, industry, hospitals etc. What is it they represent? He said: "Color is like politics." These religions—everyone has their own physiological, visual psycho-diagnostic testing, art nightmare. I, however, try to undergo ergonomic, neuro-psychological, marketing, philosophy (and psychosomatic aspects of ornithology)—in short, the universe! Famed Faber Birren during the 2nd World War was able to reduce the accident rate in American factories for the guests! While the men went to war, women went to work.

This statement is from Lizzie Wright:

I am from southern Louisiana where there is a rare folk culture, which is thriving, but caught between a culture of sameness on one end and the fast approaching Gulf of Mexico on the other. It's a region where global problems of cultural homogenization and environmental destruction are particularly concentrated and magnified. There is an impermanence and sense of play there that makes Louisiana's culture so tragic and beautiful. I am

interested in the circle of life, illustrated there so poignantly. Experiencing natural disasters has lent my work an awareness of time, an urgency. I am interested in leisure time and the outdoors, in being adaptive, and in making do.

My work is both playful and dark. Coils of rope are decorative nautical arrangements and pools of blood or oil. Holes punctured in the work function as peep holes or children's games. I like to work with materials at hand: tin cans, food, scrap wood. I am drawn toward objects that can repeat to form patterns gesturing toward folk art and Minimalism. Recently I have become interested in cages and traps, after spending time crabbing down south. I admire the way crab traps rust over time, how they stack like bricks, and how birds pick them clean. When watching crabs in a trap, most of them are feasting on the bait, unaware of the danger they are in. Only the ones that have tried to get out realize that they have been blindsided. Cages can be protective too, like chain mail. I am interested in the ambiguity of appearances and the link between sinister and protective. We really never know what we are getting into until we are in it. In the sculpture, *It's a trap!*, the baguette is a phallic symbol that cracks jokes about the cliché of women trapping men. The baguette also suggests the romanticized life of the artist.

Problem Solved investigates a desire to appear official, representing a personal triumph over my failure to attach a potato to a poster in the fourth grade. At the time, the poster was the required vehicle for presenting information. Haunted by the memory of a potato lying on the ground beneath an empty poster before my presentation, the question, "Why didn't you think outside of the box/poster?" surfaced occasionally, but I suppressed it.

The Forest, The Forest, The Forest is composed of the first three pages of a Time-Life book. The pages carry the anxiety of a quickening culture. Rather than entering deep into the forest (or a book about the forest), we stand at its precipice, endlessly repeating while looking for the next big thing.

My favorite places to visit are national forests and parks, natural history museums, and cultural institutions. I feel that giant sequoias, mountains, marble statues, and pyramids are all in it for the long haul, making their mark, sharing with me a celebration of the wondrous and a collective fear of death and inconsequentiality. Marveling at their endurance is reassuring; however, the thought of spending so much time creating my own monument seems futile. The immediacy of my work shares in the experience of being here now, and all of the uncertainty and community that sentiment has to offer.

This is the artist's statement my wife and I used when we started to give out hugs and foot washings as art and called the project *The New Economy*. We made an analogy to software so we could avoid words like "love" and other clichés. It was brief:

Using the rhetoric of systems management, Praxis describes itself as a "software development team" that uses the bodies of Bajo and Carey as hosts with which to test their operating systems on others. By receiving the benefits of The New Economy project, participants become a part of Praxis's performance, and so choose to "download" the "shareware" created by Bajo and Carey, thereby integrating the altruistic spirit of Praxis into their own "systems." The wireless downloads are achieved through specific physical actions like washing feet and giving away hugs.

As you can see, there is clearly not a formula; the writing must simply be interesting and illuminating in some way, or you must read between the lines as in poetry.

Here are two more professional, brief statements by two major artists, both a bit wordy I think, but they work too:

SAM DURANT
My artwork takes a critical view of social, political and cultural issues. Often referencing American history, my work explores the varying relationships between popular culture

and fine art. Having engaged subjects as diverse as the civil rights movement, southern rock music and modernist architecture, my work reproduces familiar visual and aural signs, arranging them into new conceptually layered installations. While I use a variety of materials and processes in each project my methodology is consistent. Although there may not always be material similarities between the different projects they are linked by recurring formal concerns and through the subject matter. The subject matter of each body of work determines the materials and the forms of the work. Each project often consists of multiple works, often in a range of different media, grouped around specific themes and meanings. During research and production new areas of interest arise and lead to the next body of work.

MILLIE WILSON

I think of my installations as unfinished inventories of fragments: objects, drawings, paintings, photographs, and other inventions. They are improvisational sites in which the constructed and the readymade are used to question our making of the world through language and knowledge. My arrangements are schematic, inviting the viewer to move into a space of speculation. I rely on our desires for beauty, poetics and seduction.

The work thus far has used the frame of the museum to propose a secret history of modernity, and in the process, point to stereotypes of difference, which are hidden in plain sight. I have found the histories of surrealism and minimalism to be useful in the rearranging of received ideas. The objects I make are placed in the canon of modernist art, in hopes of making visible what is overlooked in the historicizing of the artist. This project has always been grounded in pleasure and aesthetics.

Feel free to be as creative as you want with this, because there are really no rules. However, try to stay away from writing about "why" you make art, and by default talk about your process and keep it at 250 words or less.

Time Management Techniques

In our lives, probably the most precious commodity we have is our own time. How to do more than one thing at a time, efficiently, and without stress is the goal of this chapter and workbook. This is probably the biggest hurdle for most artists who want to become more professional in how they look after their careers. Because the question is always "How much time do I have to spend doing this stuff?" Meaning, how much time during each weekday do you need to spend on doing things like writing letters and contacting people and other things you would rather not do? There isn't a specific amount of time at all; it is more about how you perceive all your time and how you can manage that in the same way that you would manage your eating habits. If you can't manage your eating habits, there are all kinds of diets you could go on until you find the right one for you. It is not unlike that with time management. There are lots of techniques, and I will give you some here, but the important thing to recognize is that you want to change and are looking for a system. Just like dieting, you may not find the right method for yourself instantly, but if that is your goal, you will surely find it soon through trial and error.

CHANGING YOUR HABITS

Let's begin with the basics, because, just like a diet, you are already using a time management system, and just like you have a diet that you are using but are not always conscious of, so it is with your current time management plan.

I suggest using a physical calendar, a paper calendar that you can write on, instead of an online one, but if you regularly use a computer application or the one on your phone, like iCal or Google Calendar, then please do.

First begin by blocking out all your time on your calendar. Start with sleep. Mark the times that you tend to fall asleep and wake up. If it is different on weekends, then mark them that way. Then look at your weekdays. If you are working, fill in all the hours you are working. If you are not working, fill in the hours describing what you are doing that occurs regularly. Perhaps you are walking the dog, volunteering somewhere, visiting friends, or making art, but describe it all on a recurring basis in your calendar. Then move to the weekends. Is there a regular event or class or a park that you tend to go to on weekends? If so, fill it out with that information.

Now you can look over your schedule and how it is occurring without doing anything else to it. This is the step where you should print out your electronic calendar or take a good look at the paper one you just filled out.

THIS IS YOUR LIFE

After looking at your calendar, you know this is the way you have either planned it or what you default to if you are not thinking much about it. Most of us are not time planners, so the life we are living is a life by default, a life that seems to be of our choosing but in fact is very limited, because on default mode you don't realize there is extra time you can control. The next step is to control that time. So take a look at the calendar again and think about what else you need time for. Is it spending time with friends? Family? Or do you need to take a vacation? Perhaps a weekend retreat? Or maybe you need more time for the studio or more time to go out to the theatre or see art shows at museums and galleries? Maybe more time to read books? Whatever it is, take the time to write down a list of these things (use the workbook). And write down all the things you wish you had more time for. Take your time and think about anything you would like to do more of.

EXAMINING YOUR TIME

Now that you have a list, look back at your calendar. There is a finite amount of time in every week, and now you are a time designer. There is no one that will do this job but you, and no one who can really advise you on the right way to spend your time but you. So start filling in that calendar because this day might change your life; this day might have you plant the seeds of your dreams—your ideal life—in rich soil that will make it all grow easily. Just this idea is a reason to celebrate, so go out and get yourself a present for getting this far and then come back and read the rest of what I have written!

USING TIME IN SMALL INCREMENTS

I like to start with small bits of time so that you can see how the process works and not get overwhelmed by it. Pick one thing that you would like to do more of every day.

Let's say, for example, it is applying for grants.

Then go to your calendar and pick a time frame. I would say no more than thirty minutes at first. Pick which weekdays, not weekends, that you want to use for this purpose. I would pick at least four weekdays, but you can pick five if you like. Then define when the thirty minutes will occur. Is it from 9:00 to 9:30 am every day, or is it at different times on different weekdays? If you pick out your four or five blocks of time this way, it should be easy to use them the first time. Starting out this way is very helpful because you don't want to feel pressured or burdened by this process, you want to feel that it is easy and doable.

Once you have all your thirty-minute time slots put in your calendar, commit to the schedule for two weeks at the very least. In the two weeks that you have committed yourself to this, do the following:

1. Put your calendar on a wall where you will see it (even if you have to print out a portion of your digital calendar).
2. Start a diary on your computer or paper of what you have done in each thirty-minute block.

3. Treat your blocks of time reverently, like this is the time that is for your health, and it is a life-or-death situation. I mean, it is, isn't it? If we spend our lives thinking about what we could have done if we'd had more time, it is like a small death in that part of us that never gets to live. So treat this time like it is very precious. If you are supposed to be writing letters to people or applying for grants or anything else, do only that.

4. Make an agreement with yourself that you will not check email or Facebook or anything unrelated to your task during this time.

5. If you get stuck, or feel like you can't do something, then read this chapter over again and do some research. Even if you are not writing or working directly on your topic, then do research on it, like which galleries or grants you are looking for or which ones are even out there!

SMALL STEPS GET YOU VERY FAR

This is the beginning of a big step because if you can get used to managing thirty minutes of your time, five days a week, you can begin to manage other portions of your time as well. And soon, decisions you make in your daily life will be adjusted according to the schedule in your head that you are always looking forward to. Managing your time this way gives you more energy because you are excited about what is happening and there is literally more time in the day to do what you want. When it comes to inspiring stories on time management, just look to people who seem to be doing the impossible.

Not long ago, I was reading the obituary of Rosetta Reitz. Do you know who she is? She died at eighty-four years of age in New York City and had a remarkable life. She raised three children as a single mother, and at the same time pursued her career as a jazz historian, writing about women in jazz. She also wrote the first book by a woman on the subject of meno-pause and, as an entrepreneur, opened a small bookstore and started a

record label, and kept working her day jobs to pay bills. Her day jobs were answering calls in a classified advertising department and waiting on tables. Her list of accomplishments actually goes on quite a bit more, but this is enough to seem extraordinary, don't you think? How is it that she raised three children on her own with side jobs and at the same time wrote books, had meetings with all kinds of people, went to jazz clubs, made new friends constantly, and hatched new entrepreneurial ideas that worked? And as an African American woman in the United States?

BEING PASSIONATE HELPS

Certainly, her passion is the greatest factor since, in general, everything else was against her! After she had decided what she was going to do with her life, or even if she just decided one project at a time like, "I will write a book," she then had to carry through on her promise to herself, in whatever form.

Her self-given task was to raise these kids, make money, and do a lot more things. So she had to make extra time on a regular basis to do all of this. The method she used was the same that people have been using for centuries when they need to get something done: She dedicated a particular time every day to the task. Take weekends off, but stay the course, stick to the path, and complete it! There are several methods to try, but here are a few to get you going.

USING EGG TIMERS

Techniques like this are important to know of because one of them will stick with you and be very effective. And then you have a better chance of using your time in the same way, repeatedly. Try them all a few times and see what feels comfortable. Using an analog timer is simple and in some ways like a game. Go to the store and buy yourself an egg timer. I know you could use your phone or computer, but an old analog or even digital egg timer is better because it won't distract you or take time to figure out. Set the time for thirty minutes when you are ready to do your daily amount

of time. While the timer is going, you can work on only things related to your goals in the calendar for that time. No email or Facebook or anything else. The purpose of having a timer is also to prevent you from extending your thirty-minute slot because you were looking at email or something else. When the thirty minutes are over, they're over—that's it. It is worth trying this technique because, as I said, it will either work for you or not.

YOUR OWN PATTERNS

As you begin to manage your time, you may encounter resistance on several levels depending on your personality and past patterns. The first thing that I encountered when I was starting to manage my time was that I felt I wanted to be free to do whatever I wanted and resisted the notion that I had to treat my life like it was a job, checking in and out. What I was thinking was that I felt that life on the default mode of just doing what I could to make a living and enjoying myself was the ideal way to live and would make me happiest because I saw that as freedom. However, when I experimented (which I am asking you to do), I found that I certainly did get more done, even if it irritated me a little at first because I resisted it for some unknown reason. But what was more profound was that I was enjoying life more through the feeling of getting something done; even if it was through a regimented schedule, it had tremendous pleasure associated with it. This is why you are reading the chapter you are, and it is the best possible scenario when you have finished the exercises and workbook section. The idea is that you will have a similar feeling. You will experiment with several time management techniques, and one will work and, it will give you more pleasure than you imagined. Then even though you might resist doing it again, if you can remember the pleasure you got from achieving so much, you will go back to it.

ACCOUNTABILITY TECHNIQUE WITH A FRIEND

This is a classic technique where you check in with someone regularly. It could be a friend or someone you hire, like a coach. You have an agreement

with this person that goes something like this: "I will write to you every weekday before 6:00 pm, reporting on the work I did that day." Then you design your new schedule as we have before. You choose one thirty-minute period, not much longer or shorter, and you do your work in that period and send it to your friend or coach.

This is an exercise that works for me and is highly effective form of accountability for many. Also, if you ask this of a friend, you are asking them to help you, to help you accomplish a goal, and if all they have to do is receive your emails once a day, five days a week, why not? Wouldn't you help someone wanting the same thing? Offering an exchange like that with someone can work very well. This can be done with a family member, old friend, or someone you hire like a coach or an assistant. For the sake of experimenting here, you could ask a friend or someone very close to you. Tell them that you need their support and are doing an experiment to see if you can reach a particular goal. Tell them your plan: You will work thirty minutes a day on it and email them every weekday to state your progress. That is all. They have to read it but do not have to respond if they

don't want to. Chances are, they will respond a little, and you will have a relationship over just this issue. You can also swap goals with them to hold each other accountable—your daily work and their daily goals.

The main issue is that you hold yourself accountable by writing that check-in report every weekday or talking to them daily. Also, you are reaching out to someone and telling someone what it is you are reaching for, and when you begin telling the world that you will do something, it tends to get done.

TAKE TIME OFF

This one may seem easy, but for most, it is not. Especially if you are living a freelance lifestyle or if you have different jobs or even if you are a full-time artist. When do you take time off? You might think that you are always off because you can choose when you work, but that is not the same as taking time off regularly. A comparison that comes to mind is what sex therapists tell their clients. When a man and a woman go to a sex therapist and tell them that they are not having sex because of mutual resentment or something, there is one interesting suggestion that the therapist usually tries. The method is to tell the couple that they must both abstain from sex for a week or until they see the therapist again. Of course the couple protests, saying that they were already doing that, and that is not why they came to therapy. But the therapist counters by explaining that if they agreed not to have sex, it would at least be something they agreed upon! The couple is still unsure, but the therapist continues to talk, explaining that if they take time off, consciously, from having sex, they can stop beating themselves up about it. Then after the next session, they can all evaluate what happened and decide how to move on.

That's a strange method, isn't it? When I first heard that, I was amazed, but it makes sense. The person who told me about it was the husband in the couple. He said it really irritated him. But he also said it was nice not to argue about it and lay down all weapons for once. Amazing, isn't it? Simple exercises that we can do can teach us profound things about how we function in this world and how to do it more effectively.

THE TIME-OFF PLAN

Taking time off is the perfect solution for the too-busy person who is trying to get more done than is possible or at least thinks there is not enough time in the day. I would take off one entire day if possible. How about Sunday? If you must, choose half a day. Then do the following on that day:

1. Make a promise not to check email or look at a computer for that entire day (or half day).
2. Do something you enjoy for the sake of it: read a book, take a walk, or play a game.
3. Be aware that this is your day off; you earned it and are fulfilling an exercise as well.

That's it. Keep it simple, unplugged, and mindful. This is another technique in time management because it teaches you how to relax and that makes you refreshed when you go back to work, not just more of the same. It is also a lesson in enjoying yourself! When I am stressed, I always remind myself of this thought: "Why am I doing this if it is not fun?" That usually calms me down because why would we get stressed out over something we have chosen to do? We can change the situation if it is that bad, we are each designing it, we can alter it as well. The ups and downs are part of any process.

FIND THE PROBLEM, FIX IT

This is another technique that will give you more control to design your time. Carry around a small pad with you from when you wake until you go to sleep. On this pad, write down the activities you have done and how much time you spent on them. Make it very brief. Like for what I am doing now—writing this book—I would say, 9:00 a.m. to 2:00 p.m., writing the book; 2:00 p.m. to 3:00 p.m., lunch; etc. Then do it for the entire day. There will be times when you are at the computer and you are supposed to be working and instead are doing several tasks, like checking email and looking at social networking sites like Facebook. Rather than write down the

time as "work on the computer 2:00 p.m. to 6:00 p.m.," try to be more specific. If you were web surfing, mention what sites you went to roughly and if you checked your email. If after doing this for a day you feel that it wasn't accurate, do it for another day, even two days. Then look back on your notes and find where there are leaks. You know, like checking to see where the money is being spent? Check to see where you could have more time if an activity were changed. What is taking up most of your time? Write down those answers, and it will help you to decide what to change next or what time slots are free.

DON'T ANSWER THE PHONE

During one or more of your scheduled work periods, make an agreement with yourself not to answer the phone! The reason is probably obvious (it is a time waster), but it also is about behavior. All these time management techniques are after is to change your behavior. That is why they are hard for most people, because even if we want to change our behavior, it isn't always easy, and we need reminders, rewards, and proof that it is working and is also in our best interest. In this case, try not answering the phone during your thirty-minute work periods. You might hear the phone ring or see it, or a buzz from a text, but ignore it, let it go and respond back to them as soon as your session is over. This is easy and also a big relief once you get used to it.

There is nothing worse than getting all set up, ready to do your work, and then a phone call or text or social media post interrupts it all because someone needs to talk or someone needs something from you. Whatever it is, it can wait thirty minutes! As I was saying, all these ideas should feel new. If they are uncomfortable to do or you are resisting them, then we are right on track. That means we are going against the grain of learned behavior, and that is what we want to do in order to change.

MAKE A DAILY CONTRACT

This was one of the first and most effective techniques I have used and still do. At the beginning of each day, start out by writing down a contract with

yourself that is simple and doable. Write down a short list of things that if you accomplish them, then you will feel good about yourself. There are a few stipulations to this contract that you are writing daily:

1. Make your to-do list small—no more than four things on it!
2. Agree that you will feel good if you accomplish those tasks.
3. Put up the list where you can see it, like on the refrigerator or the computer.

At the end of the day, look at your list and tell yourself you did what you said you were going to do, and you feel good about that. Then write down a few thoughts about how you are feeling on a page, calling it your "time diary." At the end of your first two-week period of managing your time this way, stop and look back at what has happened. Read over your daily diary about it. What worked?

IT IS ABOUT CHANGING BEHAVIOR

Before you embark on the workbook section next, keep in mind what this is all about. Time management is not exactly the right term; it is more like behavioral reprogramming or simply changing your behavior. It is about the way you act or react to certain stimuli. For some reason, changing our behavior seems like the hardest thing to do. Addictions of all kinds run through our lives, and in fact, we are being introduced to new ones all the time. Phones, new sweet foods, caffeinated beverages, apps, and the list will continue to grow. Like all good things, they are fine in moderation, but if they are taking over precious time that you could be using for something else, then change must come. I have a friend who wrote a book that turned out to be a bestselling diet book. It wasn't just luck, though; she is a very hard worker who is aware of her habits.

We were discussing effective work habits one evening when she confessed that there were some games on her phone that she likes to play in the evening, after work. She said at first, she was aware she was playing the games, but didn't think much of it. As it grew more regular, and she

checked in on her game each evening, she realized that the time she spent on the game was significantly adding up and it might be better spent on something else. Every day she is either writing, reading, or setting aside time to go out and play with her husband.

To recognize that we are the masters of our time is powerful. It's one of the so-called "hidden secrets" in esoteric writings, self-mastery is what we search for, and it is one of the Holy Grails of our lives, yet it is also profoundly simple—just change. Depending on your age, your perspective will shift on this issue. If you are over thirty years old, you already have some habits of living and relationships that you might think you can't change because they are too established.

BEHAVIORAL MODIFICATION

Only experimenting and doing everything possible to change your behavior will tell you how much you resist or embrace certain techniques, but there are many behavioral programs that show us how effective they can be at changing your behavior at any age. The example that comes to mind is the very popular international program called Alcoholics Anonymous. As you may know, it is a program designed to change behavior. It also has a lot of support built in from others who are in the group. However, you are asked to change one behavior—you stop drinking. You may relapse or even start attending the group while you are still drinking, but the goal is to change your behavior. They don't say for how long, just one day at a time. Also, you are not asked why you are drinking or what it is you are afraid of or anything else that has to do with the mind and what it is you believe about yourself. You are asked only to change the behavior of drinking. And as you may already know, this can start at a very young age, but many who are in AA start when they are over forty and make changes that last for a lifetime.

What is also remarkable about AA is that there is no leader, by definition they are an anarchist association and one that works extremely well for the benefit of all its members.

This is a good model to think about, because people are not only changing their behavior when they are older, they are also changing a very addictive behavior that sets a pattern for everything you do. So when you do something like stop drinking, it shifts everything in your life because now not only is there time for other things, but you see all those other things quite differently. You also see the value and possibilities in change itself. So this may be the beginning or middle of your journey in the art world, but you can always change the game plan no matter what age you are or what has happened in your career.

Draw anything here. Get over the taboo of writing or drawing in books.

SCHEDULING TIME
WORKBOOK SECTION 7

This is the moment when you take out your calendar on your phone or your computer or on the wall, whichever it is. Now block out time on your calendar, just thirty minutes a day for four days a week, and during this time, you will look at this workbook and begin the business of your art. Thirty minutes is enough for now, but you need to do it at least four days a week. During your thirty-minute sessions, you are reading your plans on how to build your career from workbook section 8 and writing letters, making calls, and going out to events as needed and attending Zoom conferences and panel discussions.

Put it in your calendar, but also write down the days and times right here:

In the section below, write why you will enjoy spending your time in this way.

Generating Multiple Streams of Income

This is the chapter in which I show you some of the many ways you can create different streams of income with your art. The reason I refer to "different streams" is that your artwork has several places in the market, and some you may know of but others you may not. There are also ways that have yet to be invented and are not unlike the models I identified in chapter 1. Those examples are ways of selling your art to the world in a creative way, with a new concept. You have read that chapter, so now I will devote time to some of the more traditional methods.

ART CONSULTING

The first one is the business of art consulting. You may have heard of it, or perhaps have a whole different understanding of what it means, but for the purpose of this chapter, it is the business of selling art to an intermediary who sells it to a corporation, hotel, hospital, or other public or private institutions or a residence. No matter where you are in your career, this is at the very least another income stream you can add. It is by far the fastest way for artists to get money in their pockets, but it is not without effort.

Like any new business venture, you have to learn the ropes and see what works for you. Very often, art consultants sell work on paper and other mediums to different clients, but unlike traditional galleries, they can handle many more artists because they have to sell work in bulk, filling entire buildings in many cases. They often sell more conservative work, but not always.

Recently, many major buildings and institutions have come to want larger art for permanent display. There is a huge market in Dubai at the moment that many art consultants are trying to get a piece of. There are two ways you can approach the art consultant and interior design market. You can either begin calling all the consultants right away as an artist and asking them if they are interested in selling your work. You will find out rather quickly just what work of yours they like and what they don't. Also, you will learn to present yourself in a businesslike manner.

THE BUSINESS MODEL

The business in itself is really very straightforward, but many consultants will vary in the way they work. If you present yourself as a small business, very professionally and clearly, you will get their attention. They are not judging you or evaluating your work. They are just trying to make sales to their many clients. So if your work is organized, and you are reliable and ship things quickly, then you will do well here, most likely.

In Praxis Center, as of this writing, I highlighted and spoke with two major art consultants at artist roundtables that I host weekly, who explained how they worked with artists. That was Molly Casey of NINE dot ARTS and Wendy Posner of Posner Fine Art, both in the United States, both work internationally. On both their websites they had information for artists to contact them.

However, once you learn how to work with consultants, there is another choice: You can be one yourself. That's right, without any special knowledge, other than what it takes to choose art for different companies and establishing a business practice, this is a wide-open field for new players. Both the consultants above have backgrounds in art.

Imagine a scenario like this. After reading this book, you decide to work with a consultant. You write to dozens and dozens of them, you tweak your presentation, and within a year, you are feeling comfortable and start to earn a decent extra income from sales through these consultants.

Now that you know the rules of the game, it is fairly easy to move up one step. Now you can work with artists and represent their work to the

clients directly! You know how consultants work, and you can operate in the same manner. When approaching new clients, be businesslike and have your proposal ready and easy to understand. You do not have to take this path, as it's a big leap and a commitment, of course, but there is an option here. You can sell work through art consultants, but you can also be one yourself once you understand the business. These are options to consider as you look to new income streams.

BECOME A CURATOR AND GET PAID

Here is a story I found amazing at the time, and it is an excellent example of developing an income stream from the arts by being a curator and thinking outside the box. I once met a man who was curating exhibits at Diesel jeans stores. As an artist, I was interested because he said he wanted a proposal and would pay for an installation! That is not something you hear often as an artist, so I was very curious. I sat down with him and asked him how he got this job and his history in the arts. This is what he told me.

He was working in the marketing department at Revlon, and he decided to quit his job because it wasn't interesting anymore and he was bored with it. He wasn't sure what to do next. He shared an apartment with a roommate in Brooklyn. At the time, his roommate was an artist and he was interested in what he was doing and asked him questions. His artist roommate told him that it was difficult to get a gallery, and he wanted to have a show and sell some work.

After thinking about it for a few days, he asked the artist why he didn't just have a show in their little apartment. The artists said it was too small and no one would come. So my friend told the artist he would take care of it and try to get sponsors as well! And this is what he did.

He announced a show at the apartment, started to tell everyone about it, and then he went to different liquor companies and asked them to sponsor the event. And as I have said before, incredible things can happen when you ask. He did indeed get alcohol sponsors, and in fact, his friend sold some art as well. He was so excited by this that he decided he wanted

to make his new career about curating in the art world. Now remember, he had no experience at all in the art world, was introduced to art through his roommate, and now wants to make his living there!

HOW TO GET EXPERIENCE

What he did next was to go out and meet more artists at gallery openings. He met some that he liked, looked at their websites, and downloaded images that represented the artists. Then he printed out many of those images and made a portfolio of the artists he liked. He went to different stores—Diesel was one of them—and said he wanted to curate a show in their space. He told them it would bring in more people, create more publicity for them, and raise their profile in the arts. He was dealing with a major store, a corporation, so after he asked around and submitted a proposal, he didn't hear for several months. Then he got the job. They were paying him to curate a show, the first one he had ever curated! This alone is the envy of thousands of curators who graduate every year from prestigious schools, armed with knowledge, but not a plan. He continued to do this kind of work. He used the press he had gotten from Diesel and asked

other stores and companies the same thing. Only two years later, I saw him at Art Basel in Miami Beach, and he was promoting a book that he curated himself. He asked a group of artists to each rework a masterpiece, and he called the book *Remastered*.

AMBITION

Since then he has been doing curatorial projects for all kinds of companies and calls his curatorial business "Formavision." He says, "Through Formavision, I have curated the AQUOS Project for Sharp, the Denim Gallery for Diesel, the Starbucks Salon for Starbucks, Construkt for Girbaud, among other things, and am now also developing projects for Coca-Cola and Toyota." Pretty impressive for a guy with no art background, don't you think? And this is a job title you will not find in any art college. He created this job, this income stream. After he put together a show for Starbucks, where he chose the artists that were to be in the café and a few performers, he also started to design the whole show, how the works would be hung, the color of the paint on the walls, everything! Now his job title has shifted again; he is an exhibition designer as well as an interior designer, because now he can redesign your space as well.

Incredible, isn't it? He built a whole company out of a passing interest that got him excited. You could certainly do the same, but what does he know that you might not know? For one, he has a background in marketing and brand recognition. That means when he writes to Starbucks or another business, he doesn't just tell them his idea; he talks about branding and what is good for their company. Here is another excerpt from an interview he did at the time:

What were some of the criteria you considered when crafting not just the programming but the overall feel of this highly unconventional marketing program with Starbucks?

The fact that brands are participating in contemporary culture is now a given. Starbucks produces and distributes movies, music, books.

Even Bob Dylan released albums through Here Music, Starbucks's music label. Starbucks, like other brands, is changing the dynamics of contemporary culture, which is why I came up with the slanted gallery installation downstairs, where all the angles of the walls were off, as a literal reaction to this phenomenon.

CORPORATE CULTURE

You can see he can speak to corporate culture, and that is one of his talents. He talks about "brands" being involved with contemporary culture and how he can expand on that. He has been able to connect with a culture he understands. When he writes to them, he is talking about why they are already in this market and how he understands their interests.

This is subtle in some ways, but very important. I write in other parts of this book about how to meet people that can help you and to find out what they want to hear or what their interests are that you are part of. It is like what the private banker told me, "You must find out what the person or institution wants." It is a rule of thumb for many business people. If you are trying to make a new relationship, there has to be something in it for the person you are trying to meet! In the case of the curator/designer I am mentioning here, he has the ability to talk the corporate language that gets him in the door. This is something that you can acquire fairly easily. First, if you understand the rules of the game, companies are not looking to sponsor art exhibits usually; they are looking for innovative ways to make more money and have a higher public profile.

CONTACTING THE BUSINESS YOU ARE INTERESTED IN

If you are trying to develop an income stream like this, you have to write a letter and introduce yourself to a business or corporation. It is OK

if you are awkward at first; the main thing is to be bold and try out your idea. However, if you want extra help, I would talk to someone who works in the corporate environment and has experience communicating with businesses. It could be a friend or relative, or you could look for someone. When I was trying to start a company based on representing other artists in the corporate world, I put a notice on Craigslist. I made an ad that said I was starting a company that involved artists and corporate environments, and I was looking for someone who could help me—someone with an MBA degree. I was more specific, but you get the idea. Then I interviewed several people about it. I didn't end up hiring anyone, but I learned an enormous amount by talking to them. One person told me how to put together a "book" as a proposal for the corporations. He offered to do it for me at a cost of about $1,500. I didn't take him up on that, but I understood what was needed. I learned more about what language to use and how to approach a corporate or business client. You could certainly use this same method to develop your income and your ideas.

You will learn a lot in this particular kind of process, and it could take you to many places you never thought possible. Like the rest of this book, it is about conducting yourself like a professional.

Do you have an idea? Want to start a company or be an artistic director of some kind? Then reach for it. The way people do it, like the case I just mentioned, is by putting into words what they want. That is why you are reading this book, but also, you can seek out the advice of people who are already in the position you want to be in, or a businessperson who can help you present yourself, by looking over what you have written. In the workbook, you will do an exercise based on this, but for now, we will move on to another possible income stream.

STARTING YOUR OWN NONPROFIT ORGANIZATION

This may seem like a tall task, but starting an organization or even a temporary project can lead to a new income stream. The way I began my first business when I got out of undergrad school was to first send out a letter

asking for money for what I was about to do. That means before I did any-thing other than have an idea to start a gallery, I thought about sending out letters to everyone who would be interested and asked them to support this idea before it happened. I will tell you more details, but essentially, you are producing something of value to everyone—a gallery, a temporary school, a public sculpture, or whatever it is—and you are asking people to give you funding for their own edification and pleasure. If that sounds too grandiose, bring down the scale of it to something more manageable. Once you decide on what you want to do—let's say you are opening a nonprofit gallery or making public murals—you have to find your audience, your mailing list.

One way to get a head start is to think about who has a mailing list of people you would like to write to. That might be a local museum or a newspaper or a local magazine. Now the key is this: how are you going to get that mailing list? Most people do not share their lists, but they are all open to deals. I was having a show once at a nonprofit gallery who told me they had proposed a mailing list swap with a major museum that they actually got.

So even though a policy states that they do not share mailing lists, sometimes that is not the case, because while they may not give you their email list, they will send out an announcement for you to their email list. If you are about to launch an idea of any kind and need support, finding another related institution that is sympathetic will help.

If you are starting a gallery, as in this example, who could you work with and either get a list from or somehow "use" their list? Well, think about local wine merchants, food retailers, caterers, and framing shops. You may use all their services at some time, so they are potential partners for you to work with. You could begin by simply talking to the owner of each business and telling them about your idea and asking them to be part of it.

If you are starting a gallery that is not only about making a profit but has an educational or social mission, then you have an interesting idea that people may want to support. You can explain that you want to start this gallery, it will be called X, and you imagine that it will help the com-munity to understand more about art and why it is important. Get excited

about the idea as you are talking about it, and others will get excited too. The people you are talking to will have ideas perhaps, but here are a few.

GENERATE IDEAS

You can say that you are having an auction to raise money; would they (the business you are talking to) be willing to donate a gift certificate for this? The answer is almost always yes. That means a gift certificate for a meal at a restaurant, a hotel room, catering, anything at all. That is one way to begin to build support in your community.

Also, you can think up "cross-promotions," which means that you say to a hotel or liquor store that you will give a work of art or a discount on a work of art to the person that tells the most interesting story about art or something like that. Radio stations do this all the time. They offer something for the tenth or hundredth caller, and it is a sponsored promotion; they are giving away something like a meal or a room or tickets to a concert. Their goal obviously is to get more listeners who are actively calling in. But a traditional promotion where both parties benefit could work something like this: the hotel you made a deal with tells everyone

Life is like the game of hide-and-seek, and now is the time to say, "Ready or not here I come!"

on their mailing list that if they book a room within a month, or even if they just fill out a questionnaire about how service was at the hotel, then they will get invited to a special opening at a local gallery that is a private affair. Do you get the idea? You are asking a business to work with you on a promotion, and if they send their clients an email enticing them to do something they want, you will offer a reward.

Or you could ask something further. You could say that if the hotel client signs up for your newsletter or mailing list through the hotel, then they will get to come to all the private receptions at your gallery or VIP Zoom visits. The goal here is to get a business owner that likes what you are doing and can see the benefit in offering something to his clients that would make them better and more grateful customers. In turn you can get people to sign up for your mailing list and come to your event.

WORKING WITH NEWSPAPERS TO PROMOTE EVENTS

A common and fairly savvy way to partner is working with a local newspaper. Charles Saatchi, the advertising giant, did the following campaign in London. He asked a paper, the *Guardian*, if they would host an exhibit of artworks in one of their rooms in their News building. This is how it would work. There would be an open call to artists to submit work to a show that would be juried by the public. It would be announced through email and advertisements in the newspaper. As the art came in, this is what artists would have to do. They had to upload their work to a site (Saatchi's) and then they had to sign up for the *Guardian*'s mailing list to get news on what was happening. Not unlike my last example, there is a mailing list collaboration here. You see, after the artists upload their work, they have to tell all their friends to please vote on their work so they will win a place in this show, the idea being that this is curated by the community. (You've probably seen this tactic.)

So now take a look at the big picture here. Saatchi makes a proposal that is good for everyone. The *Guardian* is hosting an art show and telling their readers to pick the artist they like the best. That means there will be plenty of free coverage in a major newspaper. The reason the *Guardian* is

doing all this at no cost is because every time someone votes, they have to sign up on the *Guardian* website, and they are adding to their email list. For Saatchi, a wealthy man who could have paid for it all, he is getting what he wants, too. There will be more publicity for him and his new artist website, and he created a nationwide promotion that will cost him nothing. Pretty sly move, don't you think?

This is a version of what you could do. Of course you could take that exact example and go for it because it will probably work in most cities. However, the main lesson to take here is that you can partner with major media or stores and come out with a win-win situation so everyone is happy.

The way to earn an income stream from these ideas it to have something to sell or just continue to raise money for your gallery or project. That's right, no sales at all, just donations from people to keep your ideas going. This is how most small organizations and nonprofits run to some degree. What makes some more profitable than others is how savvy they are at working with other businesses and finding a way to generate more donations and a larger mailing list. This can be very creative. I am talking about a gallery model, but you could create a temporary outdoor exhibit for artists or a performance event or almost anything that will engage the community and be of artistic or cultural interest.

Is this an income stream that could make you money right away? Absolutely. As soon as you have the idea, you can begin talking about it and raising money. It will take you longer to be an official nonprofit, recognized by your government, but you do not need to wait until that happens.

FISCAL SPONSOR

A fiscal sponsor is one solution. That means there is another nonprofit or NGO that is willing to receive the donations for you. The way it works is fairly straightforward. If you are asking people for donations that you would like to be tax-deductible, or if you want to apply for grants and other funding that is only for organizations that are exempt from paying

tax, then you request that the donation be sent to another organization, which then gives it to you minus a small percentage. That is what a fiscal sponsor is.

There are many organizations that do this for artists all the time, and they take between 8 and 10 percent of the total amount donated for their services. That is generally fair because they have to deposit the donation, write you a check, and do all the accounting work themselves. There are several institutions that do this type of fiscal sponsorship, but you can go to any local organization that is nonprofit or the equivalent and ask them if they would take a donation for you for a percentage of the total. Usually everyone will say yes if they understand what you are asking.

You can tell the fiscal sponsor as much as you can about your project and why it might have a relationship to them. In other words, if you are starting a gallery or community project, then a possible match for someone who would take donations for you might be other art centers or cultural institutions. An idea of an organization that does not match your aims would be the Red Cross or a church or another organization that has little or nothing to do with the arts.

A MURALIST

Having someone who is your partner in business can be a big help. In the above example, I talked a bit about finding someone in another business that is sympathetic to yours and then marketing your services to their email list. This is a different take on creating a partner.

One thing people need when building new homes is often murals in children's rooms or someplace else. Stores and restaurants need them as well. Instead of going around to each store or finding clients one at a time, make a business partner out of someone who already knows those clients. If you put a small book together of what your art looks like and can make a nice presentation that you would be impressed by if you were a homeowner or store owner, that is the first step.

After you make a decent book, either use the original or, better yet, go to a copy shop, have it color-copied and spiral-bound or use something

like Blurb.com. Be sure to have all your information in there, like how to contact you for an estimate, etc.

Now begin making calls to local contractors and interior designers and tell them what you do; you are an artist and are available for murals and other artwork on the walls of clients' homes. Tell them you want to work out a commission with them so that they get a percentage of anything sold.

Ask for a meeting so you can discuss the details and show them your book. Once you get a few of these people to take your book and your card, they will do the hard work for you! If they have a client, they will show them your work. The important thing with relationships like this is to keep in touch. Let's say you have three contractors and two interior designers who have taken your book and have said they would like to work together.

Your book could be anywhere in their office and isn't the top priority. However, it is professional to send them an email once a week, preferably at the same time on the same day. In your weekly email to them, just say you are still offering your services and send them an image.

This is marketing made simple. In order to be effective, you have to simply send an email once a week to your clients, stating that you are available for working. That once-a-week email should only be going out to the list of contractors and interior designers. Occasionally, personalize a letter to someone you are expecting work from or have talked to recently. Always include new images.

STARTING YOUR OWN EVENT

This is a way of creating a temporary stream of income that can be fun and as creative as you want it to be. The idea is that you decide what you are passionate about socially, like helping stray dogs or troubled children, a local charity, saving trees, or anything like that, that people could donate money to. Here is a story by an artist, Susan Brown, who got very inspired about saving a forest near her.

Here is the gist of what happened as she explained it:

Reading an article in the newspaper at night in bed about an old growth hundred-year-old forest in town that the community hoped to save from development and devastation, I was infused with the desire to do something, so I thought, "I can make a painting of the forest and offer it to raise money by having a raffle—to raise awareness as well as raise money. The painting would be an ambassador for the forest." I could hardly sleep I was so excited. I called the Nature Conservancy–type organization that was trying to help acquire the land to preserve it. I went that day to their offices with samples of my work, met with the CEO, and got approval to parade the painting around the region with their endorsement. I called a dozen businesses, banks, etc., and they all said that yes, I could display the painting, and that they would collect the money. In less than forty-eight hours, everyone said yes, and I needed to make a painting! I was stunned in my enthusiasm to remember that I was making abstract paintings—I didn't paint trees!—and I had promised a representational painting of the forest! So I went to the forest and meditated with the ancient trees and a vision and tagline came to me: "Leave the trees." I took dozens of photographs and pasted them on the wall of my studio. I talked to the trees begging them to help me and inspire me to represent them. In the composition is a large "grandmother tree." I knew this was an important image for the painting and I was nervous about pulling it off. I asked the tree to guide me and went to work. I love to paint to music, and so I put a CD on. It ended so quickly. It seemed to last only a few minutes. I put on another CD. It was over in what seemed to be a few minutes, again. This happened for five CDs! I essentially went so deep into the moment that I lost all sense of time, and I had no memory of painting that tree! None! I only remembered changing the CDs. It was amazing. At the opening event for the culmination of the fundraising

(concerts, etc.), the forester who had to mark all of the trees for cutting, when looking at my painting, had an epiphany/communication that he said came from the grandmother tree. He started crying with joy and knew that he would not cut a single tree from the forest if he was hired to do so. Luckily, money was raised and the trees were not disturbed. The painting raised approximately $2,000, selling $10 tickets, and raised a lot of awareness about the local environment.

YOUR OWN EVENT

Now let's look at what she has done and how you could do something similar. To begin with, something gripped her, emotionally, about what was happening in the news. Something inside her was moved to make a difference. That was the starting point and that is the gem that you want to possess. To be inspired! For myself, I find that reading the newspaper daily often gives me inspiration in the strangest places. Sometimes I find it in the obituaries where I read about someone's amazing life accomplishments; other times I find it in the real estate section where there are often short profiles about the people who are renting some fabulous place. It can pop up almost anywhere. The important thing is to be searching, to be curious, and to be on the lookout.

I found it in an odd place recently. I was in the library with my then nine-year-old son, and as he looked around, I found myself in the "junior readers'" section and I began browsing biographies of famous people meant for young readers. I picked up a biography of Bob Geldof, the musician who was once in the Boomtown Rats. It was an easy read, fairly short, with lots of pictures in it. After reading what he did, I was amazed and energized. He was watching BBC News in London and learned about the Ethiopian famine, and not unlike the previous example of the artist wanting to save a forest, he wanted to help in Ethiopia with the famine. Was it really that simple? Yes. As the story goes, he wanted to help and decided to bring many well-known musicians together to make a song. He began making calls, asking other people if they would like to help him, and then

he cowrote the song "Do They Know It's Christmas?" It was a huge success, and he raised millions of dollars, was knighted by the Queen, and was nominated for the Nobel Peace Prize.

His story is not unlike Susan's in that after he got an idea, he began calling people. He was not a very famous or wealthy person. When you call people and tell them that you have a project that is raising money for a cause and you need help in a specific way, usually people are very happy to help if they can. It is the opposite of reaching out to someone to ask if they like your art or will exhibit your work, because you are not asking for something that is self-serving like showing your art, and people have an easier time responding positively to a cause. You are asking them if they want to help, in a personal way, with a project you are doing to raise money for a social cause.

THE VISION ARTICULATED
WORKBOOK SECTION 8

Now is the time to develop how you will make money from your work.

1. Write down which category you chose, A, B, C, D, E or F (from workbook section 2). Write the whole name of the category out as you did earlier. Now the trick is to write how much you imagine making this way. You don't have to make a business plan; just decide how much you are going to make and by what date. For example, I will make X amount [dollars or your currency here] by December 20XX, or whatever date you like.

2. Now write down what you will sell to make that money. For example, "I will sell twenty paintings at a cost of X and forty drawings at a cost of X and three sculptures at a cost of X, and I will keep my teaching job which makes X." [insert writing lines]

3. Now write down what you will do to make that happen. Your answer will depend on which category you chose.

4. Put the above three answers into one statement that summarizes it all. This is your plan and I will tell you what to do with it later. It can be changed in the future—most plans are—so don't worry about wanting to change it, just write down a complete plan.

Getting a Solo Show at the Whitney Museum

This is the story of how I got a solo show at the Whitney Museum of American Art simply by asking. And in the end, they called it a "commission by the museum," which sounded even better. The story begins with my wife and I wanting to have a show at the museum. We have always done all our work together, calling our collaboration "Praxis." We felt that we wanted to do something that was on a large scale, was sculptural, and also had video involved.

We discussed many ideas between ourselves and decided we wanted to do an installation where we created large sculptures that created the effect of entering a fantasy space. Our idea was that we wanted people to feel like they were walking into a movie, that is, to imagine walking through a movie screen and entering into that fiction. The idea was not really formed completely, but we wanted to try and secure the show with what we had (an idea).

THE BEGINNING

The first step was to decide who we were going to write to and what we would say. At the time, there was a curator there named Shamim Momin, who is still one of the top curators in the world. We wanted to have a show with her, and though we did not know her, or anyone at the museum for that matter, we decided to make a time to meet someone from the museum. We went to the museum's website and began looking at who was curating there. Of course there were several curators, and we didn't know

any of them. We decided to write to a curator who was new there. The reason we did that is because we thought the likelihood of getting a meeting with the top curator was slim. She is someone everyone wants to meet, and finding another way to her was our strategy.

We emailed the new curator and said quite directly that we wanted to meet her for tea in the museum café. It could have just as easily been done virtually on Zoom or FaceTime. That is our particular method that you can use. First find a curator who is not so busy that they can't have a meeting with you. This could even be someone from the educational department of the museum even, but find somebody who is not famous or very busy. The reason for this is that if they are interested in you, then they will pass your name along to the curator that you do want to talk to, and you are only asking for a ten-minute virtual meeting.

THE MEETING

Getting back to our story, we wrote to the curator of events, who was new, and asked her for a meeting. The reason we always ask for meetings in the museum café is because it makes it very easy and it is hard to say no to—the same goes for a Zoom meeting of ten minutes. The letter was direct and clear, and we asked for a ten-minute meeting over tea. She accepted, and we got a babysitter for our son and went to the museum.

We did not bring a portfolio, a computer, or any images at all. The reason is that when two or more people are looking at images, they are not talking to each other, and in my experience, that is what counts, the talking, the relationship. Typically when an artist shows a curator their work, it is awkward. They look at images, maybe you explain a bit of what you were doing, and the curator says politely, "Thank you, please send me updates of your progress." And that is the kiss of death because it is a conversation ender, and your meeting is over. Instead, be prepared with explanations and questions.

PREPARE FOR THE MEETING

When we had our meeting with the curator, my wife and I prepared our-selves by coming up with three exhibits we would like to have—that is, three different ideas, on different scales. One was small, one was a bit big-ger, and the third idea was huge, and that is the one we wanted to do most with one of the top curators there at the time.

This is a strategy you could adopt no matter what your medium is. If you are a painter, and you want to have an exhibit, think of three different ways to exhibit your work. For example, you could hang one painting only that is large and stands on its own. Your second idea could be to hang three to five paint-ings that are based on a theme, perhaps a theme of color or other elements. Your third idea might be to have a show of twelve paintings that need a room of their own, because they tell a story or are a meditative series or have an idea behind all of them. That is what my wife and I did when we met the curator.

The first thing the curator asked was, "So what are you working on?" We had our answers to that question prepared. We began by saying that there was a small project involving a few new works that we needed a space for.

ASKING THE QUESTION

And when I finished talking about it, I ended by saying, "Do you know of a venue where a show like that would be appropriate?" She paused for a moment and then said, "Oh, you should try X, they are wonderful people there, and this might fit." You see what happened? I did not ask her for a show, I paused, and I asked her if she knew of a venue to show this work. If you do not ask a question, you won't get an answer. Also, by asking her if she knows of a place outside of the museum we are in, I do not back her into a corner, and she can tell me what she knows. This is a very important point because if I had just asked her if I can I have the show here at the Whitney Museum, that would create an awkward situation, because for one, she might not be in a position to give me a show, and two, even if she were, that is a bit too direct and runs the risk of making her feel pressured. On the other hand, to ask her advice opens the door in a comfortable way to any connections she might have.

After she told my wife and me of a few places, we told her about another idea. Now remember, we had thought about all this in advance, and we are not showing her images, just telling her about three ideas for exhibits. Then we move on to tell her about another idea, a larger idea, and ask her the same question after we finish: "Do you know what might be a good venue for that?" She tells us of another place, and I take notes by hand at the table where we are sitting.

THE LAST QUESTION

Then came the very last proposal and question. I told the curator that we wanted to do a large-scale exhibition with sculptures as well as sets that enable the viewer to enter into the space and have an immersive experience. While I was saying all this, I was enthusiastic and excited about what I was saying, and I also kept my thoughts and ideas brief, under three minutes each, usually less. After describing the last idea, which I was most excited about because of the scale and size of it, she knew what I would ask next and said, "Oh, Shamim might like that project, and the museum has a large, six-thousand-square-foot space that could accommodate that." Of course I was thrilled at this suggestion, and I said, "Yes, that sounds perfect," to which she replied, "I could just tell her [Shamim, the curator], or do you want to send me something?" This was an interesting point in the conversation and very telling about how I presented all this. She was saying she had enough information to pass on this idea to another curator without having any more information from me. That meant that my pitch to her was succinct enough that she could remember it. That is one of the keys to getting quick results. Be clear, be compelling, and also make it memorable, ideally. My answer to her was that I would send her an email when I got home about the show that she could pass on to the curator.

FOLLOWING UP

Before I explain what I sent to her when I got home, let's look at the big picture. If I had started right off with something direct, like, "I want to

meet X, can you help me to meet her?" or if I had started right off with the big project, I may not have gotten the results I was after. But by starting small and being brief, I not only worked my way up, but the situation also became more relaxed as we became more comfortable with each other.

When I got home, I wanted to send her something that she would then pass on to the curator I was interested in. Rather than send her links to images or a website or anything else, I sent her a simple text. I made two separate texts. The first I called "Brief Summary of the Praxis Project," and in one paragraph, I described what it was. I wrote that paragraph as if it were a listing in the newspaper. By that, I mean I wrote it in third person and I described it in a way that made it sound like something interesting to go see.

That is the challenge that journalists have when summing up shows for the listing section. How do you make a listing seem compelling enough to make someone want to go there? In this case, I was fairly straightforward and just described it as though it were already happening.

I titled this short text "Brief Summary of Exhibition."

It read like this: "The artistic collaborative of Brainard Carey and Delia Bajo creates a sculptural installation so large you can walk into what feels like a Felliniesque set, complete with sculptural elements and a movie. The result is like a surrealistic amusement park for adults."

That was the brief description. Then below that I added another description that I titled "Extended Summary of Exhibition."

In that summary, I added more details to make it exciting, but never got too specific, partially because it hadn't been done yet, and I wasn't sure what we would do exactly.

THE CURATOR WRITES BACK

After I sent in that email, I got an email back that said the curator wanted to meet me and my wife and talk about what we had planned.

We were extremely excited about this meeting. We knew there would be several people there, the original person we met as well as the main curator we wanted to meet and probably a few assistants. To prepare for the meeting, my wife and I talked about what we wanted to do. However,

we were not exactly sure what we wanted to do yet. We knew it would take much more time than we had until the meeting to plan the show. What we did do was to make one image that we would bring to the meeting. It was a very simple image of the doors that led into the space we might use, and it had the name of the museum above those doors. Then, in a very simplistic way, we printed out an image from a movie, I think it was an old classic with Cary Grant, and I physically cut that image to a size that could be pasted over the picture of the door. The effect was that it looked a bit like the image was projected on the doors. This was not done with Photoshop; it was a real cut-and-paste. The image itself didn't say a lot, but it was the one piece of paper that we brought with us.

THE SECOND MEETING

At the meeting in the museum, we were at a round table with two curators and three assistants. The top curator asked us what it was we were think-ing about. We began saying that we wanted to create a space where peo-ple walked in and were able to step through the sculptures and the effect would be dreamy. We used a lot of adjectives and talked more about the experience of the viewer and less about what we were doing precisely. We showed our eight-by-ten piece of paper with the picture of the museum

If you want a sponsor or patron, you must ASK someone who is rich.

doors and the image pasted on top of it. We explained it would feel like walking through an image, or at least through doors with an image on them. The image was passed around, and everyone commented on it, saying that it looked very interesting. Of course the whole idea was still just being formed, so they were reacting to an idea of what it might be, not any images of the art itself. They didn't see the sculptures we were going to make, and we couldn't provide many more details.

QUESTIONS

Then we were asked a slightly bigger question than we had expected. The top curator said, "Well, what would you like exactly in terms of space and time?"

We hadn't thought about that beforehand, so fairly quickly we just asked for the moon. I said we wanted all six thousand square feet in the space where we were sitting, including the galleries off to the side, and we wanted it all for at least a month. She nodded her head and took notes. We were thanked for coming to the meeting and told that they would be in touch. As of that moment, the show was being considered but was not confirmed by any means. We had three more meetings before we signed a contract for the exhibit. We were asked if we could do the show in two months. We said no, that was too soon to prepare, and they said the only slot after that was a year from then, and we happily said that was the spot we wanted.

Then we spent a year working on the show. When the show finally went up, it was billed as a "commission" by the Whitney Museum, which we liked very much and were surprised by, but we also understood that how a show is publicized by the museum is up to the museum for the most part, not us.

BUDGET

One of the questions we had over the course of several meetings with the curators was how much money the museum would give us for this show.

We knew this was a tricky question because there is not a set amount that artists get in most cases. However, we had a method for finding out exactly what they could offer us. In many cases, the museum will only give you a portion of what you need, even if they are commissioning it. When we were in the group show at the Whitney Biennial, we were given a $400 budget. That was of course very little, so like many artists, we had to do fundraising beyond the show. That meant that if we needed a tent built (and we did), we would ask the company that made it to donate that to us (and they did). There was even an artist in that show (the Biennial) that the museum commissioned to do a huge installation, but the museum would not pay for it. However, because it was a prestigious show, the artist was able to ask sponsors from all kinds of places to help pay for the show, and they did.

Now in the show that I am talking about in this chapter, which was a solo show in a giant space, we had to come up with a budget. This is how we did it and is also how we found out what was the most they could afford.

PREPARING THE BUDGET SHEET

Before we met with the curators and assistants again about our show, we prepared a budget, and since we are visual artists, we made a picture on a piece of 8 ½ x 11 paper with a pen. We drew one big circle on the paper, and then inside that circle we drew several more circles. On the edge of the big circle we wrote "950K," meaning $950,000. We were guessing at an ideal figure but stayed under one million to make it seem very calculated and not too over the top. Now on the inner circles we wrote other amounts that were the numbers that added up to 950K. There was a book we wanted to make, the cost of building it all, and salaries of people to help us. There was one circle that said 22K, and that was titled "Installation Cost." The rest of the costs were mostly for a film we wanted to make of it all.

When we went to the meeting where we were supposed to talk about the budget, we brought our sheet of paper with circles on it outlining the grand budget. As I pointed to the paper (we called it the Octo-budget because there were eight circles on it of different amounts) the first number, 950K,

for the whole production, there were audible gasps. I said, "Don't worry, we can raise some of the money." And then I pointed to the circle that said 22K, and said, "That is what we need to mount the show." Quickly, the top curator said, "We can't give you more than five thousand, that's the most we have." Then the other curator said, "I could probably get five thousand as well." At that, I said, "Very good, we can work with that." And in the end, the museum did give us ten thousand to do the show, which was a lot of money for them, and for us as well.

ASK FOR THE MOON

You see, the method here is to ask for much more money than you might actually need, and when you do that, you will find out what the maximum budget for the museum is. In this case, the most the museum could give was ten thousand dollars. And that is the story of how we got that show and began funding it.

The next part of that show was how we got the additional funding. In this case, we had some great luck through perseverance. Apple donated equipment generously to the show, as did companies like Bose sound and Gibson guitar, to name a few, along with private patrons. I will write more

Don't whine, don't complain, just make art + show it to everyone.

on sponsorship and how we got those companies to get behind this show, but first let's wrap up what happened here.

I began by writing a cold letter to a museum curator and asking for a meeting. At the meeting, after giving three proposals and asking where to exhibit them, I was pointed in the direction I wanted, which was to a top curator. Then, with careful planning, my wife and I were able to talk about the show further, develop a budget, and get the museum to commit to a certain amount of support and a date and time for the show. It is a clear process that you could follow. In the next chapter, I will explain how we got funding for the show.

BIG DREAMS
WORKBOOK SECTION 9

Wouldn't you like to have a big show somewhere? Perhaps at a gallery or a museum? Perhaps even your local café or library? No matter which category you picked, it is time to have a meeting with someone and tell them what your plans are.

You just read the chapter on how I got a solo show at a museum. Now dream a bit.

What is it you would like to ask someone help for? Imagine the conversation: Someone asks you what you are doing these days, and they are in a position to help. What do you tell them? Write down your answer on a separate sheet of paper in five hundred words or less.

However, before you write this, read what you wrote again in section 8. If you need to add something to that statement in section 8, you can always do that. Then write your five hundred words. Keep them lively and interesting. You are writing what will be spoken, so it must sound natural and not forced.

Working with Sponsors and Private Patrons

Isn't this the Holy Grail for artist funding? To have a private patron is the dream of many artists. Or at least they believe it is. It has the ring of what we imagine a trust fund would be like, or the romantic stories we have heard about artists living off the regular patronage of one wealthy donor. The truth is that the relationship of artist to wealthy donor is still alive and well, and it is something that I use to support myself. I will outline how you can create that kind of relationship. Like any other methods, it will take work and dedication, but it can also be fun and very rewarding.

WHO CAN HELP?

First, there is the question of who could possibly help you. Depending on where you live in the world, you have to begin to make a list of people who could be potential patrons. Generally, these are people with an interest in the arts and deep pockets. One of the places to meet them would be at your local museum or art institution. Go to the openings at all museums when possible. Go to opening receptions at any center as well as art-related events. Go to Zoom or other virtual events! Remember who you are looking for: people who don't look like the artist's friends, people who look like they have money!

The way to organize yourself even better is to keep a list with pictures of everyone who might be a potential donor. The way to get that list is to begin thinking about who it is in your area who is interested in the arts and has money. One method that I use and mentioned earlier is to go to

the museum or art centers and find their website and look at the list of donors. There is also a board of directors listed or a group of donors that are the top level. These are the people you want to meet. All the donors to museums are people who could potentially be a patron and help support your work.

Begin by making a list of the people in your area who are donors to the art centers and museums. Search their names on the web and print out a page with their picture on it. Most likely you will be able to find a picture of them on the web, but if not, just print out a page with their names on it and whatever information you have about them, like what museum or institution they are associated with and what social, artistic, or other causes they donate money to. Then go out and talk to them at parties and at openings. OK, for most of you, that is the hard part, talking to people you do not know at openings. Well, I know it is, and I will give you some steps to take here, but you have to be bold and brave. It isn't easy for anyone, but this is how the relationship with a patron gets started.

INTRODUCTIONS WITHIN ZOOM AND OTHER VIRTUAL PUBLIC EVENTS

In the next section I will outline how you can present yourself in a casual and professional way in person. However, Zoom and other virtual meeting software has made it possible to meet these same people even more easily in most cases.

Adapting these techniques to the chat feature in Zoom and other video-conferencing software usually allows you to tag other people in the meeting so that you can actually introduce yourself directly via a public chat or you can comment on what they are also interested in, the lecture or presentation you are both attending. Then after the virtual event is over, you can write an email to the person you heard ask an interesting question, perhaps, and introduce yourself. Thus, a conversation is started.

In person, there are more rules of etiquette.

INTRODUCING YOURSELF IN PERSON

So let's take in-person meetings one step at a time. You have your list of people you want to meet who are potential supporters, and you have printed out their pictures so you recognize them when you see them. Now you are at an opening reception, alone. Don't bring a friend or you are sure not to meet the person you are seeking, or even someone new, because you will be talking to your friend the whole time. Look around at the whole scene. See if you recognize anyone from your research. You may or may not see someone, but look. If you don't see someone you know from your research, then be a detective.

You can tell who is the wealthiest by the clothes they are wearing, their shoes, their watches, and other accessories. Now is the time to be brave; you really have nothing to lose here. If you recognize someone or they just seem like they would be a good patron from their dress and attitude, go up to them, be confident, and hold your head high, extend your hand for a firm handshake, and say, "Hello, my name is X, I'd like to introduce myself." They will shake your hand back, or post pandemic might avoid a handshake (which is OK), and all the while, look at them right in the eye and be confident.

If you act too nervous or skittish, you will make the person you are trying to meet feel the same way. So do your best, and after introducing yourself, if they do not introduce themselves right away, ask them, "May I ask your name?" They will tell you, and then you can begin a brief conversation. Ask them what their favorite work in the show is and listen carefully to what they say. Respond to their words thoughtfully. If they say they do not like a particular work, ask why. Then in the conversation that ensues, offer your own thoughts. Don't make jokes, curse, or say anything negative. Be upbeat and enjoy yourself. They will most likely ask what you do, and that is your opening to say that you are an artist. If they do not ask, then you can say, "I am an artist." And then add your own comment about the show and why you came there.

Don't talk too long because you want to end the conversation gracefully, so take out a business card and hand it to the person you are talking to, with the printed side facing them so they can read it, and say, "I'd like to give you my card." If you don't have a card, by the way, print some now!

You just need your name and email address and either the word "artist" on there or something about your medium. I prefer just having the one word "artist" on mine. Then ask if you can have their business card. They will usually hand it right over to you, but even if they do not, tell them it was nice talking to them and to have a nice evening. Then shake their hand firmly, or simply smile, make good eye contact, and move on to another person the same way. If you didn't get their card, remember their name and write it down a piece of paper. At first you will feel awkward doing this, but after a little practice, you will get better and better, and before long, you will be collecting many cards from people who could be potential patrons of your art.

USING YOUR CONTACTS

The next step is to go home and keep the cards you collected in one place. As soon as you meet someone and get their card, go home and send them an email within twenty-four hours. Even if you don't get their card, remember to look up their names and find a way to send an email to them. You might not find their personal address, but you can probably find a company address for them. Write them a polite email saying that you enjoyed meeting them and that you would like to keep in touch and give them a link to see some of your images. Then keep going to openings; you will see them again, address them by their first name, and ask them how they are and talk again about what you are seeing. This is the way I do it, and it is one of the basic ways to make new friends in a setting like this. After meeting them twice, you can begin to ask them to lunch or tea or a Zoom studio visit and get to know them better and tell them more about who you are. See chapter 3 on presenting yourself for more information on what to do at the lunch meeting or a Zoom meeting.

The idea, of course, is that you are making friends with people who can help you, and the next step is to ask them to help!

If you are doing this all virtually through online meetings and lectures that museums and other institutions put on, by beginning a dialogue via chat and then email to begin a relationship, the next steps can still be

writing a beautiful letter on a gorgeous piece of paper—it is eccentric and it will get noticed.

WRITING A BEAUTIFUL LETTER

Once, when I met a trustee of a museum I wanted to talk to further, I asked her at an opening if I could call her and ask her advice on a new project I was working on, and she said yes. I tried calling her several times and only got her assistant. Then I asked her assistant when the best time to catch her was, and she told me between 7:30 and 8:00 a.m. Since then I have found that the time to get people who have assistants is in the thirty minutes just before the assistant arrives.

I called her back at that time and I said hello and reminded her who I was, and said that I wanted to ask her a quick question about fundraising. I proceeded to ask her how I should go about asking people for money for my artwork. She was very forthcoming. She told me that in her experience, there were several things that were needed for her to give money to an artist for a project.

She said that when artists send her beautiful letters, by mail, she responds. By beautiful letters, she meant that the letter was handwritten on beautiful paper, in a beautiful envelope. And the letter itself was long, chatty, and asking for a specific amount of money. She said that when people send her letters like that, she not only writes back, she saves the letter because it is so beautiful. Now there was something very important that she mentioned about how much money you are asking for in the letter.

Like most people who are involved in the arts and give a significant amount of money to the arts, she has a foundation of her own that administers how the money is given out. That means that you can search online and see what her foundation has given to in the past. She said it was important to her that people knew who she was and what she gave money to and how much she had given. The reason for that, she said, is so that people don't ask her for too much or too little money, but an amount that makes sense. She also said that she doesn't like it when people only write to her for money and don't send her letters in between giving her friendly

updates. And, at the end of our talk, which was about twenty minutes, she said, "When you get the letter done, send me a copy."

SENDING THE LETTER

Then I did much of what she said. I went to the art supply store, and I bought a few pieces of beautiful paper and an envelope to match. Then with a nice pen, I wrote out a letter explaining that I was having a show and that I needed $2,000 to complete the budget. She mailed me a check for $500. Then I sent her a thank-you note, also handwritten. Six months later, I asked her for funding again, in the same manner, and this time she sent a check for $1,000. Every time I asked for more, she gave me about 50 to 75 percent of what I was asking for. The amounts kept increasing. Now I count her as one of my regular patrons who gives me significant sums every year. What I have learned from her is that you have to build a relationship over time.

Sometimes I hear artists saying to me, "I know this person is a millionaire, and they could easily write a check to me for $10,000." That may be true, but that is not how millionaires function, especially those with foundations that have to give in a responsible way.

The way philanthropic giving is done is in small amounts that keep increasing, and the reason for that is so the donor can watch how their funds are being used. Imagine you are a donor; wouldn't you want to make sure that your money is spent wisely? If an artist asks you for $10,000, and she is a person without much money to begin with, how can you be sure it will be spent wisely? They might promise you the world, but the only way to know for sure is to give her a small amount of money first and see what she does with it and how she communicates with you. That is what you can expect from someone you write to that has a foundation, so expect that and ask for a small amount to help you build a relationship.

CHARM

Once I was talking to the avant-garde theater director Richard Foreman, and I was asking him about raising money for different projects. He started

to tell me about the late Jonas Mekas, who was the director and founder of Anthology Film Archives. AFA is a building in New York that is dedicated to showing avant-garde films. It is a nonprofit institution that was founded by an artist with the help of many other people. Mr. Foreman told me that Jonas Mekas was great at talking to wealthy people at parties. He said they used to call him "Saint Jonas" because he was so sweet to everyone, and they loved him. Foreman said Mekas was able to ask many people for large sums of money to support other artists, and they gave it to him. I never learned many more details of this story, but it is clear that part of the way he raised millions to build his institution was to befriend people in a charming manner.

You can start writing a letter today. Think of what you need money for: to complete a painting series, or make a new sculpture, or for the development of some other project or dream you have in mind. Then write it down and get into it, get excited about what you are writing, and express that with enthusiasm so the person you are writing to feels it and comes along for the ride. Then when you send updates, continue the excitement of your accomplishments.

NEGATIVITY KNOCKS

A special note here is to remember not to be too negative or say something desperate, that you need the money because you are broke, even if that's the case. The reason for that is simple; people want to fund your dreams, not pick up the pieces. They want to attach themselves to someone who is flying, not get on a sinking ship.

Put yourself in the position of donor again. If you are about to give a small or even a large donation, you want it to really make a difference, you want the artist to be happy and grateful, and make their art—and you want to hear about it in the future. A relationship is starting.

The last note about writing a beautiful letter is to come up with other ways for the letter to stand out. I often use sealing wax on the back of the envelope and I use a coin to emboss it. It looks beautiful and is one more way your letter is standing out from all the rest that come in. Or consider scenting the letter lightly with perfume!

I also do not usually mail a letter like that with the address on the front as I would with a normal letter. Sometimes I do, but generally I put the letter in a FedEx envelope or in a Priority Mail envelope. That way it is protected and will usually be opened first as well.

KEEPING IN TOUCH

One of the most important things is to keep in touch. If for some reason you have not heard from the person you sent a letter to, then call them up! It is polite and professional to make a call and ask an assistant if they have received your letter. You just need a yes or no. If they have received your letter, then continue to wait for a response. If after two weeks you do not get a response, call again, and if they already told you they received your letter, ask if they know the status on your letter and if it will be reviewed. That is polite, and you will get an answer. After you do get an answer, hopefully with a check inside, be sure to send a beautiful thank-you note back right away.

The note can be brief, but make it very sincere. If you cried out of joy when you got it, tell them. If you began screaming and saying, "Yes, yes, yes!" then tell them. It is OK to be excited; in fact, it is what they want to hear. Just put yourself in their position for a moment. When you give someone a present, what do you want in return? How do you feel when they say, "Thanks, you shouldn't have," as opposed to "Oh my God, I can't believe it! Thank you so much! I love you for this!" Wouldn't you rather have someone gush, even if it is over the top? I know I would, and generally the people you are writing to feel the same way. They want to feel happy, and they want to feel that through you.

Once when a donor sent a letter to me with a check in it, I quickly sent a text to her personal phone that said, "Wow, thank you! Your help has put a tremendous breeze under our wings, and we are soaring because of you!" I also sent her a letter, but since I had her number, I sent a text as well. She wrote back right away and said, "I love hearing that, it sounds beautiful."

APPRECIATION

That is what I do, and it is quite simple and very human. We all want to feel that people appreciate us, and the more we hear it, the better. Can you tell someone too much? I don't think so. If you sent someone a letter every week saying how much you appreciate them in different ways, do you think they would find that annoying? I know I wouldn't. The more we hear that someone appreciates us, the more we want to help that person to keep the gratitude coming. Just like giving presents. When someone has a wonderful reaction to a present we give them, we want to give them more. It is a natural reaction. We all want to be happier and more grateful even if we don't acknowledge it. We want to be more alive and share in the enthusiasm of others; that is why being enthusiastic and grateful to those who support you will take you very, very far.

OFFERING DONORS SOMETHING SPECIAL

One of the first ways I decided to get sponsors for my work shortly after I graduated from college was not by the example above but by asking them to pay for artwork in advance. This is something you could do right now, and it is one of the easiest ways to get funds fast. You can write a letter that begins with "Dear Collector," and send it out to everyone that has ever bought any art from you. Send it out to family members or even friends who you have given your art to, because they are all "collectors" of your art whether they realize it or not. If you can only come up with five or ten people, including family, that's OK; send it to them. When I wrote my letter, I sent it to a few people who had bought my work. I was making abstract monoprints then, about thirty by forty-five inches, on paper. All the prints were in fact originals, much like selling paintings on paper. In the letter, I began as I mentioned above and then quickly explained that I was working on making a series of prints. I also said that I was writing to them so that I could make a large edition of work at a special printmaking studio. I needed funding, and I had an offer I wanted to make them.

This was the offer in my letter:

I explained in the letter that normally my monoprints sell for about $1,000. (I had never actually sold one yet for that amount, but I thought they were worth that!)

Then I said that I wanted to make them a deal if they bought work in advance which would help fund my time at the printmaking workshop in NYC to produce a new series of monoprints.

I explained: If one print is $1,000, then five prints would be $5,000 if you bought them from me directly now.

Here is the deal to help me fund my dream—

For $2,000 now, I will give you $5000 worth of artwork (5 monoprints) and a handmade box worth $200. (I knew where I could get the portfolio boxes custom-made for me, at about that cost.)

I closed the letter by saying I was grateful for their past support and to ask me any questions about this if they have any.

I sent the letter out to fifteen people, and five of them sent me checks for $2,000 each—that was a fast $10,000!

I was offering them a financial deal that seemed to be a very good investment. The actual numbers I put at the end of the letter again so the deal was clear to them, that is, for $2,000 now, you get over $5,000 in art and a custom box shipped to you.

I was thrilled when I got the first $2,000 check. This was the first time I had ever asked for money, and it worked. With that money, it was easy to make the custom boxes, which cost me $1,000 for five, and then I had another $9,000 to make art. That made a lot of art indeed and also paid bills, took me on a short vacation, and more.

EMERGENCY FUNDS

Another way to use this same technique for emergency funding is as follows. Let's say you have a flood in your studio and work got destroyed or damaged, or maybe some other emergency happened, such as a health crisis, or perhaps your landlord raised the rent and you have to move your studio.

You can write a similar letter to the one I described above and explain your situation. Be clear and honest, and you won't have to dramatize anything. Just state the facts of your situation. Then tell them that what you need is help until you get your studio back or your health back, whatever it is. Explain what you would like from them. I would suggest asking for a certain amount, say $500, and tell them that if they give you money now to help you through this crisis, then they can pick out a work from your studio at double the price. So if they give you $500, then they can come to your studio in a month and they will have a credit of $1,000 toward any painting. And if they give you $1,000 now, they will have a credit of $2,000 toward any painting in your studio. This is a very good way to make a bridge for yourself in difficult times. It will allow you to not only move forward but also will begin to create and deepen the relationship you have with your collectors and even family members. Once they give you the money, then you can write to them and tell them how it has helped, what you are doing, and other updates. It may seem like a strange statement, but it is really a gift to be able to have the opportunity to help someone financially.

It is rare that someone asks in a polite and professional way for help. For the person who is being asked, if you know them, it is a chance for them to comfort you, to assist in your creative process, and that in itself is a gift to them. I often give small amounts of money to different projects on Kickstarter, and I am always thrilled by it. Giving money to others who need it has its own special reward for the donor, including a splash of dopamine, which is hard to appreciate unless you try it.

KICKSTARTER

Kickstarter.com is now one of the largest funding platforms for the arts in the world. When you go to Kickstarter, you will see a format that looks very much like YouTube. There are different artists and creative people like inventors, writers, artists, and musicians showcasing their projects on Kickstarter. They make a short video explaining what they want to achieve, like the funds to make a vinyl album of their music or maybe the funds to make the prototype of their invention or some art project about a road trip, a painting series, and anything else you can imagine. Then after you see their pitch in a video, you can pledge money to their project.

The amount can be as little as one dollar. In each category, starting at a dollar, there is a description of what you will get for your donation. It might be a thank-you letter or a postcard or a print, a book, or something else, depending on what the category amount is and your project. If you decide you need $5,000 for a project, then unless you get a total of $5,000 in pledges, you will not get any money, and the donors who pledged money will not give it. That means if you get a total of $4,500 in pledges for your project and it ends after a time of thirty days, you will receive nothing, and the project will be over.

The reason this works so well is that you only get the money that you actually need because if you did get the money before your goal was reached, you would be in danger of not being able to complete a project and disappointing the funders.

Starting a Project on Kickstarter.com or a similar platform

Now what I suggest to get going is not that you begin a project today, but that you begin funding other people's projects, which will give you a clear insight into how it is all done.

If you live in a country that doesn't have Kickstarter, then use your local online funding platform. Otherwise, when you go to Kickstarter .com, start looking around at projects you like. Then pledge a dollar or so to one or two art projects. That is a small amount of money to pledge, but it will serve several purposes.

One, it will show you how people thank you for the pledge. Also, it will show you how the system works financially because you will have to create an account for this.

Most of all, you will have the pleasure I was describing of being a philanthropist for very, very little money! You will see the joys of being thanked and knowing that you are helping a truly good cause.

The amazing thing here is that if you are pledging an amount like a dollar to ten or twenty projects a month, you will find that most of them never get funded. That means that your pledge is never actually taken out of your account because the target for funding was not reached.

So go ahead, explore that website, fund several projects, and you will get the perspective of a donor and the pleasures that come with it. You will also learn what kind of letters you like to see and what kinds of thank-you notes work and which don't. Then you can start your own Kickstarter project. They make it easy and very personal, though not all ideas get accepted. All you have to do is go to the section of the website that says "start your project" and write a brief description of what you would like to do. Once your project is accepted, you can sit back and watch the money roll in—just kidding.

Once your project is accepted, you must tell your friends and begin to promote your project. That means getting the word out there through emails, phone calls, and more. The best way to begin thinking about your project or designing it is to look around the Kickstarter website. Look at the most popular projects, the ones that received the most funding, and look at the projects that didn't get their funding. Then, ready or not, launch your idea into the world.

CORPORATE AND BUSINESS SPONSORS

Asking corporations for sponsorship is one avenue to consider when raising money for a project or a series of paintings, sculptures, or any other art-related work. To begin with, if you are asking a corporate sponsor for a donation of product or money, there has to be something in it for them. That means there has to be some publicity of some kind. If you are asking a company to donate art materials like paint and canvas, then you have to think about how they will get attention for it. You see, the incentive for a company to sponsor or support your activities in some way is to get back what they give you in the form of publicity and good will.

Examples of that might be a class you are teaching where you will tell all the students to use the materials of the company that sponsored you or an exhibit where you expect people to come and see the materials in action. It could also be in a lecture you are giving about your work or something where the company that is sponsoring you is getting attention for their products.

HOW I DID IT

Here are two examples of sponsorship I recently received. The first one is one of the most dramatic, so I will start there. My wife and I were having an exhibit (the one described in chapter 8) and I wanted to use iPhones on the walls to show off videos that were being exhibited among sculptures. I called Apple and tried to find out how to get a donation from them. In general, the place you start is to pick up the phone and call someone. There is no hard-and-fast rule on contacting corporations because most of them do not have policies on sponsorship; it is dealt with on a case-by-case basis.

I called the general number for Apple. I told the person answering the phone that I was an artist having a show and that I was looking for sponsorship and product donation from Apple. They gave me a number to call, which had a recording that said something like, "If you would like Apple to donate to your project, press 1, or if you have a marketing idea for Apple, press 2." I pressed 1 and there was a recording that thanked me for being

interested in a donation from Apple. Then the voice went on to say that Apple does not donate to projects or causes, and that their employees are already involved in community programs that give back to the people who live in their areas. The last thing the message said was that if I had a marketing idea to press 2. I pressed 2 just to see what would happen, and the recording there thanked me for my interest but said they have a marketing company that handles everything for them, and at the moment, they were happy with their marketing plans! It was all very polite, but a dead end nonetheless. I wanted to talk to a person at Apple so they could understand my show and at least say no to me with a real voice and not a recording. For me, when someone says no, it is not always a definite no, they are just sorting out people they think will waste their time because they do not want to spend time looking at proposals they are not interested in.

NOT ACCEPTING NO FOR AN ANSWER

The next way I tried to get to Apple was by calling the local Apple store. I knew at least I would get someone on the phone there. I explained my situation again and said I just wanted someone to talk to, not a recording. They gave me the number of someone in their business department. I called him and explained what I wanted, and he said he had never seen them give products, but it wouldn't hurt to try. So I sent him a very short email that had as the subject line "40 iPhones and an art show." I quickly explained that I was having this cool show and wanted Apple to consider giving me iPhones for it, and phones that didn't need to be able to call, just play video. The letter was brief, to the point, and was filled with enthusiasm. One day later, I got a response that said, "Thank you, we would like to do this, tell us when the show is close." I was stunned. I also wasn't sure I even understood the brief response! But yes, they were giving me the iPhones!

It was such an incredible feeling to be given that much product, which turned out to be a lot of money as well—when I asked Apple if they wanted the phones back, they said no. I owned them now and after the show, I was free to sell them used, which paid for even more of the show!

In general, what you can expect from corporations is that they will usually not answer quickly, or they will say no. Again, there are no rules in asking corporations, so just start calling and asking. It is amazing what can happen. I also wrote to Bose audio equipment and asked for forty pairs of headphones to go along with the iPhones. I had to make many calls to follow up and get an answer, but finally they said yes. Always keep in mind that in your letter, you must explain to them why you need them and, most importantly, why it will get seen by a lot of people. They are looking for exposure and more visibility of their product.

The department at both corporations that I reached was something called "buzz marketing" or "product placement" which is separate from their "marketing" department. Buzz marketing is where they help with some event or exhibition and the company potentially gets social "buzz" or press.

Product placement is similar—when you see Mac laptops and phones in movies and on TV, they are probably giving the filmmaker money or product to have their product in the story, which is helpful for the visibility of their business, even if they are as well known as Apple.

COMMUNICATING
WORKBOOK SECTION 10

If you would like people to support your work, it doesn't matter if you have ever had a gallery show or have had many. It begins with a letter, telling people what you do, and introducing yourself. The idea is to build a support network of family as well as old friends and new friends who enjoy the arts.

It's easier than you think.

In the space below or on a separate sheet of paper, write a letter that tells people in a chatty form what it is you are doing with your art. Tell them what kind of things you are thinking about and where you would like to travel. The idea is to explain how an artist lives and works. You are not asking for money here, you are just telling them who you are and what you have been doing. This letter will be mailed to family and friends as well as anyone who has ever bought any of your artwork. This is the beginning of communicating regularly to people who care about you and your art. It not only helps to define you, but it will also help to sell work in the future and drum up an audience for a show.

For an artist, "marketing" is about developing relationships by letting the world know what you are doing through letters, newsletters, blogging and social media posts. This is also how you develop relationships with potential patrons.

Managing the Press

Every artist wants to receive more press, more reviews from newspapers and magazines and blogs, and why not? It is part of how you get your message out into the world! The first thing you have to know about the press is that they are looking for good stories, not just good art. If you are having a show at a gallery or at a fair or through Zoom or another virtual platform, you can send out a press release to let the press know. There are many resources online to help you write a press release, but it is fairly simple.

You must write the press release as though it were an article already written about your show, in the third person. So you might start out saying something like, "The exhibit of Barrie's work is an arresting show of portraits that evoke emotions and memories of missing children." Begin your press release with a strong first line that will draw the reader in. Then continue the writing and explain why the show is a must-see. End it with the information needed to see the show, the date, time, and address of the opening, and the close date. A public relations person once told me that the press are just like you and me, and make decisions about going out based on what seems exciting to them—personally.

THE JOURNALIST

Put yourself in the position of the journalist who is reading your press release. You read a lot of press releases every day, why should you go to this show? Something has to stick out; something must be special about this event. One way to make it more appealing is to have more things

happening there than just the show, like performers, lectures, food, etc. I get a lot of invitations to shows in which I do not know the artist or the work, and generally, I don't go to them. However, not long ago, I got an announcement about an opening near me that also featured a poetry reading, jugglers, a band, and free ice cream! That sparked my interest, partly because I have a young son. I grabbed my son and went right down there. I looked at the art, had some ice cream, and learned how to juggle!

A journalist reacts the same way; they want to spend their time in the most interesting way possible, just like you and me. So when you are having your exhibit, consider adding something else to the mix to make people notice and want to come. Perhaps all the things I mentioned at the opening I went to, or something edgier, like burlesque dancer(s) or fire eaters or anything else that would make you raise your eyebrows and think, "Wow, that sounds interesting!" If you can get a celebrity there or a popular local band, that will also bring the press in. It doesn't matter if your show is in a local coffeehouse or a gallery. Make it worth going to.

TALKING TO THE PRESS

Once a journalist is there, here are a few tips for talking to the press. To begin with, have in mind what you would like to say. What is the show about? What would you like people to know? Who influences your work? Why do you make art? Be prepared, because those are some of the questions that the journalist will ask you. When speaking to the journalist on camera or audio only, remember to do the following: When asked a question, pause, repeat the question, and then answer it. For example, let's say the question is about what the work means, its message.

Start by pausing and say, "Let me tell what this work means . . ." or "When people ask me what my work is about, I say . . . " The reason you are repeating the question and pausing is so that the journalist can use your voice only when the piece is edited. It is much better sounding that way and easier for the journalist to use, as you are creating what is known as a good "sound bite"

Another tip to keep in mind is what to do when the journalist asks you a question you do not want to answer or will have difficulty answering. The easiest way to manage that situation is to say, "That reminds me of an important aspect of my work, which is . . . " and then tell them a story that you want to tell, ignoring their question entirely. You can always lead the journalist away from the question they asked by confidently starting another topic.

RELAX

It is also important to be patient with the press. If a journalist makes an appointment to see you and then cancels at the last minute, be patient. Write to them and ask what happened. I can't tell you how common it is for a journalist to say they will show up only to be distracted by another story or event. It is easy to be angry at this, at someone wasting your time in this manner, but if you react with politeness and consistency, you will get far. That is my experience, and I have dealt with it many times. We are all sensitive people, and even when I am irritated, I continue to pursue the journalist to reschedule our meeting. I have always found that when you do this, and get the meeting eventually, the person interviewing you is apologetic for the delays and your patience and makes it up by doing a very good job and giving you more than they might have previously.

DELIVERING THE PRESS RELEASE

There are many ways to deliver a press release through email or online services. However, when you want to get press in your local area, even if it is a big city like New York, I would consider hand-delivering it to the newspaper departments you are interested in, if possible. That is what I have done, and it is very effective. There is nothing like getting a physical press release in an envelope handed to you if you are a journalist because it is rare. Sometimes, you will even be asked a question or two right there about what it is, and you can explain it is an art opening. Of course, emailing it and regular mailing is fine as well. In general, you are looking for

ways to stand out from the crowd of press releases pouring in. You can hire people online through sites like Fiverr and Upwork to send out press releases to a huge press email list for a small cost, and perhaps you should, but local journalists will like the email or letter coming from you directly.

YOUR PRESS RELEASE
WORKBOOK SECTION 11

To begin writing a press release, which is really just an announcement of an exhibit, first you need to take some notes. In this exercise, we will get down an idea. Once you have the notes, you can begin to assemble it into a piece of prose that reads like an article already written.

If you have an exhibit of your work at a virtual show and the opening is on Zoom, or a gallery, a library, a café, or an apartment, you can send out a press release for your show.

To write a press release, which is an announcement to the media, you will need to have the following information: What is the name of this event or show? What is happening there? Who are you? Why is this something of interest? What are the exact time and date of the show?

Write down those things here. If you do not have a show coming up, then make one up and still write the notes for it.

Here are a few samples of press releases sent from galleries and a museum to promote their artists. These are taken from some of the best galleries, so this is how a top PR firm writes. Many times in galleries, the artist's statement and the press release are very similar. Read these and then write your own. This first press release is from Pace University in NYC which has a gallery (Pace University Art Gallery). Note the title and the fact that this is during the pandemic so it is seen by appointment or through the street level windows.

Press Release: Brooklyn Printmaker Simonette Quamina Seeks to Transcend Memory in Her Solo Exhibit, The Night Gardener

New York (November 2020)—Pace University Art Gallery is pleased to present *The Night Gardener*, the first solo exhibition in New York by Brooklyn-based printmaker Simonette Quamina. The exhibit will be open for in-gallery viewing appointments through November 24, 2020 at the

41 Park Row location. Street-level window viewing will continue through January 17, 2021.

The inspiration for Quamina's new body of work in *The Night Gardener* exhibit came from one of her frequent late-night writings, "I left my story at the side of the road, carefully tucked away in a green glass bottle of hope." Quamina's artworks collectively function as a bildungsroman, a coming of age story told in layered black and white flashbacks to her childhood moving between Canada, Guyana, St. Vincent, and the United States.

She states: "They are narratives that re-evaluate perceptions of cultural, racial and social norms, while simultaneously challenging preconceived, romanticized ideas of the Caribbean."

Figures and places are literally and metaphorically pieced together and superimposed as the artist, perhaps entirely, reconstructs past events in her large-scale collages made of her graphite prints, drawings, and matrices.

Describing her strictly grayscale work, Quamina states, "I've currently limited my color palette as a means of fully exploring the materiality of graphite and its ability to reflect, absorb and transcend the idea of memory." Although she exclusively uses one medium, she employs the graphite in many forms—solid, powder, wet—each marking multiple possible evolutions from past to present and place to place. Quamina's neo-diaspora experiences in assimilating to many new countries directly informs the way in which she uses traditional materials and methods to merge complex narratives.

The Night Gardener exhibit is free and open to both the Pace community and the public. The interior exhibit is on view by appointment through November 24, 2020. It may also be viewed 24 hours/day via the street level windows through January 17, 2021. For additional information or to make a viewing appointment, please contact Sarah Cunningham, Art Gallery Director, at scunningham@pace .edu or (212) 346–1733.

About the Artist: Simonette Quamina was born in Ontario, Canada, and spent her early childhood living between South America, the Caribbean, and New York City. Her diverse upbringing is constantly woven into the narratives of her large-scale drawings, prints, and collages. She earned her Bachelor of Arts from the City College of New York and a Master of Fine Arts in Printmaking from the Rhode Island School of Design. She is the recipient of the Elizabeth Foundation for the Arts Studio Program in New York City, the recipient of the 2017–2018 Provincetown Fine Arts Works Center Residency and the 2017 Salem Art Works Fellowship as well as a current 2020 Queen Sonja Print Award nominee. Her work has shown both nationally and internationally. It has been acquired for private and public collections, including the Fleet Library's special collections. Her recent group exhibitions include *Embody* at The Mandeville Gallery, *Figuring the Floral* at Wave Hill Glyndor Gallery, *Artist I steal from* at Gallerie Thaddaeus Ropac in London, *Coded* at the Boston Center of the Arts, Mills Gallery, and *Bathing* at Planthouse Gallery in New York City. She maintains an active studio in New York City and is an Assistant Professor of Printmaking at the Massachusetts College of Art and Design.

About the Art Gallery at Pace University: Founded with the conviction that art is integral to society, the Art Gallery at Pace University is a creative laboratory and exhibition space that supports innovation and exploration for both artists and viewers. Open to students, staff, and faculty from across the Pace campuses and, equally, to the Lower Manhattan community and visitors from around the world, the Art Gallery encourages personal investigation and critical dialogue via thought-provoking contemporary art exhibits and public programming. Enhancing the Art Department's BA and BFA programs, the Art Gallery offers students real-world opportunities to exhibit their own art

and to work directly with professional artists to install and promote exhibitions.

Images Attached: Untitled, *Mr. Farrell's Plumrose Tree*

Here is a fairly unconventional but high-end gallery press release from a gallery before the pandemic but using a form that you could also adopt, starting with something like a poem.:

MARY BOONE GALLERY
745 FIFTH AVENUE NEW YORK, NY 10151. (phone number here) MIKA ROTTENBERG

Mary Boone Gallery, in conjunction with Nicole Klagsbrun Gallery, is pleased to present Squeeze, a new 20 minute video installation by MIKA ROTTENBERG.
Squeeze heavy mass
magnetic force friction
a crack a squeak
twinkling stars electromagnetic fields a buzzzzz
tongue flickers fountain squirts space expands
pressure applied to Rose's cheeks Redness extracted
Iceberg Lettuce Pure Latex Cream pressure at its max
moist butts bouncing ponytails
two holes align ice crackles
temperature declines
space shrinks back to first position
shrinks, back to first position. Ingredients willed in, first layer is laid.
Mika Rottenberg's latest work Squeeze continues the artist's inquiry into the mechanisms by which value is generated, considering the logistics of global outsourcing and the alchemy of art production. Through movie-magic portals, Rottenberg links video of her Harlem studio stage set to on-location footage of an iceberg lettuce farm in Arizona and a rubber plant in Kerala, India. This composite factory toils ceaselessly to create a single precious

object, one small sculpture. The video is presented in a custom-made theater.

The sculpture is inaccessible—preserved offshore, out of reach for public or private viewing.

Squeeze is an architectural portrait of crisscrossing assembly lines: a multidirectional labyrinth that spins energy within a closed circuit. The central protagonist— the product around which all the work takes place—is only revealed through its raw ingredients. In the continuous video loop, the manufacturing process is never completed, remaining in constant flux. The video narrates a step-by-step choreography of rooms and mechanisms, bodies and landscapes, laboring hands, feet, tongues and buttocks requiring pampering and maintenance. Interior spaces are penetrated by the eruptions of "foreign elements" from the exterior. As these various components of the factory "make effort" they also seem to move purely for the sake of motion.

Squeeze was shot by Mahyad Tousi, set engineering and special effects by Katrin Altekamp and Quentin Conybeare; acoustic consultation by Steve Hamilton; production by Andrew Fierberg.

Mika Rottenberg was born in Buenos Aires in 1976, and holds a BFA from the School of Visual Arts (2000) and an MFA from Columbia University (2004). She lives and works in New York.

The exhibition is at Mary Boone Gallery, 541 West 24 Street, in Chelsea. For further information, please contact Ron Warren at the Gallery, or visit our website: www.mary boonegallery.com.

Another press release by an arts association with a program that is mostly by Zoom:

FOR IMMEDIATE RELEASE: NOVEMBER 2020
ASIA WEEK NEW YORK 'LIVE' ZOOMS-IN ON *TALES OF CONSERVATION, SCIENCE, AND ASIAN ART* ON NOVEMBER 18 AT 5PM EST

New York: Asia Week New York is pleased to announce that *Tales in Conservation: The Application of Science to Asian Art*–a live panel discussion featuring world renowned experts–will be held on Thursday, November 18 at 5:00 p.m. EST, 2:00 p.m. PST. This is a one-time opportunity to hear these speakers address issues that are important to collectors.

"Science and conservation are inextricably aligned in the field of Asian art and Asia Week New York is thrilled to bring together this highly qualified group of people to offer their compelling stories and perspectives on the subject," says Dessa Goddard, U.S. Head, Asian Art Group, Bonhams, and member of the Asia Week New York Planning Committee.

The participants include Leslie Gat, from the Art Conservation Group, Asian and Tribal art dealer Thomas Murray, of his eponymous California gallery, Mary Ann Rogers, founder of Kaikodo LLC, which specializes in Chinese, Japanese and Korean Art, and John Twilley, the highly acclaimed art conservation scientist. Each special-ist will discuss specific approaches and scientific tech-niques in the conservation of ancient objects including gilt bronzes and Indian textiles. Dessa Goddard will moderate the discussion.

About Asia Week New York
The collaboration of top-tier international Asian art gal-leries, the six major auction houses, Bonhams, Christie's, Doyle, Heritage Auctions, iGavel, and Sotheby's, and numerous museums and Asian cultural institutions, Asia Week New York is a week-long celebration filled with a non-stop schedule of simultaneous gallery open houses, Asian art auctions as well as numerous museum

exhibitions, lectures, and special events. Participants from Great Britain, India, Italy, Japan, and the United States unveil an extraordinary array of museum-quality treasures from China, India, the Himalayas, Southeast Asia, Tibet, Nepal, Japan, and Korea.

Asia Week New York Association, Inc. is a 501(c)(6) non-profit trade membership organization registered with the state of New York. For more information visit www .AsiaWeekNewYork.com @asiaweekny #asiaweekny

One last press release from a gallery representing an artist who is no longer living:

Noah Davis
Press Release
Location
David Zwirner
525 & 533 West 19th Street, New York
Dates
January 16—February 22, 2020
David Zwirner is pleased to present work by American artist Noah Davis (1983–2015), organized by Helen Molesworth. On view at the gallery's 525 & 533 West 19th Street locations in New York, the exhibition will provide an overview of Davis's brief but expansive career.

Davis's body of work encompasses, on the one hand, his lush, sensual, figurative paintings and, on the other, an ambitious institutional project called The Underground Museum, a black-owned-and-operated art space dedicated to the exhibition of museum-quality art in a culturally underserved African American and Latinx neighborhood in Los Angeles. The works on view will highlight both parts of Davis's oeuvre, featuring more than twenty of his most enduring paintings, as well as models of previous exhibitions curated by Davis at The Underground Museum. The exhibition also includes a "back room," modeled on the working offices at The Underground Museum, featuring

more paintings by Davis, as well as *BLKNWS* by Davis's brother Kahlil Joseph; a sculpture by Karon Davis, the artist's widow; and Shelby George furniture, designed by Davis's mother Faith Childs-Davis.

Helen Molesworth notes:

Noah Davis (b. Seattle, 1983; d. Ojai, California, 2015) was a figurative painter and cofounder of The Underground Museum (UM) in Los Angeles. Despite his untimely death at the age of thirty-two, Davis's paintings are a crucial part of the rise of figurative and representational painting in the first two decades of the twenty-first century.

Loneliness and tenderness suffuse his rigorously composed paintings, as do traces of his abiding interest in artists such as Marlene Dumas, Kerry James Marshall, Fairfield Porter, and Luc Tuymans. Davis's pictures can be slightly deceptive; they are modest in scale yet emotionally ambitious. Using a notably dry paint application and a moody palette of blues, purples, and greens, his work falls into two loose categories: There are scenes from everyday life, such as a portrait of his young son, a soldier returning from war, or a housing project designed by famed modernist architect Paul Williams. And there are paintings that traffic in magical realism, surreal images that depict the world both seen and unseen, where the presence of ancestors, ghosts, and fantasy are everywhere apparent.

Generous, curious, and energetic, Davis founded, along with his wife, the sculptor Karon Davis, The Underground Museum, an artist- and family-run space for art and culture in Los Angeles. The UM began modestly—Noah and Karon worked to join three storefronts in the city's Arlington Heights neighborhood. Davis's dream was to exhibit "museum-quality" art in a working-class black and Latinx neighborhood. In the early days of The UM, Davis was unable to secure museum loans, so he organized exhibitions of his work alongside that of his friends and family, and word of mouth spread about Davis's unique curatorial gestures.

In 2014 Davis began organizing exhibitions using works selected from The Museum of Contemporary Art's collection as his starting point. In the aftermath of Davis's passing, the team of family and friends he gathered continued his work at The UM, transforming it into one of the liveliest and most important gathering places in Los Angeles for artists, filmmakers, musicians, writers, and activists.

A select portion of the exhibition will travel to The Underground Museum, where it will be on view beginning in March, 2020. On the occasion of the exhibition, a new monograph, featuring an introduction by Molesworth and oral history interviews that she conducted with Davis's friends, family, and colleagues, is forthcoming from David Zwirner Books and The Underground Museum.

Born in Seattle, Washington, *Noah Davis* (1983–2015) studied painting at The Cooper Union School of Art in New York before moving to Los Angeles, where, in 2012, he founded The Underground Museum in the city's Arlington Heights neighborhood with his wife and fellow artist, Karon Davis.

Davis's work has been the subject of solo exhibitions at Roberts & Tilton, Culver City, California (2008, 2010, and 2013); Tilton Gallery, New York (2009 and 2011); PAPILLION, Los Angeles (2014); and the Rebuild Foundation, Chicago (2016), among others. *Noah Davis: Imitation of Wealth* opened at The Underground Museum on the same day as the artist's untimely death at age 32, due to complications from a rare cancer, in 2015. In 2016, Frye Art Museum, Seattle, presented the two-person exhibition *Young Blood: Noah Davis, Kahlil Joseph, The Underground Museum*—the first large-scale museum show to explore Davis's work alongside that of his brother.

The artist was featured in the landmark exhibition *30 Americans*, which was organized by the Rubell Family Collection, Miami, and traveled extensively throughout the United States from 2008 to the present (the exhibition is currently on view at The Barnes Foundation, Philadelphia

through January 12, 2020, and subsequently travels to the Honolulu Museum of Art, the Albuquerque Museum, and the Columbia Museum of Art, South Carolina in 2020–2021). Davis's work has been included in other notable group exhibitions, including ones held at the Santa Barbara Museum of Art, California (2010); The Studio Museum in Harlem, New York (2012 and 2015); Carnegie Museum of Art, Pittsburgh (2017); and the Massachusetts Museum of Contemporary Art (MASS MoCA), North Adams (2018).

Davis was the recipient of the Los Angeles County Museum of Art's 2013 Art Here and Now (AHAN): Studio Forum award. Works by the artist are included in the permanent collections of numerous institutions, including the Hammer Museum, Los Angeles; Los Angeles County Museum of Art; The Museum of Contemporary Art, Los Angeles; Nasher Museum of Art at Duke University, Durham, North Carolina; Rubell Family Collection, Miami; San Francisco Museum of Art; and The Studio Museum in Harlem, New York.

Helen Molesworth is a Los Angeles–based writer and curator. While chief curator at the Museum of Contemporary Art, Los Angeles from 2014 to 2018, she forged a partnership with The Underground Museum and organized the exhibitions *Kahlil Joseph: Double Consciousness* and *Noah Davis: Imitation of Wealth*. She is currently curator-in-residence at the Anderson Ranch Arts Center, Snowmass Village, Colorado.

For all press inquiries, contact
First and last name, phone number, email address.
Image: Noah Davis, *Untitled*, 2015 (detail). © The Estate of Noah Davis. Courtesy The Estate of Noah Davis
Download Press Release (link to download it)

International Recognition

The art world has gone online since the pandemic, and it will remain there indefinitely, it seems.

Of course there will be exhibitions and public art, but virtual exhibitions, walk-throughs, and panel discussions via Zoom and FaceTime are here to stay.

To be part of the global conversation, the global market, you are now using videoconferencing and presenting through Zoom and other platforms. All the biennials, art fairs, and public works have adapted to virtual and remote residencies, as well as exhibitions and group conversations.

No matter where you are in your art career, the idea of international recognition might be important to you. Some artists tend to exhibit only in their own country, or very locally, and that is fine, of course, but the art world is an international dialogue, an international showcase.

This is evidenced by biennials that now are in almost every country on the planet, as well as the art fairs like Art Basel that we see traveling the globe. To be in an art biennial or a good international art fair like Art Basel are two ways to get major international recognition.

However, I want to strongly caution against ever—and I mean *ever*—paying for these opportunities. Do not pay to be in a biennial or an art fair. Even if it is Venice or Florence, do not pay for these, please. Biennials are nonprofit ventures, nothing is sold there, and you should not pay a fee to exhibit. It is the responsibility of the biennial to invite you and pay for your expenses.

I was invited to a biennial in Ljubljana, Slovenia, and they paid for my air tickets and room, and gave me a daily "per diem" which was about $50 per day of spending money. I came back from there without a profit at all, but I did not spend money to be part of that biennial.

Same with an art fair. Even since the Art Basel Fair became popular, some satellite fairs keep popping up all around it, like Scope, Pulse, etc. There have also been people charging artists to show in a lobby of a hotel or a hastily constructed fair near the main Art Basel fair. Please do not pay to be in those, because you will not sell art in a fair where you are being charged for a booth or wall space—or at least it is extremely unlikely.

If you have a gallery, they should invite you to have work in the fair— the gallery pays all the expenses of shipping, because they are getting 50 percent of your sales, so that is how the money should work there.

For international recognition, here is the essential pattern:

The nonprofit half of the equation is items 1, 2, 3, and 4 and the for-profit elements are 5 and 6.

1. Apply to nonprofit residencies, and you will get into some. Often the residency itself will pay for travel and living expenses and you will meet curators and artists there while you work on your own art in your own studio. This is an extremely important step for artists anywhere in the world. It is literally one of the most vibrant places of gathering for the international art community. You will see the language and the tone of the international conversation, and you will also see the people who can connect you to more residencies and even biennials. You can find opportunities using a website like rivet.es.

2. Visit international biennials online and in person when possible to see what art they are showing and how they talk about it and also keep track of what curators are putting on the shows, because if you relate to some of the work, these are curators you could pursue at a later time. If you can apply to the biennial in the future, then do so.

3. Apply for grants (if you want and need them) because when you receive an international grant, that fact alone travels in international circles and helps your recognition on a global scale.

4. Apply to nonprofit shows and even "artist-run" spaces because these spaces are not selling work, they are presenting it for educational purposes and this is often where commercial gallerists can "discover" you. (But never pay—*no* pay-to-play schemes, ever.)

5. Work with a good commercial gallery, because then your work can be sold to collectors who have other great work and it will boost your profile among collectors.

6. Take on commissions or other "commercial" work to support your career.

Those are the main elements of getting international recognition, that is, the attention of the global art community of collectors and curators.

To clarify the reasons why noncommercial as well as commercial activity is very important, let me explain how they operate together. If you are in a biennial, say, and have a gallery, then the biennial will generate attention for you (not sales) while the gallery will probably have an increase of sales because you are in a biennial. Without the biennial, the gallery alone might sell, but not as much and not to the global community.

The same applies to residencies. You will meet important curators at these residencies, even by Zoom, and that in turn can lead to a commercial gallery representing and selling your work, because independent curators that are part of a residency usually also work with galleries.

Finally, the last "commercial" idea is to use your artistic abilities in service of another income stream. That could mean painting portraits, for example, or doing interior murals.

I know an artist who supports an art career that is often politically charged in approach, and so her portraits generate an income stream so that she can keep pursuing her main studio work which often gets exhibited but does not sell as well, or at least not consistently.

If you are a photographer, you have many options for commercial work outside your practice and if you are a sculptor or filmmaker, again, you have the possibility of doing small commissioned projects for people. Don't think for a moment this can hurt your other "studio practice" because, just like a teaching job, it will instead support it.

How the Living Organize Their Estates

While this may sound like a morbid topic, which I suppose it is in some ways, it is also a topic that is not just about what happens to all of your work after you die, but is also about how you manage your work while you are living. How you organize your work and prepare, not for an eventual death, but for every day. Some Buddhist monks go to bed saying a prayer that they are thankful for the day, and if this is their last day, they are prepared to die in their sleep. The idea of this is interesting. They are preparing for death each day by having their things in order. Can you imagine that? Having everything in order so that if you died the next day, all your belongings and work will have its proper place? When I first heard of that, I thought it sounded terribly death-centered on a daily basis! However, it has another aspect to it, which is that you must be very organized to do this and very aware of what happens to your affairs after you die. I am writing this chapter not only to help you get organized, but also to do the responsible thing for those left behind. We may think of death as something far off, but we also know it could happen tomorrow, so it is not just for your legacy, it is also for those you care about so they will have an easy time dealing with your art the way you intended.

VIVIEN MAIER'S STORY

Even if you don't want to work too much on this, at the very least your work should be organized and properly labeled. Let's look at the unusual example of Vivian Maier, the photographer I mentioned in the introduction.

The story is that a young real estate agent bought a box of negatives from an unknown photographer at an auction for $400. There were thirty thousand negatives in the boxes he bought. He eventually bought all the work he could, about one hundred thousand negatives in all. But there was more! Her cameras, small Super 8 films, and audiocassettes, as well as some clothing. These were all the things in her room, as well as some in storage. Almost everything was labeled with the date and where it was photographed. There were boxes and boxes of her images and related letters. She was putting them all in storage. She never showed these images to anyone as far as the owner of the negatives knows. The story of what he did next is fascinating. He posted some of the images online and got publishing offers as well as a movie offer. He created a project on Kickstarter and raised over $20,000 in less than two months to make a film about her life. I mention all of this because if her work was not in some kind of order and organized, it would not be possible for him to make the film and book he is making. Vivian Maier also was homeless for a time, and because all of this was in storage, her work survived. In many ways, her story is very sad because she never got to exhibit her work or know that a book and film were being made. However, they have been made, after her death, and besides it being a case of good luck, that is, being found by the right person, it is also a case of an artist taking care of her work.

STEPS TO TAKE NOW

Hopefully you will get recognition at an earlier stage of your career than Maier did, but nevertheless, she sets the example for the minimal amount of organizing that is necessary to preserve your work and make it easier for others to enjoy it and share it. First step: to begin with, start labeling your work and photographing it. If you are a photographer, begin scanning your images, if they are in film format. If you are a photographer who shoots digital images, then make digital folders and organize them by the year. If you are a painter, sculptor, or installation artist or work in mixed media of some kind, documentation is essential. Begin today by committing yourself to documenting your work with a camera. Ideally,

you should have a professional photographer do it, one who specializes in taking images of art. I can't overstate the importance of a professional photographer.

USING A PROFESSIONAL PHOTOGRAPHER

Throughout my career as an artist, I have had friends who were great photographers, the kind who exhibited regularly and went to school for photography, but unfortunately, none of them could document art very well. That may seem strange, but it isn't, because getting a good image of artwork is a talent all its own. Once I was working with an artist who was quite wealthy, owned several businesses, and he wanted to document his paintings and even reproduce some of them with the digital images of the work. Rather than hire a professional photographer, he used his assistant. I warned him against this, but he responded with logic, saying that he had bought the best camera for this; he had also bought light stands and had plenty of time to do this with his assistant. He also said that it is a fairly simple process in that all you have to do is bracket the images, meaning take several shots of each at different exposures to get the right one.

His assistant, who also happened to be a photographer, began taking the images according to his instructions, which seemed to make sense

from a technical point of view. After the assistant shot about ten images over the course of a day, the artist began to look over them. He was very frustrated by what he saw because for some reason, the colors weren't right in any of them! So the artist spent more time working on the images with Photoshop until he got the image he wanted. The Photoshop work took him hours, and he was unhappy about that. However, he was a consummate entrepreneur and felt that he could figure this out, so he continued to work with the assistant, who he was paying $20 an hour.

After another week of him getting frustrated and spending hours on Photoshop, not to mention having hundreds of images of his work that he was having a hard time sorting out, he gave up. He hired a photographer who was more expensive but did the job perfectly the first time. That was a very expensive learning experience for him when you count up the equipment plus the assistant's time and the artist's time on Photoshop. What happened? Honestly, it is hard to say what happened here. It seems to defy logic, but in my experience, I have encountered the same thing. So take heed and hire a professional if you want the best images of your work. Find someone who has taken images of artists' works in the past and look at the work yourself.

THE NEXT STEP

The second step is to label and organize your images. It is not enough to keep them all in digital format. In fact it is dangerous. More and more we rely on web storage like Google, but it is unreliable for a few reasons. The main reason is that when you stop paying storage fees on most sites, your images will disappear. Also, no one knows when an online business can go bust, also resulting in lost images, forever. Maybe you are thinking you can store them on your own hard drive? Hard drives are built to fail, though solid state drives last much longer. For people who must store data on hard drives, you must duplicate excessively. For example, I know an audiophile who has thousands of hours of music as well as video, all in a digital format. What he does, knowing his big expensive multiterabyte drives will fail one day, is to make more than one copy. That means the

contents of one giant drive are duplicated on not one, but two more drives. He also burns DVDs of everything, which is another medium that has a short life expectancy. DVDs may last one hundred years, but right now, no one knows, and it's safe to say they are not safe! As we know, one scratch and the material is gone.

THE ANSWER IS TO USE HARD PRINTS OF YOUR IMAGES WHEN POSSIBLE

The third step is to get a filing cabinet that is fireproof. Put it in your apartment or storage unit. Use file folders that are acid-free and, starting with the current year, make a folder for each month. In the folder, put images of your work, printed out in as nice a format as you can afford. At the least print out documentation of your work on 8 x 10 photo paper from your inkjet printer. On the back of each print, make a label that has the following information on it: the title of the work, the date it was completed, where it was completed, the size, where it is located or stored, and any other notes you want to add. If that seems like too much information for a label, then on the label, make a reference to a separate document that has all the information and notes. That separate document is a letter-size piece of paper that is also in the folder and is typed neatly with your name and address on it, as well as a note saying this is referenced from a folder of a certain date and day. If you have too many images or material for one month, then make a second folder for that month and put a section in your file cabinet for that month. Start with the current month so you don't get overwhelmed, and move forward from there.

CREATING A NEW HABIT

The fourth step is to make this process a habit. At the end of every week, set a time in your calendar to document your work and put it in a folder. If you don't have a great photo of your work, that is OK for now; just take one with your own camera and put it in the file. When you get a chance to have the work photographed professionally, you can always replace or

supplement your image at a later date. That is the way for your work to be archived, and after you are doing this for a while, you can begin to archive work from past years. You may not be able to do it as methodically as you are doing the present work, so if you find a work of art from the past, just determine the date it was made. You can approximate the date if you don't remember and then put it in a folder, and as they accumulate for that year, you will have a whole new section.

CONTACT A LAWYER

The fifth step is to think about what you would like to happen to all of this if you are not here anymore. This is maybe the hardest step, but one of the most important because if all your work is archived perfectly, but no one knows, it will probably be thrown out or sold at some point. The idea is to make a living will, which you can do with a lawyer who can advise you on more details of it. A simple version of it would be to make a video recording of yourself speaking and also a handwritten document that is notarized and put it in a safe-deposit box at your bank. Most people don't take this step, but it is really a generous thing to do, and this is why. When you leave loved ones behind, grieving, they have to do all kinds of things for you, and the easier you can make it for them, the better. It is a way to comfort them and make them feel confident in the choices they are making. If you are not sure what you want done with your work, you can say that, as well as give a few options; it is up to you, but this step, although it is a courageous and difficult one to make, will also help you sleep better, just like the monks, knowing your things are in order. These are my thoughts on organizing yourself this way, but for living wills, it is best to contact a lawyer who can guide you through the proper steps.

CALL A LAWYER
WORKBOOK SECTION 12

It's time to organize your estate.

No one thinks they are ready for this step, but it is simply about having your artwork organized so that it might be handled appropriately if you die, or at least your wish will be recorded.

1. In this section below, write down what artwork of yours you will document with photos this month. If you have not made work this month, then write down the last five pieces of work you have made.

2. Now make labels or separate sheets of paper with information about the work made and put it together with an image of the work in a folder with a date on it. (This should be a real folder that goes in a filing cabinet.)
3. Repeat steps 1 and 2 once a week or more, depending on how often you produce work.
4. Call a lawyer when you are ready to make a will.

The Attitude

As I am sure you know, your attitude plays a crucial role in how you use this book and how you make it in the art world.

On one level, it is simplistic. When you are feeling good, it tends to rub off on others, and the opposite, of course, is also true. When you are enthusiastic about your work, your life, and the latest thing you are working on, those around you share that enthusiasm, and it can only work to your benefit.

The trick is figuring out how to maintain that level of feeling good every day, or at least on most days. For artists of all types, I think that one of the biggest issues is to work on your career on a regular basis. If you are using the time management techniques in here and are spending at least thirty minutes a day, four days a week on the work that it takes to get your art seen in the world, it will have a profound and positive effect on your career. By committing yourself to such a schedule, you are also telling yourself that you are in control of your life and that you are working toward a goal. That in itself will not only put a smile on your face and some self-assurance in your step, but will also prevent the feeling of being unsure about the next steps you are taking.

We all have to find the path that fits us, and it seems to be different for everyone, but a consistent curiosity helps.

I have become very interested in Alchemy and Mysticism as a way to discover and support my own inner path and psychic struggles which are often connected with external turmoil. It has also become an integral part of my art and a way of self-studying.

HEALTH

Another aspect to consider is your general health. While this may seem obvious, artists operate under certain myths about partying. Drinking alcohol and doing any kind of drugs will not help in giving you access to the art world of your dreams. I am not saying that you should never drink alcohol or go to a party, but I am saying it would help to be conscientious about it. At openings for galleries, it is not helpful to drink the alcohol unless you do it very sparingly. When you are in control and aware of what is happening, you have the ability to really make things happen. Sincere enthusiasm is catchy, but slightly drunk enthusiasm is viewed suspiciously. Wouldn't you view it the same way? There are artists that have been notorious party animals, but it is often to their detriment, either healthwise or in terms of their career. It is just easier to function and be ambitious when you are feeling healthy. It is very easy for artists to get involved in addictions to drugs, alcohol, cigarettes, food, sex, or something else, because to be an artist, you have to create your own structure, and since most don't create that structure, they are in an environment that is unstructured and vulnerable to doubt. General well-being is also an important contributor to your attitude. Again, this may be obvious, but if you don't practice it, it will not help you. To be healthy, really healthy, you need to do some

kind of vigorous exercise every day. That could be walking at a quick pace for thirty minutes or working out at the gym or something similar, but it means sticking to a schedule.

EATING HABITS

How you eat is another step, and a major one in my experience, of controlling your mood and attitude. I became a raw foodist at one point, meaning that I only ate salads, more or less. I didn't cook anything; I ate plenty of fruits, nuts, and lots of greens with avocados and tomatoes and other delicious vegetables. I did not eat bread or grains of any kind. I also started to fast once a week.

The way I fasted was to drink only distilled water for an entire day. I would fast every Sunday and eat raw food for the rest of the week. That in itself changed my life. The first big show I had at the Whitney Biennial came when I was a raw foodist. There is an incredible feeling to seeing quite clearly that everything you eat looks like it came from a plant or a tree. I lost weight and began biking every day and felt like a million bucks. This may not be the diet for you, but the more salads you eat, the better you will feel. Experiment and see. After eating raw food for several months or even days, have a plate of pasta or a bagel and see how it feels. In my experience, it feels awful, and suddenly I become sluggish and tired. That feeling of being tired extends to everything. You've felt that, I'm sure. Once you are tired, or not feeling well, all your best-laid plans are useless. There are plenty of books on the raw food diet and also books on how to fast, but make it easy on yourself and just try to swap out regular meals for a salad at least a few times a week, and you will feel better and have more energy to pursue the plan you have created with this book.

STRESS, ANXIETY, DEPRESSION

We are in a traumatic age, and a traumatic decade, and if you are feeling its effects, that would make sense. It is a stress-inducing time.

If you have serious depression, consult a physician; the other method to battle stress, anxiety, and depression is to meditate. While fasting, raw food, and exercise are important for health, stress is not managed entirely that way. As you move through your career, you will have ups and downs, and the downs can be difficult to manage if you don't have a plan to deal with them. Meditation is simple, and it is the answer to stress that affects nearly all of us. You don't need to take classes in meditation in my opinion, any more than you need to take classes in how to breathe. It is very simple. Sit in a comfortable chair every morning and set a timer for ten minutes. If you don't have a timer, you can sit near a clock and open your eyes occasionally to check the time. With your eyes closed, breathe in and count to yourself starting with the number one. Then breathe out and say the number two, breathe in for three, and so on until you reach ten, and then start over again. Do not worry about other thoughts coming into your head; just continue to focus on counting. If you go over ten by accident, just start over at one. It is best to do this twice a day, in the morning and before you go to bed. It is an ancient technique that really works. Try it. If you want to know exactly what I do, I would recommend an app that I use for meditation called Breethe.

GENEROSITY

While almost everything in this book is geared to help you make it, there is as much to be said for helping others along the way. It is all too common to hear artists who are jealous of other artists' success. One of the cures for this unfortunate emotion is to be consciously generous to other artists in particular. Examples are to listen closely to friends' ideas and help them sort things out or encourage them when you see them hesitate to pursue a dream. One of the online fundraising platforms, kickstarter.com, is a good way to be generous with your money. I'm sure you have heard this can work both ways, so it is important to be financially and emotionally supportive of other artists. That means anything from lending your friend money to supporting several artists for a dollar or more each on kickstarter.com. You can go there now and begin to be a philanthropist

for very little money. It will make you feel good and also give you a taste of what it is like to get letters from people thanking you for your generosity. Some of those letters will make you smile more than others, and that will be a tool to illustrate the pleasure of giving.

YOUR PLAN
WORKBOOK SECTION 13

After finishing this book, keep the workbook close to you and use it every day to follow your plan. You made an investment in yourself and this book, now it is up to you to see it pay off.

Now gather all the pages of this workbook and put them all together. If you wrote it all out in this book and on separate sheets of paper, then photocopy the workbook part, and put it all together with a paper clip or bind it, if you can, using a spiral wire at the copy shop. Put this sheet at the very top, as it is the cover!

If you printed it all out, then bind it. If you want to write it all over, you can print out a blank workbook here: yourartmentor/workbook.pdf

Execute the Plan This Way

Read all the workbook pages once before beginning the plan. Read those pages like an editor. Correct mistakes and adjust parts to make them as accurate as possible. If necessary, write sections over for clarity.

1. Your calendar should have thirty-minute daily blocks of up to four days a week when you work on this plan.

 If these blocks of time are not written in your calendar already, stop now and write thirty-minute blocks of time, four days a week for two months, into your online or printed calendar.

2. Begin each morning and end each evening by reading aloud the sentence you wrote in workbook section 8, number 4. That is a big sentence, or maybe two or three sentences, that describes what it is that you want and how you will get it financially. Close your eyes after you read it aloud and visualize it actually happening. In other words, see yourself showing your work, having it sold, and traveling. But visualize it enough so that it starts to actually feel good. You know this is happening because you will start to smile. Keep thinking about the words in your plan and add to that this advice to yourself, "The means to achieve this will come to me." You are not asking for magic here, you are asking to be inspired. As much as we are putting a plan into action in these pages, you

must bring your own creative spark to it, which cannot be taught. You may use many of the plans that we talked about in this book, but even so, you will add your own style to the approach.

Read that morning and night for one month and work on making that happen in your thirty-minute blocks of time, four days a week.

3. In the second month, double your time commitment to one hour. I know you might be doing that much already, but that's OK, you are still changing the commitment. Adjust your daily statement if new ideas or something else came up.

Practice this for two months.

4. In the fourth month, keep your pace going and add one meeting every other week to your business schedule. That meeting has to be with someone who can help you and your art in some way, like a gallery owner or a collector.

Continue this for eight months, then reevaluate your plan, make adjustment where necessary, and begin again.

Notes on How to Design Your Thirty-Minute Sessions

Keep the work sessions at regular times.

Begin the work session by reading your statement aloud, unless you have done that already.

Using a piece of paper or document on your computer, make notes for each work session. Write down times of start and end as well as comments about what you worked on.

Always write down what you will accomplish in the next session after the one you are finishing.

Find someone to report to. That means anyone from friends, family members, or a spouse, to a professional coach. This is a very important part of the whole process. Very important! Find someone you can write to twice a week, maybe Wednesday and Friday or two other days. The idea is that someone else knows you are trying to accomplish something. By reading your emails that you send to that person twice a week, that friend will support and encourage your process.

Think of who that friend is and write or call them now. Just ask if they would mind getting an email twice a week from you about building your career. Tell them you have some professional goals and you need someone to help you set deadlines. Make a definite beginning and ending, such as from now on for six months or one month or one year. An ending is important so you can evaluate what happened then, and also so that you and the friend supporting you feel committed to the same goal, and will know whether or not you have achieved it!

If you cannot find someone or prefer to work with a professional coach, then look for one and hire one or attend a professional development class or school. (Full disclosure—I direct Praxis Center, a learning space for artists and I can support you there in a fee-based school, praxiscenterforaesthetics.com for more info.)

Write the name of the person or coach or school you decide to work with on the line below.

The Parallel Art World

I am often asked, "What are you doing, Brainard? What kind of art do you make now?" Here is the answer in a form that hopefully makes sense; this is a work in progress.

The Parallel Art World (PAL) is a project that my wife and I are exploring as a new system for art exchange and exhibitions. We collaborate on all art we make under the name Praxis. Here is our latest, though that is also the beginning of a new project.

The Parallel Art World (PAL)

There is a world that can be made by artists and for artists and it can survive by means of sheer will. It will be financed by our dreams and it could run on a fuel we can't see and it will transcend what we know of as reality, because it is art, it is a world that is open to you and it is a world made by you because there are no leaders or tastemakers, only artists.

This is a secret society—which means it can be printed on this page and read by almost anyone, but some will see a new door open, or they will hear a voice or have a sudden enthusiasm. They are reading between the lines on this page, these lines which are a guide but not a set of instructions to enter PAL.

The Parallel Art World is like a secret society without a leader; imagine a space that everyone shares and all art is hung, music is played, poetry is read, meals are served, but none of it is familiar, and there is a place to rest.

Imagine a laboratory with an alchemist and that alchemist is you. Imagine you are experimenting.

This is physical and it is not. There are no defined boundaries and no one makes the rules including the writer of this.

To enter into this world you only need to desire it and if you do, you already are there.

Are you in?

If you answered yes, the next words are—welcome here.

You are now a part of the parallel art world, a place where anything does happen because it is free of rules and structure.

Which means that now we are all creating this new parallel art world together. What is it? A website, a new software, an alchemical storefront! Maybe a new language, a new way of writing, a new way of buying or exchanging art?

We have established a domain as a public repository of ideas of what the parallel art world should include or become or avoid. This will grow organically without anyone at the helm, this site

Try something totally new.

is only for conversation, to grow the seeds of the ideas which are sure to germinate around the world to grow something new and unexpected.

We are cultivating the earth together so that art can grow in new forms and new ways.

—Praxis, Parallelartworld.com

Afterword

To be an artist is a calling, and if you have read this book then you are an artist that deserves to have your work shown and shared with the world.

It doesn't matter if you make paintings of sunsets or idea-based work like I do, or one of the many, many other forms of art there is in the world.

What matters is that you believe in your work and yourself, and take the steps to share your work and your presence. That is all.

This whole book was about the many forms of how you can share your art: through a Zoom presentation or through gallery shows, biennials to café and library walls or your own home or studio. It doesn't matter much where you show. What's important is that you take the action to show and share your art.

If you need more support or want your website reviewed by me or want help with your strategy, that is what I have been doing for over ten years through Praxis Center for Aesthetics, the online school for artists to develop their careers.

You can learn more here: praxiscenterforaestheticstudies.com/.

There are many ways to get support for your art, but if you want to ask me any question, anytime, just contact me through that link above and I will do my best to answer you.

I wish you great joy and success with your studio practice.

I believe art can save the world, one dream at a time; artists are culture producers, you literally make the rich culture that is art history in the making.

Without you and your art, there is no culture, no art history. The world is under a great global shift right now, everything seems to be changing, and you are the dreamer that can lift everyone to a new level of awareness.

Thank you for your dreams and your art and the contribution you are making to the future.

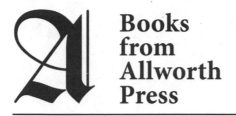

Books from Allworth Press

Allworth Press is an imprint of Skyhorse Publishing, Inc. Selected titles are listed below.

Starting Your Career as an Artist
by Angie Wojak and Stacy Miller (6 × 9, 288 pages, paperback, $19.95)

The Profitable Artist
by Artspire (6 × 9, 256 pages, paperback, $24.95)

The Business of Being an Artist, Fourth Edition
by Daniel Grant (6 × 9, 408 pages, paperback, $27.50)

Legal Guide for the Visual Artist, Fifth Edition
by Tad Crawford (8½ × 11, 280 pages, paperback, $29.95)

Art Without Compromise
by Wendy Richmond (6 × 9, 232 pages, paperback, $24.95)

Artist's Guide to Public Art: How to Find and Win Commissions
by Lynn Basa (6 × 9, 256 pages, paperback, $24.95)

Selling Art Without Galleries: Toward Making a Living From Your Art
by Daniel Grant (6 × 9, 288 pages, paperback, $24.95)

Fine Art Publicity: The Complete Guide for Galleries and Artists, Second Edition
by Susan Abbott (6 × 9, 192 pages, paperback, $19.95)

How to Start and Run a Commercial Art Gallery
by Edward Winkleman (6 × 9, 256 pages, paperback, $24.95)

The Artist-Gallery Partnership, Third Edition
by Tad Crawford and Susan Mellon (6 × 9, 224 pages, paperback, $19.95)

Business and Legal Forms for Fine Artists, Third Edition
by Tad Crawford (8 ½ × 11, 176 pages, paperback, $24.95)

The Artist's Complete Health and Safety Guide, Third Edition
by Monona Rossal (6 × 9, 416 pages, paperback, $24.95)

Learning by Heart
by Corita Kent and Jan Steward (6 7/8 × 9, 232 pages, paperback, $24.95)

The Quotable Artist
by Peggy Hadden (7 ½ × 7 ½, 224 pages, paperback, $16.95)

Guide to Getting Arts Grants
by Ellen Liberatori (6 × 9, 272 pages, paperback, $19.95)

To see our complete catalog or to order online, please visit *www.allworth.com*.